The Years Before "Anne"

The Years Before "Anne"

Francis W. P. Bolger

NIMBUS
PUBLISHING

Nimbus Publishing Limited
PO Box 9301, Station A
Halifax, NS B3K 5N5
(902) 455-4286

All photographs courtesy of the Public Archives of Canada,
 unless otherwise noted.
Cover design: Arthur B. Carter, Halifax
Printed and bound in Canada by Best Gagné Book
 Manufacturers Ltd.

Canadian Cataloguing in Publication Data

Bolger, Francis W.P., 1925-
The years before Anne
Reprint. Originally published: [Charlottetown, P.E.I.]: Prince
Edward Island Heritage Foundation, 1974.
Includes bibliographical references.
ISBN 0-920154-77-7
1. Montgomery, L.M. (Lucy Maud), 1874-1942. I. Title.
PS8526.055Z58 1991 C813'.52 C91-097571-X
PR9199.3.M6Z58 1991

The year 1974 marks the centenary of the birth of Lucy Maud Montgomery. This book is written as a humble tribute to the woman who receives and eminently deserves recognition as Prince Edward Island's most famous international personage.

The emphasis in this monograph, as the title implies, is on the years prior to Lucy Maud Montgomery's publication of *Anne of Green Gables* in 1908. This period in her literary career is selected largely because some very valuable and interesting original source material covering this time frame was made available. First, in order of importance, is a sequence of letters written by Lucy Maud to her intimate friend, Penzie Macneill, of Cavendish during the year that she spent with her father, Hugh John Montgomery, in Prince Albert. These letters, written during a critical and influential year in the rise of Lucy Maud to literary fame, give the reader a glimpse of a side of her character not otherwise revealed. Secondly, two of her early scrapbooks which contain all her published short stories, serials, and poems, written in the 1890's make it possible to accompany Lucy Maud step by step on her gradual ascent of "the Alpine path, so hard, so steep, to true and honoured fame." The supplementing of these valuable sources with her autobiographical sketch, "The Alpine Path," and her revealing series of letters to Ephraim Weber, her pen-friend of some forty years, makes it possible to add an important new dimension to our knowledge of the character of one of the world's greatest creators of fiction.

I am deeply indebted to William V. Stevenson, the original possessor of the Penzie Macneill letters, and to Merritt Crockett, chief librarian of the University of Prince Edward Island, the present custodian of the collection, for making the letters available to me. I should also like to thank Ruth Campbell of "Silver Bush," Park Corner, and the trustees of the L. M. Montgomery birthplace, New London, for allowing me to use the early scrapbooks of Lucy Maud Montgomery. I am grateful to Terence Macartney-Filgate, producer for the Canadian Broadcasting Corporation, who permitted me, with permission of L. M. Montgomery's son, Dr. Stuart Macdonald, to read portions of his mother's hitherto unpublished diaries. I also recognize, with gratitude, the invaluable assistance rendered, during many hours of conversation, by the Macneills of Cavendish, the Montgomerys and the Campbells of Park Corner. Finally I wish to acknowledge the tremendous contribution made by Paula Coles, who assisted with the research, by Shirley Dillon, who typed the many versions of the manuscript, by Wendell P. H. MacIntyre and David Weale who read the final manuscript and made many worth-while suggestions. It is my sincere hope that this book will help its readers to comprehend more fully and appreciate more deeply the fascinating life and brilliant career of Lucy Maud Montgomery.

Francis W. P. Bolger

Francis W. P. Bolger
University of Prince Edward Island
November 30, 1974.

*This book is dedicated to all
those who share Lucy Maud Montgomery's
affection for Prince Edward Island.*

AUTHOR'S NOTE FOR 1975 REPRINTING

The centenary of Lucy Maud Montgomery's birth occasioned a renewed interest in the remarkable literary career of Canada's best-selling woman author. *The Years Before Anne,* a study of her early career, and *The Alpine Path,* an autobiographical sketch of her life until 1917, were both published in 1974. A sensitive ninety-minute T.V. drama-documentary, *Lucy Maud Montgomery: The Road to Green Gables,* filmed by Terence Macartney-Filgate, was released by the Canadian Broadcasting Corporation in September, 1975.

A book of literary criticism of her published works, to which I am contributing the historical background, will add an important dimension to our knowledge of Lucy Maud Montgomery's literary career. It is a singular honor indeed to assist readers to comprehend more fully the fascinating and brilliant life of Prince Edward Island's most distinguished international personage.

Francis W. P. Bolger
September, 1975

Contents

Illustrations

The Years Before "Anne"

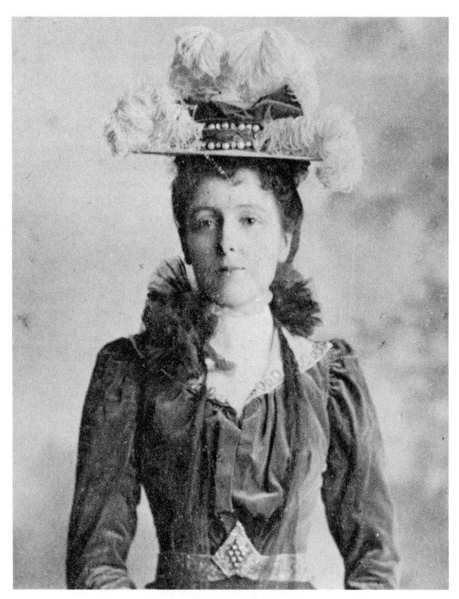

LUCY MAUD MONTGOMERY

CHAPTER I

THE AUTHOR'S BACKGROUND

In 1917, Lucy Maud Montgomery, Prince Edward Island's most famous personage, was requested by the editor of *Everywoman's World* to write the story of her career. Although Lucy Maud had already achieved international acclaim through her publication of the immortal *Anne of Green Gables* and six sequels, *Anne of Avonlea, Kilmeny of the Orchard, The Story Girl, Chronicles of Avonlea, The Golden Road*, and *Anne of the Island*, she states that the request led her to smile with incredulous amusement:

My career? *Had* I a career? Was not — should not — a "career" be something splendid, wonderful, spectacular at the very least, something varied and exciting? Could my long, uphill struggle, through many quiet uneventful years, be termed a "career"? It had never occurred to me to call it so; and, on first thought, it did not seem to me that there was much to be said about that same long, monotonous struggle.[1]

In spite of her reservations, Lucy Maud agreed to tell her "tame story"[2] with the hope that it might "encourage some other toiler who is struggling along in the weary pathway I once followed to success."[3] Consequently, she wrote a series of six fascinating articles entitled, "The Alpine Path," which appeared in *Everywoman's World* from June until November, 1917.

In the first of these autobiographical sketches, Lucy Maud reveals why she chose the captivating title, "The Alpine Path." She states that since her childhood a stanza from a poem entitled, "The Fringed Gentian," which she had pasted on the portfolio containing her letters and school essays, had always been the keystone of her "every aim and ambition."[4]

> *"Then whisper, blossom, in thy sleep*
> *How I may upward climb*
> *The Alpine path, so hard, so steep,*
> *That leads to heights sublime;*
> *How I may reach that far-off goal*
> *Of true and honoured fame*
> *And write upon its shining scroll*
> *A woman's humble name."*[5]

The theme of this book, Lucy Maud's heroic ascent of the "Alpine path, so hard, so steep,"[6] until she achieved "true and honoured fame"[7] with her publication of *Anne of Green Gables*, is a truly fascinating story.

Lucy Maud Montgomery, daughter of Hugh John Montgomery and Clara Woolner Macneill, was born in the small, picturesque village of New London (Clifton), Prince Edward Island on November 30, 1874, in an attractive little home which still stands, relatively unchanged, on the same location. Here her industrious father operated a general store which he called "Clifton

House," some six miles distant from his birthplace at Park Corner. Shortly after Lucy Maud's birth, her mother developed tuberculosis which soon became so debilitating that her husband was obliged to move his wife and young child to the Macneill homestead in Cavendish. Here on September 14, 1876, Clara Woolner Macneill died at the age of twenty-three. Lucy Maud relates with almost unbelievable detail her recollection of her mother's death:

> I distinctly remember seeing her in her coffin — it is my earliest memory. My father was standing by the casket holding me in his arms. I wore a little white muslin dress and Father was crying . . . I looked down at Mother's dead face. It was a sweet little face, albeit worn by months of suffering. My mother had been beautiful, and Death, so cruel in all else, had spared the delicate outline of feature, the long silken lashes brushing the hollow cheek, and the smooth masses of golden brown hair . . . I reached down and laid my baby hand against Mother's cheek. Even yet I can feel the coldness of that touch . . . The chill of Mother's face had frightened me. I turned and put my arms appealingly about Father's neck and he kissed me. Comforted, I looked down again at the sweet placid face as he carried me away. That one precious memory is all I have of a girlish mother who sleeps in the old burying-ground of Cavendish, lulled forever by the murmur of the sea.[8]

Lucy Maud, now motherless at the age of twenty-one months, her father departed for a new career in Prince Albert, Saskatchewan, was left in the care of her maternal grandparents, Alexander and Lucy Macneill, in the old Macneill home in Cavendish.

The years that Lucy Maud Montgomery spent at Cavendish were destined to have a profound influence upon her success as an author. Her association with the scores of Macneills residing in Cavendish plus the natural environment provided by the pastoral beauty of the countryside washed by the sparkling waters of the Gulf of St. Lawrence were formative influences indeed. Many years later, Lucy Maud remarked that the incidents and environment of her childhood had a marked influence on the development of her literary gift.[9] "A different environment," she added, "would have given a different bias. Were it not for those Cavendish years, I do not think *Anne of Green Gables* would ever have been written."[10]

Lucy Maud had a deep and passionate affection for Prince Edward Island, Canada's smallest province, cradled peacefully and unobtrusively in the Gulf of St. Lawrence. "Old Prince Edward Island," she writes in "The Alpine Path," "is a good place in which to be born — a good place in which to spend a childhood. I can think of none better."[11] "Prince Edward Island," she adds glowingly, "is really a beautiful province — the most beautiful place in America, I believe. Elsewhere are more lavish landscapes and grander scenery; but for chaste, restful loveliness it is unsurpassed. Compassed by the inviolate sea, it floats on the waves of the blue gulf, a green seclusion and haunt of ancient peace."[12] She elaborates upon her personal predilection,

the overpowering attractiveness of the sea:

Much of the beauty of the Island is due to the vivid colour contrasts — the rich red of the winding roads, the brilliant emerald of the uplands and meadows, the glowing sapphire of the encircling sea. It is the sea which makes Prince Edward Island in more senses than the geographical. You cannot get away from the sea down there . . . Great is our love for it; its tang gets into our blood; its siren call rings ever in our ears; and no matter where we wander in lands afar, the murmur of its waves ever summons us back in our dreams to the homeland. For few things am I more thankful than for the fact that I was born and bred beside that blue St. Lawrence Gulf.[13]

Throughout the thirty-seven years that Lucy Maud spent on Prince Edward Island, the Gulf of St. Lawrence was always a romantic and mysterious inspiration. "The sea," she remarked to Ephraim Weber, her platonic pen-friend for some forty years, and to whom she dedicated the novel, *The Blue Castle*, "is a mighty soul forever moaning of some great unshareable sorrow that shuts it up in itself for all eternity. You can never pierce into its great mystery — You can only wander, awed and spellbound on the outer fringe of it . . . The woods are human but the sea is of the company of the archangels."[14]

Lucy Maud spent much of her childhood at Cavendish shore then called Cawnpore. She tells us that the shore was a part of her life from her "earliest consciousness."[15] "I learned," she wrote, "to know it and love it in every mood. The Cavendish shore is a very beautiful one; part of it is rock shore where the rugged red cliffs rise steeply from the boulder-strewn coves. Part is a long, gleaming sandshore, divided from the fields and ponds behind by a row of rounded sand-dunes, covered by coarse sand-hill grass. This sand-shore is a peerless spot for bathing."[16] "In vacations," she added, "I would spend most of the day there, and I soon came to know every cove, headland, and rock on that shore. We would watch the boats through the sky-glass, paddle in the water, gather shells and pebbles and mussels, and sit on the rocks and eat dulse, literally by the yard."[17] The enchanting influence of Cavendish beach remained indelibly imprinted in Lucy Maud's memory and it was no accident indeed that her first published poem and short story, "Cape LeForce," and "The Wreck of the Marco Polo," dealt with events that took place on Cavendish beach.

Lucy Maud's love of, and attachment to, the countryside of Cavendish was as intense as her love of the sea. Throughout her life she reminisced about her "childhood and girlhood years spent in an old-fashioned Cavendish farmhouse, surrounded by orchards."[18] "Everything," she relates, "was invested with a kind of fairy grace and charm, emanating from my own fancy, the trees that whispered nightly around the old house where I slept, the woodsy nooks I explored, the homestead fields, each individualized by some oddity of fence or slope."[19] "I had always," she continues, "a deep love of nature. A little fern growing in the woods, a shallow sheet of June-bells under the firs,

moonlight falling on the ivory columns of a tall birch, an evening star over
the tamarack on the dyke, shadow-waves rolling over a field of ripe wheat —
all gave me 'thoughts that lay too deep for tears' and feelings that I had then
no vocabulary to express."[20] She also had a great fascination for trees and flow-
ers. "I am grateful," she remarks, in "The Alpine Path," "that my childhood
was spent in a spot where there were many trees, trees of personality, planted
and tended by the hands long dead, bound up with everything of joy or sor-
row that visited our lives. When I have 'lived with' a tree for many years it
seems to me like a beloved human companion . . ."[21] "Dear Old Trees!," she
concludes, "I hope they all had souls and will grow again for me on the hills
of Heaven."[22]

Lucy Maud was equally ecstatic about flowers. "At the present mo-
ment," she wrote to Mr. Weber in May, 1905, "I'd rather be a girl than an
angel if angels can't have mayflowers. I'm surrounded with them — mayflow-
ers, I mean. A vaseful on each side of me and a big jugful on the shelf over
my head. Oh, they are divine! A lot of us went up to the barrens Saturday
and picked great basketfuls. Today I read that Henry Ward Beecher said
once: 'Flowers are the sweetest things God ever made and forgot to put souls
into.' But I don't believe He forgot. I believe they *have* souls. I've known
roses that I expect to meet in heaven."[23] She became beautifully theological
in her approach to flowers. "My Roman Narcissus and white hyacinths," she
informed Mr. Weber, "are out now. The latter are the sweetest things God
ever made. They seem more like the souls of flowers than flowers themselves
. . . I love best the flowers I coax into bloom myself, be they tall or small,
white or rosy. It seems as if I were taking a hand in creation — giving light
to those unsightly bulbs that hide such rainbow possibilities in their
cores."[24] She became amusingly fastidious in her flower arrangements.
"I don't like *bouquets* at all" she told Mr. Weber, "in the sense of several
varieties of flowers being bound together. I never mix flowers and very
seldom colours. In a tall glass vase or low bowl, as suits the flower, I put a
few blossoms of one kind with a bit of foliage or fern and then sit back and
adore them. At the most I never put more than *two* kinds together. More
would swear at each other, seems to me."[25] Her garden, at the Macneill
home, adorned with beautiful flowers, was a constant source of inspiration
for Lucy Maud during the years that she spent in Cavendish. It seems
fitting that the first poem for which she received a monetary reward was
entitled, "The Violet's Spell." This poem was published in *The Ladies'
World* in 1894.

Lucy Maud's affection for the rural charm of Cavendish was paralleled
by an equally deep attachment for Park Corner, the home of her paternal
grandparents, Senator Donald and Mrs. Montgomery, and her mother's sister,

Annie Macneill, who was married to John Campbell. She absolutely revelled in the beauty of the gentle rolling hills of Park Corner surrounded by babbling streams, small ponds and the sea. She spent many of her school vacations with her relatives. "The Park Corner jaunts," she tells us, "were always delightful. Uncle John Campbell's house was a big white house smothered in orchards. Here, in other days, there was a trio of merry cousins to rush out and drag me in with greeting and laughter. The very walls of that house must have been permeated by the essence of good times."[26] Characteristically, it was the beauty of nature that left the deepest impression:

I was very fond of trouting and berry picking. We fished the brooks up in the woods, using the immemorial hook and line with "w'ums" for bait ... We picked berries in the wild lands and fields back of the woods, going to them through wooded lanes fragrant with June-bells, threaded with sunshine and shadow, carpeted with mosses, where we saw foxes and rabbits in their native haunts. I have never heard anything sweeter than the whistling of the robins at sunset in the maple woods around those fields.[27]

Lucy Maud's attachment to the Campbell home remained constant. Many years later, in response to a request from her cousin, Donald Campbell, for some modest financial assistance, she wrote: "I am actuated in all I do and say in this matter by a sincere wish to do right by all concerned, and to help Park Corner to get back where it used to be. I love the old spot better than any place on earth, and I have done more than you may realize for it."[28] Two generations later, thanks to the Campbells and Lucy Maud, this venerable home still retains its original beauty.

Lucy Maud Montgomery's intimate association with the Macneills and the Montgomerys had a marked influence upon her development. The history of Prince Edward Island is replete with descendants of these families who have made notable contributions to the economic, social, religious, cultural, and political life of the province. The intellectually curious Lucy Maud informs us that, as a child, she "listened with delight to the many traditions and tales on both sides of the family as they talked over them around winter firesides."[29] These stories made a vivid impression upon her sensitive mind and formed an important part of a storehouse of memories upon which she drew to good advantage in later years to weave her own immortal masterpieces.

Through her mother, Clara Woolner Macneill, Lucy Maud was a great-great-granddaughter of John Macneill, one of the co-founders of Cavendish. William Simpson, Senior, his sons, William Junior and James Simpson, and his sons-in-law, William Clark and John Macneill were the original families that began the settlement of Cavendish.[30] John Macneill and his wife Margaret Simpson obtained rights to some five hundred acres of land bordering on the north shore of Cavendish, and it was upon this comparatively

large domain that the Macneills of Cavendish had their beginnings. John
and Margaret had twelve children, eleven of whom grew to maturity, mar-
ried, and established families. Six of the eleven settled in Cavendish, and
so the Macneills were closely associated with the development of a young
and growing community. They were prodigious workers, and exemplary
citizens, endowed with solid intellectual and moral standards. John and
Margaret Macneill's oldest son, William, (1782-1870), Lucy Maud's great-
grandfather, was quite a clever man, well-educated for this period, and
exercised a significant influence on the political and social life of the Island.
He was a school teacher, farmer, shipbuilder, and politician. He sat as a
member of the House of Assembly from 1814-1834, and served as Speaker
for the last four of those twenty years.[31] His role in the Legislature earned
him the title, "William the Speaker," or, even more commonly, "Old Speaker
Macneill." He became the veritable patriarch of the district, was Commis-
sioner of Public Works, and as magistrate, wrote wills, settled legal disputes,
and performed most of the marriages.[32] From his marriage to Eliza Town-
send of Park Corner he had a large family of eleven children, one of whom,
Alexander, (1820-1898), the farmer-postmaster of Cavendish, was destined to
provide a home for his motherless granddaughter, Lucy Maud Montgomery.

Lucy Maud relates in "The Alpine Path," that it was from her mother's
family — the Macneills — that she "inherited her knack of writing and her
literary tastes."[33] Lucy Maud's closest association was, of course, with her
grandfather, Alexander Macneill, with whom she lived for some twenty-four
years. Alexander inherited his father's homestead and took care of his par-
ents during their golden years. He married Lucy Woolner, a very clever
woman, who had attended an excellent school in England prior to the emi-
gration of the Woolner family to North Rustico, Prince Edward Island.
Lucy Maud, on innumerable occasions, recognized, with grateful apprecia-
tion, her literary indebtedness to her grandfather, Alexander, his wife, and
to three of his brothers and sisters. She states that her grandfather "was a
man of strong and pure literary tastes, with a considerable knack of prose
composition."[34] His brother, William, she notes, "could write excellent
satirical verse."[35] In addition, another brother, James, "was an excellent
poet."[36] Lucy Maud, who often heard her grandfather recite James's
poetry, insists that his poems were "witty, pointed, and dramatic,"[37] and
that he was something of a "mute inglorious"[38] Robert Burns.

It was, however, for her grandaunt, Mary Macneill, wife of David Law-
son, that Lucy Maud expressed her deepest appreciation and admiration.
"Aunt Mary Lawson," to whom she dedicated her sixth book, *The Golden
Road*, was a charming *raconteur* of Island history and folklore, and pro-
vided Lucy Maud with an abundance of subject material for many of her

short stories, serials, poems and novels. In "The Alpine Path," Lucy Maud expressed her gratitude to her beloved grandaunt:

No story of my "career" would be complete without a tribute to my "Aunt Mary Lawson," for she was one of the most formative influences of my childhood. She was really quite the most wonderful woman in many respects that I have ever known. She had never had any educational advantages. But she had a naturally powerful mind, a keen intelligence, and a most remarkable memory which retained to the day of her death all that she had ever heard or read or seen. She was a brilliant conversationalist, and it was a treat to get Aunt Mary started on tales and recollections of her youth, and all the vivid doings and sayings of the folk in those young years of the Province. We were great "chums," she and I, when she was in her seventies and I was in my teens. I cannot, in any words at my command, pay the debt I owe to Aunt Mary Lawson.[39]

Such associations certainly facilitated Lucy Maud's successful ascent of "The Alpine Path."

The influence of the Montgomery family in Lucy Maud's formation as an author was almost equally as significant as that of the Macneills. Through her father, Hugh John Montgomery, Lucy Maud was a great-great-granddaughter of Hugh Montgomery who settled in Malpeque, Prince Edward Island in 1769. The Montgomerys, like the Macneills, were principally farmers and politicians, and played a prominent role in the social and political life of the Island. Family tradition, narrated by Lucy Maud, informs us that Hugh with his wife and family and two brothers intended to settle in Quebec. Their ship anchored off the Island for water after the long Atlantic crossing from Scotland, and Hugh's wife, Mary MacShannon, desperately seasick, went ashore for a respite. Once ashore, she informed her husband that nothing could persuade her to leave dry land. "Expostulation, entreaty, argument," Lucy Maud relates, "availed nothing."[40] Hugh was thus obliged to remain at Malpeque, and the Prince Edward Island branch of that family are descendants. Prince Edward Island is grateful that a woman's strong will prevailed. One of the brothers returned to Scotland and the other settled in Toronto, where one of his descendants merited a footnote in Canadian History through his operation of "Montgomery's Tavern," the celebrated locale of William Lyon MacKenzie's abortive rebellion of 1837.

Hugh Montgomery and Mary MacShannon had a family of three sons and three daughters. Their son, Donald, Lucy Maud's great-grandfather, married Nancy Penman, daughter of George Penman, a United Empire Loyalist who came to Prince Edward Island at the end of the American War of Independence. Lucy Maud told the story of their romance in *The Story Girl* published in 1911, the last book written by her in Cavendish. Lucy Maud often remarked that the writing of this book gave her the greatest pleasure because the characters and the landscapes were the most real. The *Donald Fraser* of *The Story Girl* was Donald Montgomery and *Nancy*

Sherman was Nancy Penman. Lucy Maud tells us that "the only embroidering she permitted herself in the telling of the tale was to give *Donald* a horse and cutter."[41] "In reality," she adds, "what he had was a half-broken steer, hitched to a rude, old wood-sled, and it was with this romantic equipage that he hied himself over to Richmond Bay to propose to Nancy!"[42] Her betrothal to David Murray, *Neil Campbell* of *The Story Girl*, did not prevent *Nancy* from agreeing to marry *Donald*. The rival suitor, outdistanced by *Donald's* speedy ride, was consoled when *Nancy's* sister, Betsy, proposed and married him. Lucy Maud insists that she, herself, was the winner on both counts. Her grandfather, Senator Donald Montgomery, the son of Donald and Nancy, married his first cousin, Ann Murray, the daughter of David and Betsy. If the reader is not now hopelessly confused genealogically, it can be gleaned that Nancy and Betsy were both great-grandmothers of Lucy Maud!

The whole span of Island history, especially its political history, was available to Lucy Maud through her association with the Montgomerys. Her great-grandfather, Donald Montgomery, was a member of the House of Assembly for Prince County for thirty-five consecutive years. In 1838, his son, Donald (Big Donald), Lucy Maud's grandfather, was elected a member of the House of Assembly for Princetown Royalty. He represented that district in the Assembly until 1862, serving as Speaker from 1858 until 1862. When the Legislative Council became elective in 1863, he was returned for the First District of Queen's County. He was chosen unanimously as President of the Council and continued in that role until he resigned in March, 1874, to enter the Canadian Senate. He remained one of Prince Edward Island's four Senators until his death in July, 1893, at the age of eighty-five.[43] During his fifty-five years in various legislative bodies, he never missed a single session, a record perhaps unrivalled in the annals of Canadian political life.

During her frequent visits to Park Corner, Lucy Maud spent a great deal of time with her grandfather and his family. She tells us in "The Alpine Path," that many of her earliest and happiest memories are connected with visits to her Grandfather Montgomery's farm at Park Corner. He and his family lived in the "old house" then, "a most quaint and delightful old place as I remember it, full of cupboards and nooks, and little, unexpected corners."[44] After her father left to live permanently in Saskatchewan in 1881, Lucy Maud became even more attached to her Grandfather Montgomery. "Grandfather Montgomery," she remarked in 1890, "is a handsome old man, just like a grandfather out of a story book. I love him. He is always so good and kind and gentle to me." He became, in many ways, her *real* father. The Montgomery connection seemed even more meaningful to

The Macneill Homestead in Cavendish
(Courtesy Mrs. Ernest Macneill)

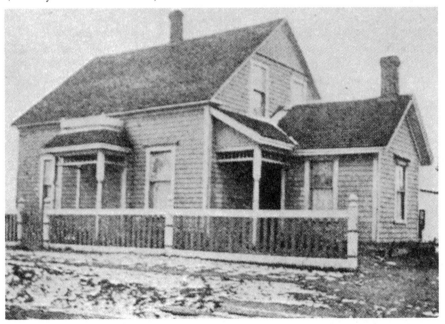

L. M. Montgomery's Birthplace in New London

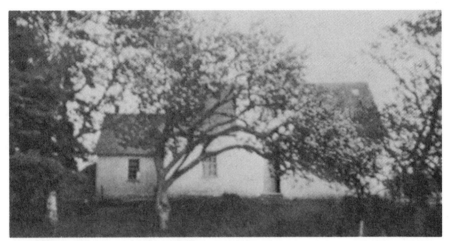

The Macneill Home in Cavendish
(Courtesy Prince Edward Island Heritage Foundation)

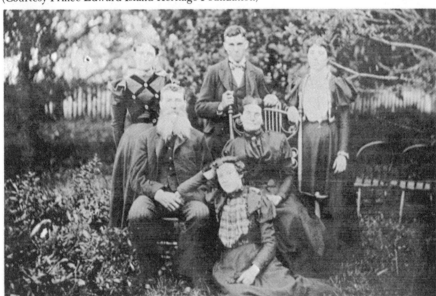

The Campbell's of Park Corner (L-R Clara, George, Stella, John Campbell, Annie Macneill Campbell, Fredericka)
(Courtesy Ruth Campbell)

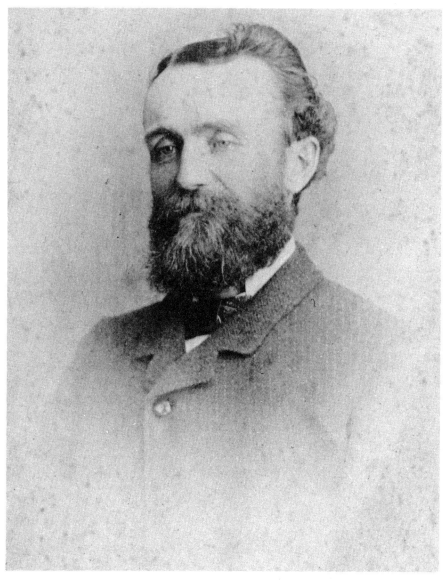

Hugh John Montgomery (L. M. Montgomery's Father)
(Courtesy Mrs. Garnett Campbell)

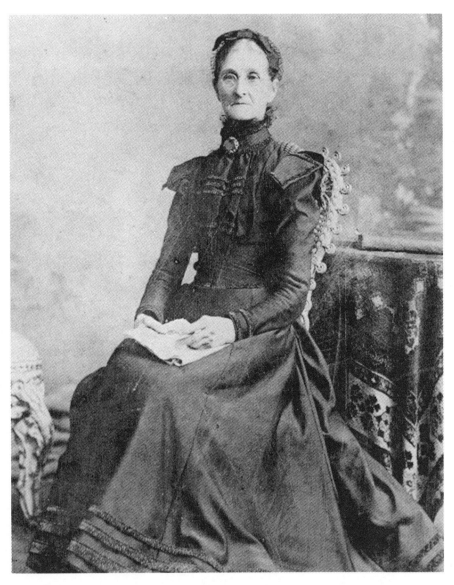

Lucy Woolner Macneill (*L. M. Montgomery's Maternal Grandmother*)
(Courtesy Ruth Campbell)

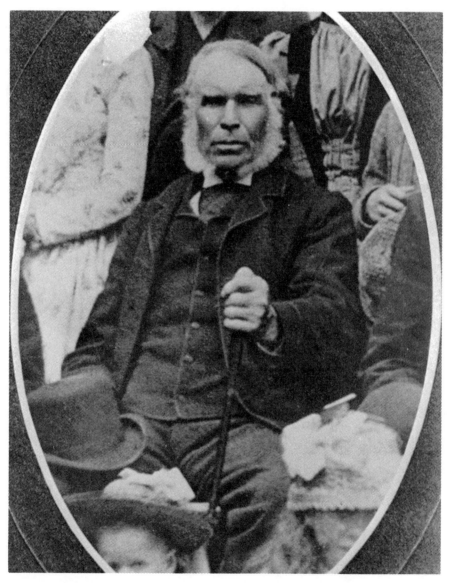

Alexander Macneill (L. M. Montgomery's Maternal Grandfather)
(Courtesy Ruth Campbell)

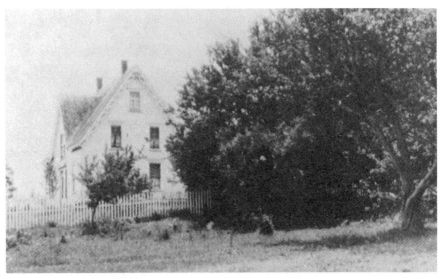

The Campbell Home, Park Corner
(Courtesy Ruth Campbell)

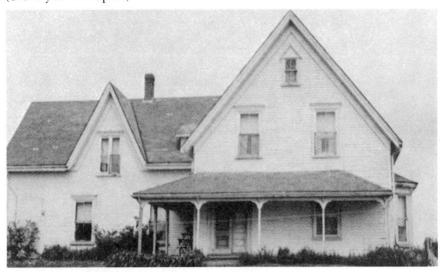

Senator Donald Montgomery's Home, Park Corner
(Courtesy Ruth Campbell)

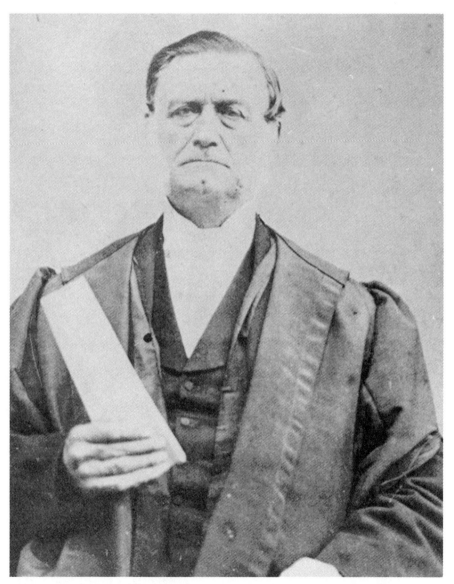

Senator Donald Montgomery (L. M. Montgomery's Grandfather)
(Courtesy Mrs. Heath Montgomery)

her than that of the Macneill's during this stage of her development. And, when Lucy Maud went to Prince Albert, Saskatchewan to spend a year with her father and new stepmother in 1890, it was *Grandpa* Montgomery who accompanied her and paid for the trip. The learning experience that Lucy Maud received from this kindly, clever, and venerable legislator, had a marked influence upon her own future success.

Park Corner, of course, had a double attraction for Lucy Maud. Across the road from Senator Montgomery's home, and just above Campbell's pond, Lucy Maud's Lake of Shining Waters, was the Campbell homestead. This property was first owned by James Townsend Campbell, J.P., who was married to Elizabeth Montgomery, sister of Senator Montgomery. When Lucy Maud, as a young girl, visited Park Corner, the owner of the property and the attractive new home of which she spoke so endearingly, was John Campbell, son of James Townsend Campbell, who was married to Lucy Maud's aunt, Annie Macneill. The "trio of merry cousins" referred to in "The Alpine Path," with whom she played were — Clara, Stella and Fredericka. Her happy associations with the Campbells of Park Corner provided her with many inspirations for her later writings. The story of "The Blue Chest of Rachel Ward" in *The Story Girl*, was literally the chest of Lucy Maud's jilted cousin, Eliza Montgomery, and the chest can still be seen today in the kitchen of the Campbell home at Park Corner. Lucy Maud loved the Campbells deeply, and when she was obliged to leave the Macneill home after her grandmother's death in March, 1911, she moved in with the Campbells, and it was in the living room of this attractive home that Lucy Maud married the Reverend Ewen Macdonald in July, 1911.

Lucy Maud's association with her "merry cousins" did not end with her marriage. At the Manse in Leaskdale where Lucy Maud lived from 1911 to 1926, the Campbells often made their amiable presences felt. One of the servants notes that "during the early years of Lucy Maud's marriage, her cousins Fredericka (Fred for short) and Stella Campbell from the Island visited her. When they were at Leaskdale, the Manse rang with music. Stella liked to sing while Mrs. Macdonald played."[45] A neighbouring minister, Rev. W. M. Mustard, remarked that the major impression left upon him respecting the early days of L. M. Montgomery at Leaskdale was "the gaiety, the laughter and the joy of the Manse, especially when the Campbell cousins from P.E.I. made one of their many prolonged visits. Then we saw and caught something of the spirit of *Anne of Green Gables* being radiated in our community."[46] Lucy Maud always treasured the Campbell connection and never failed to spend part of her annual holidays at her Uncle John Campbell's house at Park Corner occupied as the years passed along by his son George, (Happy George), later by his son James

Townsend, and, now, by James Townsend's widow, Ruth, and son, George.

Lucy Maud's attitude to her immediate "clan" has always been and remains a subject of passionate controversy. From her own testimony it is quite evident that she often found life with her grandparents in Cavendish an exceedingly tedious experience. While her grandparents generously provided a home for her, life in that home was not always pleasant. Lucy Maud describes her grandfather Macneill as a stern, domineering, and irritable man whom she always feared. She claims that he continually bruised her childish feelings, and constantly inflicted humiliation on her childish pride. While admitting that her grandmother Macneill was kind to her in a material way in that she was always well-cared-for, well-fed, and well-dressed, she points out that there was an irreconcilable conflict between herself, a warm-hearted, impulsive and emotional girl, and her grandmother, a cold, reserved woman, narrow in her affections and sensibilities.

Her grandparents were also extremely strict with her. She was seldom allowed to attend social functions, and her young friends were rarely made welcome in the Macneill home. She deeply resented her grandparents' frequent allusions to her father's failure to provide for her maintenance. For these reasons, Lucy Maud found her visits with the Montgomerys and Campbells at Park Corner veritable "escapes." Life was so much easier and happier there. And yet — the Park Corner relatives never provided her with a permanent home. Therefore, Lucy Maud always recognized that she owed a deep debt to her aging grandparents who never faltered in their resolution to make a home for their motherless granddaughter. Moreover, a year in Prince Albert with her father and stepmother, when she was fifteen, led her to remark that the little peculiarities of Grandfather and Grandmother Macneill were nothing compared to Mrs. Montgomery's jealousy and bad temper. She gradually became philosophical, and concluded that life on earth, was not all "beer and skittles." Besides, she always had her three great consolations, her world of nature, her world of books, and her own personal world, namely, her voluminous diary, in which, for some fifty-five years, she poured out daily, with immense intellectual and emotional satisfaction, her joys, her sorrows, her ambitions, her frustrations, and her reflections on the people and events of her day. The experiences of a temperamental and imaginative girl in an exceptionally strict environment were almost inevitably bound to be traumatic. Her literary success, however, is proof positive that she skillfully managed to make a balanced adjustment.

It becomes quite evident from these considerations that Lucy Maud Montgomery, throughout her literary career, derived her principal inspiration from the beauty of nature and from her family associations. Her

novels, poems and short stories reflect the cultural, intellectual and emotional climate of her childhood and adolescence. Her descriptions always mirror the familiar background of pastoral Prince Edward Island. The beauty of her environment, the warmth of human relationships, the sheer happiness of life are the *stuff* of Lucy Maud Montgomery's stories. Her creative writings have a wholesome purity which was nurtured by her intimate association with forebears of strong character and high ideals.[47] In *Emily's Quest*, Lucy Maud has *Emily's* beloved teacher, Mr. Carpenter, say to her: "Live under your own hat. Don't be lead away by these howls about realism. Remember *pine woods* are as real as *pigsties*, and a darn sight pleasanter to be in."[48] Generations of readers remain eternally thankful that Lucy Maud Montgomery, in all her writings, always makes *pine woods* triumph over *pigsties*.

Lucy Maud Montgomery's relationship with

The Macneills
The Montgomerys
The Campbells

✿✿✿

The Macneills

William Simpson Macneill (Speaker) (1782-1870);
Married Eliza Townsend (1788-1869).

Eleven children
one of whom:

Alexander Marquis Macneill (1820-1898);
Married *Lucy Ann Woolner* (1824-1911).

Children: 1. Rev. Leander (1845-1913); Married
 1. J. Perkins, 2. Annie Putman, 3. Mary
 Kennedy.

 2. Annie Laura (1848-1924); Married John
 Campbell (1833-1917).

 3. John Franklin (1851-1936); Married Anna
 Maria McLeod (1848-1933).

4. Clara Woolner (1853-1876); Married Hugh
 John Montgomery (1841-1900).

 Lucy Maud Montgomery (1874-1942),
 was the daughter of Hugh John
 Montgomery and Clara Woolner Macneill.

5. Mary Emily (1856-1937); Married John
 Malcolm Montgomery (1843-1895).

6. Chester B. (1861-1942); Married 1. Hattie Hayden,
 2. Catherine McLeod.

✿ ✿

The Montgomerys

Donald Montgomery (1760-1845); Married Nancy Penman (1788-1857).

Seventeen children
one of whom:

Donald Montgomery (Senator), (1808-1893);
Married 1. Ann Murray (1809-1856), 2. Louisa Cundall Gall (1821-1889).

Eleven children
one of whom:

Hugh John Montgomery (1841-1900);
Married 1. *Clara Woolner Macneill* (1853-1876).
2. *Mary Ann McRae* (1863-1910).

Children - First Marriage: Lucy Maud Montgomery, (1874-
 1942); Married Rev. Ewen
 Macdonald (1870-1943).

 Children:

 Chester Cameron (1912-1964).

Hugh (13-8-1914 - 14-8-1914).
Stuart (1915-1982).

Children - Second Marriage: Kate, Bruce, Hugh Carlyle, Ila May;
Lucy Maud's Half Brothers and Half
Sisters.

✿ ✿

The Campbells (Park Corner)

John Campbell (1833-1917); Married *Annie Laura Macneill* (1848-1924).

Lucy Maud Montgomery's Aunt and Uncle.

Children: 1. Clara Elizabeth (1877-1932);
Married Frederick Wilson.

2. Stella (1879-1955); Married
Lowry Keller.

Lucy Maud's
"merry cousins." 3. George Leander (1881-1918);
Married Mary Ellen Johnstone
(1876-1955).

4. Fredericka Elmanstine (1883-
1919); Married Cameron
MacFarlane.

✿ ✿

FOOTNOTES TO CHAPTER ONE

[1]Lucy Maud Montgomery, "The Alpine Path," *Everywoman's World*, Vol. VII, No. VI, (June, 1917), p. 5, P.A.C.

[2]*Ibid.*

[3]*Ibid.*

[4]*Ibid.*

[5]*Ibid.*

[6]*Ibid.*

[7]*Ibid.*

[8]*Ibid.*, p. 39.

[9]L. M. Montgomery, "The Alpine Path," *Everywoman's World*, Vol. VIII, No. 11, (August, 1917), p. 16.

[10]*Ibid.*

[11]L. M. Montgomery, "The Alpine Path," *Everywoman's World*, Vol. VII, No. VI, (June, 1917), p. 5.

[12]*Ibid.*

[13]*Ibid.*

[14]L. M. Montgomery to Ephraim Weber, 10 November, 1907, p. 57, *The Green Gables Letters*, ed. Wilfrid Eggleston, (Toronto, 1960).

[15]L. M. Montgomery, "The Alpine Path," *Everywoman's World*, Vol. VII, No. VII, (July, 1917), p. 33.

[16]*Ibid.*

[17]*Ibid.*

[18]L. M. Montgomery, "The Alpine Path," *Everywoman's World*, Vol. VII, No. VI, (June, 1917), p. 38.

[19]L. M. Montgomery, "The Alpine Path," *Everywoman's World*, Vol. VIII, No. II, (August, 1917), p. 16.

[20]*Ibid.*

[21]L. M. Montgomery, "The Alpine Path," *Everywoman's World,* Vol. VII, No. VII, (July, 1917), p. 32.

[22]*Ibid.*

[23]L. M. Montgomery to Ephraim Weber, 8 May, 1905, *op. cit.,* p. 29.

[24]L. M. Montgomery to Ephraim Weber, 16 December, 1906, *Ibid.,* p. 48.

[25]L. M. Montgomery to Ephraim Weber, 28 June, 1905, *Ibid.,* p. 33.

[26]L. M. Montgomery, "The Alpine Path," *Everywoman's World,* Vol. VII, No. VII, (July, 1917), p. 35.

[27]*Ibid.*

[28]L. M. Montgomery to Donald Campbell, 7 March, 1932. Ruth Campbell Collection of L. M. Montgomery Letters, Park Corner, P.E.I.

[29]L. M. Montgomery, "The Alpine Path," *Everywoman's World,* Vol. VII, No. VI, (June, 1917), p. 5.

[30]Harold H. Simpson, *Cavendish, Its History, Its People,* (Truro, 1973), pp. 20-112. This book is carefully researched and documented, and gives the reader a valuable insight into the history of Cavendish.

[31]*Ibid.,* p. 75.

[32]*Ibid.,* pp. 75-77.

[33]L. M. Montgomery, "The Alpine Path," *Everywoman's World,* Vol. VII, No. VI, (June, 1917), p. 38.

[34]*Ibid.*

[35]*Ibid.*

[36]*Ibid.*

[37]*Ibid.*

[38]*Ibid.*

[39]*Ibid.*

[40]*Ibid.,* p. 5.

[41]*Ibid.,* p. 38.

[42]*Ibid.*

[43] *The Daily Patriot,* July 31, 1893.

[44] L. M. Montgomery, "The Alpine Path," *Everywoman's World,* Vol. VII, No. VI, (June, 1917), p. 39.

[45] Margaret M. Mustard, *L. M. Montgomery as Mrs. Ewan Macdonald of the Leaskdale Manse,* 1911-1926, (Leaskdale, 1965), p. 14.

[46] *Ibid.,* p. 16.

[47] See genealogical chart at the end of this chapter.

[48] L. M. Montgomery, *Emily's Quest,* (Toronto, 1927), p. 29.

<div align="center">

CHAPTER II

PRELUDE TO A LITERARY CAREER —
FIRST SUCCESSES

</div>

On the frontispiece of a scrapbook, belonging to Lucy Maud Montgomery, and comprising all the poems and short stories published by her between the years 1890 and 1898, there appears, in her own handwriting, the following words from Lord Byron:

<div align="center">

"T'is pleasant sure, to see one's name in print;
A book's a book although there's nothing in't."[1]

</div>

It is easy to imagine the consolation that Lucy Maud derived from Lord Byron's *obiter dictum* as she proudly pasted offprints of her first published articles with their dates of publication in that old scrapbook.

Lucy Maud's objective since her early youth had been to see her "name in print."[2] She elaborates upon this objective in "The Alpine Path:"

When I am asked, "When did you begin to write?" I say, "I wish I could remember." I cannot remember the time when I was not writing, or when I did not mean to be an author. To write has always been my central purpose around which every effort and hope and ambition of my life has grouped itself. I was an indefatigable little scribbler, and stacks of manuscripts, long ago reduced to ashes, alas, bore testimony to the same. I wrote about all the little incidents of my existence. I wrote descriptions of my favourite haunts, biographies of many cats, histories of visits, and school affairs, and even critical reviews of the books I had read.[3]

Lucy Maud began her "apprenticeship" early in life. She tells us that she was always "passionately fond of reading."[4] Among the books in the Macneill homestead were such selective classics as *Rob Roy*, Bulwer Lytton's *Zanoni*, *Pickwick Papers*, Hans Andersen's *Fairy Tales*, and for Sundays, *The Pilgrim's Progress* and Talmage's *Sermons*.[5]

The Macneills' strict code on novels was not applied so rigidly to poetry, so that Lucy Maud was allowed to "revel at will in Longfellow, Tennyson, Whittier, Byron, Milton and Burns."[6] "Poetry pored over in childhood," she remarked, "becomes part of one's nature more thoroughly than that which is read in mature years."[7] "Its music," she added, "was woven into my growing soul and has echoed through it, consciously and unconsciously, ever since."[8] Lucy Maud's youthful immersion was certainly a valuable asset as she prepared to embark upon a literary career.

She was only nine years old when she first discovered the thrill of writing a poem. Her first effort, which she called "Autumn," was written in blank verse. Her father, home from Prince Albert for a visit with his daughter, did not share her elation as she proudly read the poem to him. He remarked unenthusiastically that it "didn't sound much like poetry."[9] When

she explained that it was blank verse, his deflating response was that it was "very blank indeed."[10] Lucy Maud admits that while she was squelched for a time, she soon recovered. "If the love of writing is bred in your bones," she emphasizes, "you will be practically non-squelchable."[11] And so she continued her effusions. "Once I found out that I could write poetry," she tells us, "I overflowed into verse over everything. I wrote in rhyme after that though, having concluded that it was because "Autumn" did not rhyme that father thought it wasn't poetry."[12] "I wrote," she concludes, "yards of verse about flowers and months and trees and sunsets."[12] Lucy Maud employed this technique throughout her literary career. Many years later, she elaborated upon her rhyming method to her friend, Ephraim Weber:

When I begin to write a poem the words seem to fall naturally into the rhythm best suited to the idea, and I just *let* them fall and devote my energies to hunting out rhymes which I do in a very mechanical and cold-blooded way, using a little rhyming dictionary I made myself. (Tennyson used a rhyming dictionary you know. How nice to be like him in something!!) Sometimes, I write a whole poem without a single rhyme in it. Then, when I've caged my ideas I substitute end words that rhyme and there you are![14]

Thus the "yards of rhyming verse" written in her childhood helped her immeasurably throughout her successful career.

One of Lucy Maud's more ambitious childhood efforts was a long poem, written when she was twelve years of age, which she called "Evening Dreams," the first two stanzas of which were:

> *When the evening sun is setting*
> *Quietly in the west,*
> *In a halo of rainbow glory,*
> *I sit me down to rest.*
>
> *I forget the present and the future,*
> *I live over the past once more,*
> *As I see before me crowding*
> *The beautiful days of yore.*[15]

Generous commendation of the poem by her discriminating Cavendish school teacher, Izzie H. Robinson, convinced Lucy Maud that she had composed a masterpiece. That winter she made a painstaking copy of "Evening Dreams," and sent it to the editor of an American magazine called *The Household*. Several weeks later, the poem was returned with an icy rejection slip. Lucy Maud then sent it to the editor of the Charlottetown *Examiner* hoping that it would find a resting place in the Poet's Corner. Alas, the results were the same.[16] Although Lucy Maud admits that these rejections "drained her cup of failure to the very dregs,"[17] and, "crushed

her in the very dust of humiliation,"[18] she continued to write poems, "because I couldn't help it."[19] "I went on writing," she emphasized, "because I had learned the first, last, and middle lesson — Never give up!"[20]

Lucy Maud's first taste of real success came some three years later when she was living in Prince Albert, Saskatchewan. On August 11, 1890, accompanied by her paternal grandfather, Senator Donald Montgomery, the fifteen-year-old Lucy Maud began the long journey by rail and stage to visit her father. Interestingly enough, immediately prior to their leaving, Lucy Maud and her grandfather spent a few hours in Kensington, in the private railway car of Sir John A. and Lady Macdonald who were on a visit to the Island. Hugh John Montgomery, now remarried to Mary Ann McRae, and living in their new home in Prince Albert, had responded affirmatively to his daughter's repeated requests to make her home with them. A desire to be with her father whom she loved deeply, the hope of improved educational facilities, and a welcome break from the strict atmosphere imposed by her demanding and aging grandparents in Cavendish, motivated her desire to move to Saskatchewan. Although she regretted the move within weeks, and remained only one year in Prince Albert, she, nevertheless, achieved outstanding results in her literary pursuits.

Painfully homesick and with time passing unbearably slowly, Lucy Maud sought solace through feverish literary activity. In October, 1890, "I wrote up," she informs us, "the old Cape Leforce legend in rhyme and sent it down home to the *Patriot,* no more of the *Examiner* for me!"[21] Lucy Maud relates in "The Alpine Path," that she learned the story of Cape Leforce from her grandfather Macneill.

The story of Cape Leforce is a bit of tragic, unwritten history harking back to the days when the "Island of St. John" belonged to France France and England were at war. French privateers infested the Gulf sallying therefrom to plunder the commerce of the New England Colonies. One of these was commanded by a Captain named Leforce.

One night they anchored off the Cavendish shore, at that time an unnamed wooded solitude. For some reason the crew came ashore and camped for the night on the headland known as Cape Leforce. The captain and his mate shared a tent, and endeavoured to come to a division of their booty. They quarrelled, and it was arranged that they should fight a duel at sunrise. But in the morning, as the ground was being paced off, the mate suddenly raised his pistol and shot Captain Leforce dead.

I do not know if the mate was punished for this deed. Probably not. It was a mere brief sentence in a long page of bloodshed. But the captain was buried by his crew on the spot where he fell, and I have often heard Grandfather say that *his* father had seen the grave in his boyhood. It has long ago crumbled off into the waves, but the name still clings to the red headland.[22]

It was a poem written partly in Cavendish, and partly in Prince Albert, based upon this dramatic legend, that Lucy Maud sent to *The Daily Patriot*

in Charlottetown.

Lucy Maud graphically recounts, in "The Alpine Path," her reaction when she received the November 26, 1890 edition of *The Daily Patriot.*

Four weeks passed. One afternoon Father came in with a copy of the *Patriot.* My verses were in it! It was the first sweet bubble on the cup of success, and, of course, it intoxicated me. There were some fearful printers' errors in the poem which fairly made the flesh creep on my bones, but it was my poem, and in a real newspaper! The moment we see our first darling brain-child arrayed in black type is never to be forgotten. It has in it some of the wonderful awe and delight that comes to a mother when she looks for the first time on the face of her first-born.[23]

That same evening, she wrote gleefully in her daily journal: "I feel at least three inches taller than I did yesterday. I can't find words to express my feelings."

This poem entitled, "On Cape Leforce," was Lucy Maud Montgomery's all-important first step on the road to literary fame and success. Her motto — "T'is pleasant sure to see one's name in print" — had been fulfilled with the publication of this poem.

On Cape Le Force.

[*A legend of the early days of Prince Edward Island*]

One evening, when the sun was low,
 I stood upon the wave-kissed strand,
And watched the white-sailed boats glide by,
 Their sails by evening breezes fanned.

In dimpling azure lay the sea,
 The rippling wavelets tinged with gold,
While to the rosy-clouded west
 A sparkling path of glory rolled.

I climbed the rocky cliffs and gained
 A rugged cape, around whose sides
The wavelets crept with moaning sigh,
 Or surges dashed their mighty tides.

Behind the lovely village lay
 The fertile fields of waving green,
Fair sloping hills and quiet dales,
 With spruce and maple groves between.

Before me slept that peerless sea,
 Its beauty tranquil and serene:
Search all our lovely Island o'er
 Thou will not find a fairer scene.

I stood upon that lovely cliff
 And called to mind the legend dread
Which made it an accursed spot —
 One shunned by superstitious tread.

'Twas years ago — ere yet the flag
 Of Britain claimed our loyalty,
And fair Prince Edward Island owed
 Allegiance to the fleur-de-lis.

When war's dark cloud hung threatening low
 Above our fair Canadian land,
And echoes of the troubled strife
 Reached e'en our Island's quiet strand;

And o'er our blue Saint Lawrence Gulf
 Sailed many a plundering privateer,
Defying law and right and force
 In their piratical career.

But, when the strife of war had passed
 And gentle Peace resumed her reign,
They met the fate they well deserved —
 Captured or wrecked upon the main.

And one — a treasure-laden ship —
 Was stranded here one autumn day,
And off this headland, lone and bleak,
 With all her precious freight she lay;

And, loth to lose his ill-won wealth,
 The captain planned how he might save
The treasure that his vessel held
 From English foes or ocean wave.

"The shore," he said, "is bleak and wild,"
 The rocks no human footsteps bear;
And death will seal the lips of those
 Who know I hide the treasure there.

So all that sunny autumn day,
 The captain and his pirate band
Bore untold wealth from ship to shore
 And hid it on the rocky strand.

But, when the western sky had pealed
 And darkness veiled the forests wide,
They tented on the lonely cape
 To wait the dawn of morning tide.

Then rose the bursts of laughter wild,
 Mingled with curses deep and strong,
The taunting sneer, the fierce reply,
 The vulgar joke, and drunken song.

Wild was the scene; but when the moon
 Rose slowly up the eastern blue,
Tipping the dark fir trees with light,
 Unconscious lay the drunken crew.

And all were wrapped in heavy sleep
 Save two — the captain and the mate —
Who sat together in a tent,
 Their faces drawn with rage and hate.

And, as they sat, above them poised
 The friends of hatred and despair,
Of malice, envy, murder, scorn,
 Revenge and avarice — all were there.

There, to divide their ill-won gains
 And plan the murder of the crew,
Had met those different types of crime,
 And quarrelled — as all such will do.

Facing each other, there they sat —
 The captain, tall and dark and stern,
With sneering lip and glittering eye,
 Where all dark passions seemed to burn.

The mate, with vicious, brutal face,
 Growled, like some snarling beast at bay
Defiant threats and savage oaths
 Of vengeance on the coming day.

"Well, be it so," the captain cried,
 "To-morrow, when the sun shall rise,
Our pistols will decide our claims
 And one shall lose or win the prize.

Good night, my friend, and pleasant dreams,
 I leave you now till dawn of day."
He bowed with air of mocking scorn
 And sought the moonlight's silver ray.

The night was calm; all sounds were hushed,
 Save for some lonely night-bird's cry,
Or wavelets splashing on the shore,
 Or cool night-breezes rustling by.

All night, upon the sullen verge,
 With restless tread the captain walked,
While o'er the sea the moonbeams played
 And shadows past the headland stalked.

Did some presentiment of ill,
 Upon the morrow, cross his brain?
Felt he repentance for the past?
 Or schemed he but fresh crimes again?

At length, when morning flushed the east,
 The rivals met. The half-drunk crew
Stood huddled in a powerless group,
 Not knowing what to say or do.

A look of craven fear was stamped
 Upon the mate's low, brutal face,
Mingled with sinister cunning, as
 Before the tent he took his place.

The captain, calm, composed and firm,
 Betrayed no trace of doubt or fear;
His face still wore its cool contempt,
 His lips, their cold, sardonic sneer.

"Twelve paces off, I'll stand," he said,
 And, with his pistol in his hand,
He lightly turned upon his heel
 And calmly walked toward his stand.

Sudden the mate his pistol raised —
* What need is there the rest to tell?*
A sharp report! and, in his blood,
* Shot through the heart, the captain fell.*

Then, 'ere the fear-struck crew could stir,
* Flinging his weapon from his hand,*
The guilty wretch sprang down the cliff
* And fled along the rocky strand.*

No hand was raised to stay his flight;
* Few knew the crime, none cared who did,*
And 'ere the sun had left the wave,
* The murderer was in safety hid.*

And ne'er was he to justice brought,
* For, in those days of blood and strife,*
Murder was deemed a slight offence
* And lightly held was one man's life.*

And, on this lonely wind-swept cape
* Right where the murdered captain fell,*
A hasty grave the sailors made,
* And winds and surges rang his knell.*

Forgotten in his lonely grave
* He slept, while years unnumbered fled,*
And dark traditions of the spot
* Enwrapped it with unfading dread.*

<div align="right">✿ ✿ ✿ ✿ ✿ ✿ ✿</div>

Long since, all vestige of the grave
* Has vanished — but the legend lives,*
And to this headland's rocky steeps
* A weird and awful interest gives.*

And, to this day, this lonely cape,
* Which stems the billows stormy course,*
Still bears the name of him who fell
* Upon its summit — Cape Le Force.*

LUCY MAUD MONTGOMERY.

Prince Albert, Saskatchewan, North West
Territory.[24]

Cavendish beach, one of Lucy Maud's favorite childhood haunts, had provided the subject material for her first publication. Fittingly enough, that same beach, bordering upon the sparkling blue waters of the Gulf of St. Lawrence, inspired her second published article. This story centered on the wreck of the famous *Marco Polo* off Cavendish beach in the summer of 1883. Lucy Maud, then eight years of age, witnessed this tragic, yet thrilling spectacle, as the fastest sailing boat of her class ever built, sprung a leak in a ferocious windstorm, and was driven ashore by her Captain in a desperate attempt to save his cargo and crew. After his rescue, the Captain boarded with Lucy Maud's grandparents while he and his twenty-man crew awaited final insurance payments. Lucy Maud's personal recollections of the actual incident, together with the knowledge she gleaned from the Captain, makes her story of "The Wreck of the Marco Polo" quite vivid and graphic. She entered the story in a prize competition sponsored by the *Montreal Witness,* and was successful. It was published in the *Montreal Witness* in February, 1891, and was copied by *The Daily Patriot* of Charlottetown on March 11, 1891.

THE WRECK OF THE MARCO POLO

IN CANADIAN PRIZE STORIES

By Lucy Maud Montgomery,
Cavendish, P. E. I.

(Written for the Montreal Witness.*)*

In writing an essay for the Witness *it is not my intention to relate any hair-breadth escapes of my ancestors, for, though they endured all the hardships incidental to the opening up of a new country, I do not think they ever had any hair-raising adventures with bears or Indians. It is my purpose, instead, to relate the incidents connected with the wreck of the celebrated "Marco Polo" off Cavendish, in the summer of 1883.*

Cavendish is a pretty little village, bordering on the Gulf of St. Lawrence and possessing a beautiful sea-coast, part of which is a stretch of rugged rocks and the rest of broad level beach of white sand. On a fine summer day a scene more beautiful could not be found than the sparkling blue waters of the Gulf, dotted over with white sails and stately fishing vessels. But it is not always so calm and bright; very often furious storms arise, which sometimes last for several days, and it was in one of those that the "Marco Polo" came ashore.

The "Marco Polo" was a barque of the "Black Ball" line of packets and was the fastest sailing vessel ever built, her record never having been beaten. She was, at the time of her shipwreck, owned by a firm in Norway and was chartered by an English firm to bring a cargo of deal planks from Canada. The enterprise was risky, for she was almost too rotten to hold together, she made the outward trip in safety and obtained her cargo; but, on her return, she was caught in a furious storm and became so waterlogged that the captain, P. A. Bull of Christiania, resolved to run her ashore as the only way to save crew and cargo.

What a day that 25th of July was in Cavendish! The wind blew a hurricane and the waves ran mountains high; the storm had begun two days before and had now reached its highest pitch of fury. When at its worst, the report was spread that a large vessel was coming ashore off a little fishing station called Cawnpore, and soon an excited crowd was assembled on the beach. The wind was nor'-nor'-east, as sailors say, and the vessel, coming before the gale, with every stitch of canvas set, was a sight never to be forgotten! She grounded about 300 yards from the shore, and, just as she struck, the crew cut the rigging, and the foremast and the huge iron mainmast, carrying the mizzen-top-mast with it, went over with a crash that could be heard for miles above the roaring of the storm! Then the ship broached-to and lay there with the waves breaking over her.

By this time, half the people in Cavendish were assembled on the beach and the excitement was intense. As long as the crew remained on the vessel they were safe, but, if ignorant of the danger of such a proceeding, they attempted to land, death was certain. When it was seen that they were evidently preparing to hazard a landing all sorts of devices to warn them back were tried, but none were successful until a large board was put up, with the words, "Stick to the ship at all hazards" painted on it. When they saw this they made no further attempt to land and thus night fell.

The storm continued all night but by morning was sufficiently abated to permit a boat to go out to the ship and bring the crew ashore. They were a hard-looking lot — tired, wet and hungry, but in high spirits over their rescue, and, while they were refreshing the inner man, the jokes flew thick and fast. One little fellow, on being asked, "if it wasn't pretty windy out there," responded, with a shrug of his shoulders, "Oh, no, der vas not too mooch vind but der vas too mooch vater!"

Lively times for Cavendish followed. The crew, consisting of about twenty men, found boarding places around the settlement and contrived to keep the neighborhood in perpetual uproar, while the fussy good natured captain came to our place. He was a corpulent, bustling little man, bluff and hearty — the typical sea-captain; he was idolized by his crew, who

*would have gone through fire and water for him any day. And such a crew!
Almost every nationality was represented. There were Norwegians, Swedes,
Spaniards, two Tahitians, and one quarrelsome, obstinate little German who
refused to work his passage home and demanded to be sent back to his
fatherland by steamer. It was amusing to hear them trying to master the
pronunciation of our English names. We had a dog called 'Gyp' whose
name was a constant source of vexation to them. The Norwegians called
him 'Yip,' the irritable little German termed him 'Schnip' and one old tar
twisted it into 'Ship'.*

*But the time passed all too quickly by. The "Marco Polo" and her
cargo were sold to parties in St. John, N.B., and the captain and his motley
crew took their departure. A company of men were at once hired to assist
in taking out her cargo and eighteen schooner loads of deal were taken from
her. The planks had so swollen from the wet that it was found necessary to
cut her beams through in order to get them out and consequently she was
soon nothing but a mere shell with about half of her cargo still in her.*

*One night in August about a month after she had come ashore, the men
who were engaged in the work of unloading resolved to remain on the ves-
sel until the following morning. It was a wild thing to think of remaining
on her over night, but, seeing no indication of a storm, they decided to do
so. It was a rarely beautiful evening; too fine, indeed — what old weather-
prophets, call a "pet" day. The sun set amid clouds of crimson, tinging the
dusky wavelets with fire and lingering on the beautiful vessel as she lay at
rest on the shining sea, while the fresh evening breeze danced over the
purple waters. Who could have thought that, before morning, that lovely
tranquil scene would have given place to one of tempestuous fury! But it
was so. By dawn a storm was raging, compared to which, that in which the
"Marco Polo" came ashore was nothing.*

*The tidings spread quickly and soon the shore was lined with people
gazing with horror-stricken eyes at the vessel, which, cut up as she was,
must inevitably go to pieces in a short time. One can only imagine the
agony of the relatives and friends of the poor men at seeing their dear ones
in such danger and knowing that they were powerless to aid them. As for
the men themselves, they were fully alive to their danger, for they knew that
the vessel could not hold together much longer. Their only boat was stove
in by the fury of the waves so that their sole hope of rescue lay in some boat
being able to reach them from the shore which, in the then state of the sea,
was impossible. In spite of the fact that the boat was full of water three of
the men insanely got into it and tried to reach land. Of course the boat was
instantly swamped and the men left struggling in the water. Two of them
managed to regain the wreck in safety, but the third, a poor Frenchman*

called Peter Buote, was drowned instantly and, several days after the storm,
his body was picked up some distance away.

The horror-stricken onlookers still kept their eyes fixed on the fated ves-
sel, in horrible expectation of the inevitable catastrophe; suddenly a cry of
horror burst from every lip as the ship was seen to part at the fore-castle
head and at once go down. The next minute, however, it was seen that the
windlass and a small piece of the bow still remained held by the anchors,
and that the men were clinging to this. With the courage of desperation,
several attempts were now made to reach the wreck but all the boats filled
with water and were compelled to return. Nothing could now be done till
the storm would abate and it was only one chance in a hundred that the
fragment would hold so long.

Meanwhile the beach was a sight to behold; the vessel having broken
up, the planks in her washed ashore and for miles the shore was piled with
deals and all sorts of wreckage till it was absolutely impassable!

At last, towards evening, the sea grew a little smoother, and, though
the attempt was still fraught with much danger, a seine-boat was procured
and a party of brave men went to the rescue. They reached the wreck in
safety and hauled the men on board by means of ropes. Thus they were all
brought safely to land, exhausted with cold, wet, and hunger, but still alive.
What rejoicing there was when they were safely landed, and, as the kindly
neighbors crowded around with that "touch of nature that makes the whole
world kin," there was joy indeed except among the poor Frenchman's rela-
tives, who were mourning the loss of their friend.

About a week afterward, in another gale, the last vestige of the vessel
disappeared and that was the end of the famous "Marco Polo," celebrated in
song and story. Her copper bottom, chains, anchors, etc., in all, it was said,
about $10,000, are still there, and, though almost buried in the sands, in a
clear calm day the little fishing-boats sailing over the spot can discern, far
beneath, the remnants that mark the spot where the "Marco Polo" went
down.[25]

Lucy Maud enjoyed additional literary successes during the remaining
months that she spent with her parents in Prince Albert. In June 1891, a
descriptive article on Saskatchewan, which she entitled, "A Western Eden,"
was published in the Prince Albert *Times*, copied and commented on quite
favourably by several Western newspapers.[26] As usual, Lucy Maud was
enthralled by the scenic beauty that nature had bestowed upon the region,
and she used her descriptive powers to the fullest in her portrait of Saskat-
chewan. Lucy Maud provides her readers with an unforgettable descrip-
tion of the prairies — "those grassy meadows, sweet with the breath of the

dainty prairie bluebells and wild roses"[27] watered by the Saskatchewan — "that magnificent river that rolls its blue tides, freighted with the mysteries of former ages, past its poplar-fringed banks ..."[28] Having read her "Western Eden," the reader is inclined to exclaim with her: "Hurrah for Saskatchewan!"[29]

A WESTERN EDEN
by L. M. Montgomery

"Let others raise the song of praise
Of lands renowed in glory;
The land for me of the maple tree
And the pine in all its glory!
Hurrah, for the grand old forest land
Where Freedom spreads her pinion!
Hurrah, with me for the maple tree!
Hurrah for the new Dominion."
McLauchlin.

An unlimited expanse of gentle slopes and velvet meadows, dotted with groves and clumps of poplar, a pretty little town nestling at the foot of the terraced hills; a noble river flowing past, and beyond it the vast sweep of the forest primeval — that is Saskatchewan and Prince Albert. To be fully appreciated, Saskatchewan must be seen, for no pen, however gifted or graphic, can describe, with anything like justice, the splendid natural resources, the unequalled fertility, and the rare beauty of the prairies of this Western Eden. Nature has here seemed to shower down with most unstinted generosity her choicest gifts; and certainly, if richness of soil and mineral wealth, beautiful scenery, and unsurpassed climate have anything to do with the advancement of a country, then Saskatchewan is bound to speedily come to the front as one of the finest and wealthiest portions of this, our fair Dominion.

To any lover of nature, a ride over the prairies of Saskatchewan is filled with the keenest pleasure. Never does one feel such a deep sense of beauty of the universe as when, pausing on some breezy hilltop, spread out beneath is seen this magnificent wilderness where a century ago the buffalo and deer roamed undisturbed and where, even as yet, civilization has obtained little more than a footing. Pause with me here, reader, and let us from this point of vantage take a look over this country which some timid people have, in days of yore, asserted to possess a winter nine months long and a remaining three of very doubtful character. On every hand, as far as the eye can reach, extend the prairies adorned with groves of willow and poplar, clear

and distinct near by, but in the distance mingling into a seeming forest
clothed, over the outline of the distant hills, in hazy purple mists. Here the
prairies extend in level, grassy meadows, sweet with the breath of the dainty
prairie bluebells and wild roses; there they swell in ranges of picturesque
bluff which curve around, every few yards, to enclose a tiny blue lake in its
encircling of frost-yellowed grasses, like a sapphire set in gold. All is
quiet — sound there is none save when some happy bird trills out a gush of
warbling among the willows, or when the cool breeze rustles the poplar
leaves in silvery music, and sweeps airly over the hills, bringing with it de-
licious whiffs of sweet clover and meadow grasses. The drowsy summer sun-
shine sleeps lazily on the slopes, the air is full of fragrance, and above, the
peerless Canadian sky — dark azure in the tranquil deeps o'er head, paling
to silvery blue and pearl towards the horizon, with here and there trails of
filmy white clouds tinged with golden on the sunward side — arches its
glorious dome over a scene which inspires us to exclaim with enthusiastic
pride, -
 "This is my own, my native land!"
But look! see those cloud mountains away in the south-west horizons.
Heaped on each other in soft, white masses, golden and rose in the shadows,
they are beautiful indeed, but certain ominous dark vapors stealing upward
from their base warn us that perhaps a thunderstorm may be near, and that
we'd better leave our sunny hill if we don't want a wetting, though we must
admit wettings are rare in Saskatchewan where weeks of fine weather at a
stretch are enjoyed.
 But although the prairies surrounding it are so lovely, Prince Albert's
greatest beauty consists in the magnificent river that rolls its blue tides,
freighted with the mysteries of former ages, past its poplar-fringed banks,
with the busy little town on one side, and the unbroken forests of the north-
land on the other. Passing over the great importance of the Saskatchewan
for navigation, we must take a glimpse at the natural beauty of this river on
whose forest-clad banks the tribes of the red men have, in bygone centuries,
hunted the buffalo and deer, fought their battles and passed to their happy
hunting grounds undisturbed by the intrusion of a stranger race.
 In beauty and variety of scenery, the Saskatchewan, with its soft Indian
name, is second to no river in Canada. Springing from the eternal glaciers
of the Rockies, its waters, ever cold from their birth, and gifted, so saith the
legend, with magic power, sweep through Alberta and Saskatchewan, —
 "A full fed river winding swift
 By herds upon an endless plain" —
until the shores of Lake Winnipeg are reached.
 Beautiful at all times the river is — at night, when the stars are mirror-

ed brokenly on its dark surface, like shattered flakes of light, and the roar of its current sounds distinct in the silence; or at morning, when the flushed light of eastern skies creeps over its silvery blue and the rosy mists fade from its waters; or at noon, when every ripple dances in the sunlight till it is a river of sparkling gold with cleared depths beneath its banks, and, afar up, the islands that gem it are hazy with pale blue mists. But it is beneath the sunset skies that it is most beautiful of all. The rush of the day is past, and in the dewy hush of evening, a soft stillness steals over all. The fire and orange of the western skies is reflected on the still waters, shading off into fairy tintings of blue and rose, silver and pearl, while transparent shadows chase each other swiftly over the bright expanse.

A sudden curve in the river shuts off the western glory, and here the waters are deep and clear and dark, with golden and brown undershadows, and crystalline depths along the banks where the breeze ripple of the mid stream do not disturb its perfect rest.

But paler and paler grow the sunset dyes, deeper and deeper the purple glooms of twilight, more and more indistinct the swaying outlines of the distant woods. And now the golden glow has vanished, the river is a sheet of silver, broken here and there, into a whirl of grey shadows, the air is clear and sweet, the sky dusky and tender with a few early stars in its opal depths and the gleaming scimetar of a thin young moon in the south west, and, on the opposite shore, the poplars sway eerily in the gathering gloom — all so weird and mysterious that one half expects to see a dusky warrior, clad in all his ancient panoply of war-paint and feathers, spring from their shadows, and ring his war whoop over the waters of the river his forefathers once claimed as their own.

But the warrior never does appear. Don't think he will. He belongs to an extinct species now. Before I reached the banks of the Saskatchewan I had only very dim, vague, misty opinions concerning Indians, and the perusal of "The Last of the Mohicans" and similar works had led me to half expect that I would here meet the heroes of their pages in real life. Would they, I wondered, be clad in all the historic garb of their ancestors — moccasins, deerskin leggings, blanket, war-paint and feathers, together with the indispensable accessories of tomahawk and scalping knife? And would they, like Cooper's braves, talk mysteriously of "palefaces" and "setting suns" and "many moons" and "happy hunting grounds" and look with disdainful hatred upon the usurping white man? Alas for my illusions! They were soon destroyed.

Doubtless, in past ages, arrayed in the before-mentioned costume, and stalking under the boughs of his native forest, the "noble red man" was a very romantic and fear-inspiring object; but as we look at the poor Indian

now, clad in ragged garments fashioned after those of his conqueror, with a
dirty blanket flung over his shoulder, as he shuffles through the busy streets
of another race, glancing upward with cowed submission in his dark eyes,
or engaged in chopping wood and other menial tasks for the white man, the
last atom of romance vanishes, leaving only pity and compassion behind.
But, even decayed as they are, the Indians are interesting still, and consid-
erable amusement may be extracted from a study of their speech and habits.
A fondness for exceedingly gay attire characterizes the Indian ladies (please,
oh scornful masculine readers do not exclaim that it is a failing common to
the whole sex, white or red) and the dresses of the dusky belles would make
Joseph's coat dull and shabby by contrast. Many of the young squaws are
comely — before age and hard work have coarsened the graceful litheness
of their figures and roughened the round outlines of their features, while in
their soft eyes, dark as shadowed lakes, they possess a beauty unowned by
any paleface maiden.

The squaws are great talkers (I suppose the men will grow sarcastic
here again) and it is a pleasure to listen to their soft musical language as they
laugh and chatter among themselves. They are industrious too — far more
so than their worse halves (here's a chance for the ladies to indulge in a
spice of irony now) in whose appearance and habits there is little to excite
interest.

In a few decades at most the red Indians will become extinct, and the
dusky children of a race, whose origin and history are shrouded in impene-
trable mystery, will have forever vanished from the land over whose plains
and rivers they once held supreme control. As we thus glance over this
beautiful district — a province doubtless, in the not very distant future — we
feel that it is indeed a country to be proud of, and a country well worth wait-
ing and working for. It is a country where prosperity and freedom are
awaiting thousands, a country where all may be happy and equal, a country
where

"A man is a man
If he's willing to toil
And the humblest may gather
The fruit of the soil."

and a country fit to breed a race of heroes physically and intellectually for,
in the crisp, invigorating air of its wind swept prairies, and in the earnest
toil that will be so abundantly rewarded, there is little to encourage sickly
sentimentality or brainless idolence. Hurrah for Saskatchewan!

Cavendish School
(Courtesy Louise Lowther)

Cavendish Presbyterian Church

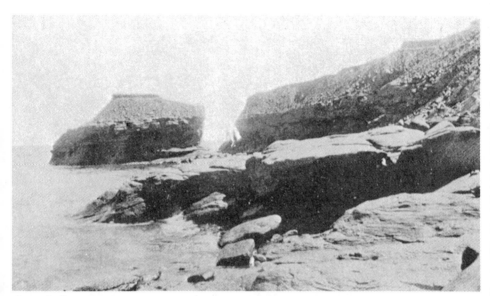

Cape Leforce
(Courtesy Mrs. Edna Jenkins)

The Saskatchewan River Below Prince Albert (*L. M. Montgomery's "noble river"*) (Courtesy Paula Coles)

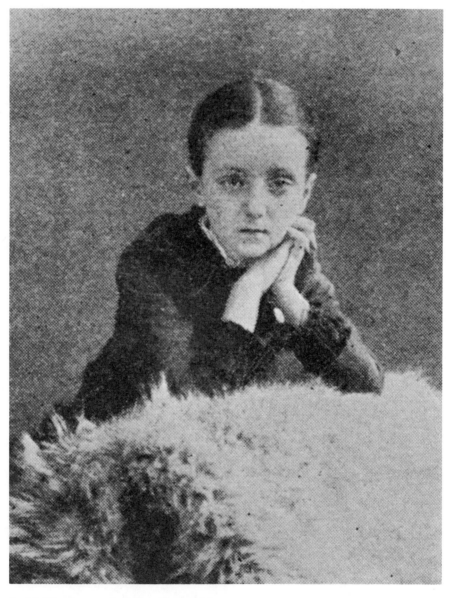

L. M. Montgomery at Ten Years of Age

L. M. Montgomery at Fourteen

"God save our Queen and Heaven bless
The Maple Leaf forever."

Prince Albert, June 12th, 1891.[30]

The month of June, 1891, was certainly a red-letter month in the literary career of Lucy Maud Montgomery. On the same day that the Prince Albert *Times* accepted her article, "A Western Eden," the Charlottetown *Daily Patriot* published a ten-stanza poem which she entitled "June".

JUNE

"Wake up," the robins warble,
"The summer time" is here,
The month of blushing roses,
The darling of the year.

Wake up, you lazy dreamers!
The summer's waiting you.
The days are long and golden;
The skies are tender blue.

The earth is full of gladness,
Of light and song and bloom.
Join in the summer brightness,
Nor ever think of gloom.

Make haste, June-days to welcome,
For summer-time will fleet
As swift as flying shadows
Across the ripened wheat.

And, when the autumn breezes
Sigh through September's leaves,
And all the sloping hillsides
Wave rows to tasselled sheaves.

The birds that follow summer
Will seek a southern sky,
The sweetness of her blossoms
Will, all forgotten, die.

And summer to her lover
 Will yield her weary charms,
Sink peacefully to slumber,
 And die in autumn's arms.

Come, then, ye lazy dreamers,
 Come forth to light and love.
The earth is wreathed with garlands,
 The skies are blue above.

The birds their love songs carol
 'Mid golden summer blooms;
The breezes whisper softly
 In twilight's opal glooms;

All glad things bid you welcome
 While last the summer hours.
Who wishes more than June-time,
 With song and light and flowers.
 Lucy Maud Montgomery
 Prince Albert, Saskatchewan[31]

Lucy Maud was extremely pleased with her literary success, and she tells us that she "was beginning to plume herself on being quite a literary person."[32] There was every reason indeed for the sixteen-year-old Lucy Maud to be satisfied with her gradual ascent of that "Alpine path, so hard, so steep".

Summer days, following her productive year in Prince Albert, beckoned Lucy Maud back to her beloved Prince Edward Island. Although she had gradually become more adjusted to life at Prince Albert, she decided that she wanted to pursue her education and career in the province of her birth. On the day of her departure from Prince Albert, August 25, 1891, she wrote a poem entitled, "Farewell," which was later printed in *The Saskatchewan*. The editor's introduction to the poem indicates the stature that Lucy Maud was achieving in Prince Albert:

> Miss Maud Montgomery, the talented daughter
> of our friend Hugh J. went East last
> Thursday and returns to her home in distant
> Prince Edward Island. Read her poetic
> "Farewell".[33]

FAREWELL

Sunset: and all the distant hills are shrouded
 In dusky golden light!
Day burns herself to death in funeral splendor
 Before the birth of night.

I stand beside the swiftly flowing river
 Its deeps another sky,
Far up the winding curves are lost in glory
 Far down the shadows lie.

Across the prairie misty glooms are creeping
 And clustering by the stream;
The evening breezes rustle mid the branches
 And all things lonely seem.

Half-sad, I gaze upon the noble river
 In its remorseless flow;
Onward and onward ever — all regardless
 Of human joy or woe.

A dewy hush; I hear the softened chiming
 Of some faint, far-off bell;
And here beneath the golden skies of sunset,
 I come to say —farewell!

Proud river, rolling past the floods of ages;
 Fair isles with beauty crowned!
Dark forests tossing weirdly 'gainst the golden
 Dim misty hills beyond.

'Tis time to bid farewell to these and hasten
 To a far distant land,

Back where the ocean moans in cease-
less sorrow
 On the Atlantic's strand.

Farewell! farewell! blue tide of "migh-
ty waters"
 A living friend you seem;
How oft in rapture gazing on your
beauty,
 I've wandered by your stream.

Your spirit speaks to mine in nature's
music
 Beneath the darkening light;
'Tis with a saddened heart — that now
I bid thee
 A long farewell to-night.

Farewell, ye prairies, bright in sunlit
beauty
 Where buds of sweetness bloom,
Where breezes float across the dim-
pied lakelets
 In breaths of rich perfume.

Bright, pleasant memories round your
hillsides cluster
 And through the coming years
Your fairy slopes my thoughts will oft
revisit
 Farewell, with many tears.

Farewell dark forests with your lone-
ly vistas,
 Your secrets of the past,
The mystic whisper of your soughing
branches
 Your purple shadows cast!

Your myriad voices answer through
the stillness
 In one long shivering sigh:
Farewell, farewell, they seem to
whisper softly
 And then in silence die.

*Farewell, dear friends, your kindness
I will cherish
 Among all memories sweet
Long years may pass ere once again
I'll greet you,
 Yet oft in thought we'll meet.*

*Farewell, Prince Albert, pride of
western prairies!
 Bright may thy future be;
Rise to a noble and a wealthy city,
 Farewell, farewell to thee.*

*Fainter and fainter grow the distant
outlines
 And phantom shadows glide
Where, 'neath the thickets of o'er-
hanging branches
 Plashes the rippling tide.*

*In the far blue some early stars are
shining,
 The west has lost its light
All sounds are mingled in one gentle
murmur
 Beneath the touch of night.*

*I turn to go 'my eyes with tears are
misty'
 Still rings that distant bell
Hills, prairies, forests, river, all — I bid
you
 One last, one long farewell.*
 LUCY MAUD MONTGOMERY

Prince Albert Aug. 25th 1891.[34]

Shortly after her return to Prince Edward Island, Lucy Maud published an article in the *Daily Patriot* called, "From Prince Albert to P.E. Island". Her powers of observation and her descriptive talents are very evident in this account of her return trip to the Island. This article, and those already published, presents incontrovertible evidence that Lucy Maud Montgomery's year in Prince Albert had certainly launched her upon a successful literary career.

FROM PRINCE ALBERT TO P. E. ISLAND

BY L. M. MONTGOMERY.

We leave Prince Albert early one fresh August morning just as the new born sunshine creeps over the prairies to kiss the dew from the grasses and coquette with the waters of the blue Saskatchewan. There is the usual bustle at the railway station, the good-byes, promises, reminders, the fluttering of handkerchiefs and the pressing of finger tips; then the train glides slowly out, and as the last straggler on the platform vanishes, we realize that we are really off and "homeward bound!"

Quickly, familiar landmarks disappear, and soon we are flying over the virgin prairie, no trace of civilization in sight, — save where now and then we pass a little log cabin surrounded by nodding wheat fields of dead gold. The long grasses and prairie blue-bells are still damp with dew, and the shadows are black and long under the tall white-skinned poplars and straggling willows. Now and then we pass through ragged groves of pine and fir, looking dead and dismal with the gray streamers of moss clinging to their black branches, or speed by a little blue lake, rippling on its glassy shores.

We have plenty of time for inspecting the scenery! The train does not go very fast! It is so occupied with slowing up every few minutes, because of cows on the track, that it cannot, and our only amusement is to stick our heads out of the car windows and watch said cows running, wondering meanwhile if we look as funny ourselves as do the other people whose heads are also out.

By noon we are at Saskatoon, and the rest of the way there are no blue lakes, shivering poplars, yellow wheat fields, or herds of lazy cows, — in fact, there is no ANYTHING! A more desolate expanse could not well be imagined. Far, far, far, as the weary eye can reach, is one exasperating level, covered with grass the hot sun has scorched to a dusty brown. Here and there are bare black tracts that prairie fires have swept, and off to our left winds a river valley, whose banks, broken into round dark hills, are inexpressibly dreary. Scenery there is none, unless occasional piles of buffalo bones can be called so; neither is there any sign of life, save, once or twice, a troop of prowling jackals, and a solitary fox who tries to race with the train, but gives it up in despair! And we count the telegraph posts and the bone piles, and watch the clouds and speculate as to the possibility of the ghosts of buffalo ever revisiting their old trails that are still visible; and finally we turn around in disgust and go to sleep.

We are at length awakened by a hurrying and scurrying, shouting and banging doors, flashes of light and a general confusion from which our bewildered senses gather that we have arrived at our day's destination. We climb off in the chilly dark, and find ourselves in the surging jostling crowd at the Regina station. Regina is not remarkable for beauty. The surrounding country is bare and level and the city itself is a dusty-looking place. But to do it justice, it is plucky and go-aheaditive and bound sooner or later to be one of the busiest and most populous of the cities that are swiftly growing up all over the bright western prairies.

It is half past eleven at night when we leave Regina. The Pullmans, they tell us, are full, so we have to go in the first-class. To our dismay we find it is literally packed. In nearly every seat are two and sometimes three. Some few fortunate mortals have secured seats all to themselves, and selfishly refuse to allow any one else to disturb their naps, so we have to squeeze down into a seat with two others and bear it as philosophically as possible. Sleeping is out of the question. We take cat naps now and then, yawn, fidget, and study our fellow travellers. Anything funnier than a first class car at midnight we have never seen. If we were not feeling so sleepy and unamiable we could almost laugh. Here are some of those previously-mentioned selfish individuals stretched out on their seats in various stages of dishabille and limpness snoring as peacefully as if on the downiest couches. There are those who are wide awake and generally glum. One man in particular growls and squirms and wonders why on earth people crowd the car so, and is so generally disagreeable that everybody is glad when he leaves.

Oh, what a long long night it is! How slowly the minutes creep away. And the train flies on, on, on, till we feel as if it never would stop, over the dark prairies. But at last far over the level, where the greens and the blues meet, we see a faint stain of orange that grows deeper and brighter, before we know it the day is born and we are on the prairies of Manitoba. On, on we speed — now by the ripe Manitoban wheat fields and snug farmhouses, now by some pretty little village and often through tracts yet free from man's dominion, where the luxuriant grasses are green and long, and the ranks of the prairie sunflowers dance and nod their impertinent yellow heads in the wandering breezes.

Rat Portage is quite a city and Virden is a rapidly growing little town. Brandon is a charming spot and presents quite a handsome appearance, but we only see enough to wish for more, for our train, in common with its kind, has a detestable trick of starting just as we become interested in something. We have been watching a stout lady laden with innumerable parcels coming rapidly down the wet street. She had reached a muddy crossing where she

*suddenly slips, throws up her arms and is just in the act of falling when the
train glides past and we are forever left in tantalizing ignorance as to the
state of the stout lady and her parcels.*

*As we approach Winnipeg the general subject of conversation changes.
Previously it has been the boodling transactions recently exposed at the
capital. Some have moodily declared that the result will be utter ruin, con-
fusion and general anarchy, while others have confidently assured that all
these "little fusses" will blow over without serious harm to anyone. Now,
however, every one discusses the recent frosts, and opinions are as varied as
before. Some say the crops are ruined, others that they are unhurt. In
both cases the truth seems to be between each of these extremes. We are not
long in Winnipeg — just an hour! Only time to take a peep at some of the
principal streets and conclude that Winnipeg is a busy, thriving city, as
handsome as it is energetic.*

*Then we are off again, and as twilight shadows creep over us we see
that the country we are in now is very different from that which we have
crossed. It is rugged and hilly. Big boulders and scrubby growths of
spruce and fir are seen at intervals. We are approaching the forest wilds
of Northern Ontario.*

*It has grown raw and cold. The sun sets amid gray cloud-fringes with
a cruel savage sort of splendor, and the wind that comes moaningly over
the waste brings with it a promise of rainy days. A promise that is fulfilled,
for when we take a good-night look into the dismal night, we see nothing
but a gloomy forest, with dark, sorrowful spruces looming out of the mist-
like phantom trees, while afar off a line of weird firs, "like tall thin priests of
storm," are outlined against the last streak of dying gold.*

*Morning again! and a grey, dismal morning, with rain streaming down
in slanting lines over the wet, shading trees, and splashing on the still, dark
surfaces of the woodland streams we cross; and the train goes rocking and
swaying on through the hills that rise around us, until, just as we are be-
ginning to imagine that we must be nearing the confines of the world, lo!
we pop down on a little oasis of civilization hidden away among the
mountain — Fort William at last!*

*We scowl considerably on finding that we have to wait here a day for
the boat; but grumbling does no good, and is productive of wrinkles besides,
so we go to an hotel, and then sally out in the pouring rain to "do" Fort
William. That operation does not take long. Charred stumps, wandering
pigs and streets that run off into the woods are the principal sights. We say
all we can, honestly, in praise of it — it is active and hardy and a 'rising
town,' but there we stop. It is undeniably rough and ugly, and not even the
limitless forests and tree-clad mountains, sheathed in gray vapor, can re-
deem it.*

Next day, even when the sun is bright and the blue hazes wrap the rugged slopes, it is but little better, and we confess that we are heartily glad to shake the dust of Fort William from our feet, and board our boat — the palace steamer Manitoba.

Then we steam slowly down the river of the unpronouncable name, and find ourselves fairly out on the blue waters of Lake Superior. Slowly the forest slopes recede and the myriad islets become scarce until we are at last out of sight of land on that great inland sea. It is a charming day. The delightful breeze barely ripple the dancing, sunlit waters and the glorious Canadian skies are blue and tender. The beautiful boat is alive with mirth and gaiety. Everyone is in good spirits. If there are any unfortunate victims of seasickness they keep in their staterooms and nothing disturbs the general merriment. The promenade deck is the favorite resort of all — ourselves included — for here we find the best opportunities for noting the amusing characteristics of our unsuspecting fellow travellers. There are all sorts of people on the boat. The stout, elderly lady with a fondness for knitting and theological discussions, the abstracted man of business with his columns of figures, the ubiquitous spoiled small boy who tyrannizes over all the other children on board, the anxious mother of five small babies who keep her in a perpetual worry over their wanderings, the talkative Yankee who considers everything American 'superb' and everything Canadian 'despisable,' the cynical individual with spectacles and Darwinian views — we think he really must have descended from a monkey, — the lady who hopes we will have 'one real awful storm just to see what it is like you know,' the timid little woman who is so afraid there will be a collision or explosion, the creature who waylays everybody, even our ignorant selves, to discuss politics, the honeymooners who 'promenade' ceaselessly and run into everybody so absorbed are they, and the literary friend who prowls around, forever scribbling in an ominous black note-book. Sunset on Lake Superior! Who can describe it? The steady tramp goes on around us, for in the cool evening, the deck is thronged, but we lean over the railing and watch the changing loveliness with awed rapture — the greens and blues and crimsons mingling in the translucent waters and the high hills — for we are again in sight of land — lying darkly against the golden skies. How appropriate to the scene are Scott's lines. Surely here is a lake that

> "In all her length far-winding lay
> Of promentory, creek and bay,
> And islands that empurpled bright
> Floated amid the livelier light,
> And mountains that like giants stand
> To sentinel enchanted land."

And as it grows darker and duskier, the stars begin to peep out in the rosy
sky, and on every shadowy cape and island

> "Springs into life a grim gigantic
> shape,
> Holding its lantern o'er the restless
> surge
> ∘
>
> A new Prometheus chained upon the
> rock,
> Still grasping in his hand the fire of
> Jove,"

and now and then some vessel creeps past like a huge, noiseless shadow.
The deck is almost deserted, and, as a gush of laughter and music comes up
from below, we shiver and suddenly realize that all the fairy light is gone,
and that the Lake Superior damps are beginning to play havoc with our
poetic fancies; so we retreat.

Next day is as gloriously fine as ever. We get to the 'Soo' about noon.
We are 'locked in' while at dinner, so we miss that performance and when
we go on deck again we find ourselves in the lock, close to Uncle Sam's
territory, with the American part of pretty Sault Ste. Marie on one hand and
on the other the rapids foaming restlessly between us and our Canada.

Everyone is on deck, our American friend included. Somebody asks if
this is the American side of the Sault. 'Of course it is' he says loftily, 'you
might know that by the fine houses. You'd never see a nice house or a pretty
girl in Canada.' 'Must be some fine looking men in the States, if he's a
specimen,' murmurs a gentleman near us, sotto voce, and we have the satis-
faction of seeing that our critic evidently overhears it, for he gets very red
and immediately finds something interesting on the other side of the boat.

We are three hours at the Sault and after the novelty wears away the
delay is long and tedious. We all lean over the railing and chat in a desul-
tory fashion over one thing or another. Our American friend has digested
his humor and returns to his place. A United States officer attracts his eye.
'Ah,' he exclaims, exultantly, 'it does me good to see a blue uniform like that
again after those red jackets the Canadians wear. I detest them, don't
you?' turning to us. We respond indignantly that indeed we don't but in-
stead admire them very much. 'Why,' he says, 'they are too flashy for any-
thing. And besides,' he adds, with the air of one advancing a crushing argu-
ment, 'they are no good! They never did anything!'

'Oh, didn't they?' we murmur innocently, 'well, of course, we may be
wrong, but it seems to us that, when going to school, we remember learning

*in a history that those same red coats did beat somebody — but, of course,
it couldn't have been blue coats — at Queenston Heights and Lundy Lane.
But maybe the historian was incorrect.' 'Why', he gasps, 'are you Cana-
dian?' 'Of course we are: we declare proudly we wouldn't be anything else
for the world.' At this he gives another gasp and goes away in disgust at
finding us so hopelessly depraved. But in justice, be it said, the other Amer-
icans on the boat are not like this. They are kind and pleasant, thorough
ladies and gentlemen, and we have a very nice time all around. Finally we
get away and steam slowly down the St. Mary's River, where the scenery is
simply exquisite, past the maple clad shores, till we emerge upon Lake
Huron. Another night on the boat and at noon next day we reach Owen
Sound, which presents a charming appearance from the water. We have
just time to hurry off the boat and scramble on board the waiting train
when off she goes! What a delightful ride it is! Really Ontario is almost
as pretty as our own dear Island! We go at a dizzy rate past the smiling
farms, pretty towns, beautiful groves and green woods, where an occasional
early dyed maple hangs out its scarlet flag — on, on, on till at three we reach
Toronto. Beautiful Toronto! We are only there a few hours, but in that
time we see quite enough to convince us that the Queen City is indeed the
most beautiful one in Canada.*

*But nine o'clock comes, and off we are again! All night we ride! It is
fearfully dismal. Just as sure as we coax ourselves into a dreamy doze, along
comes a conductor to demand our tickets or make us change cars until, when
we finally alight at Ottawa in the chilly gray dawn, we feel more unamiable
than ever we did in our lives.*

*We have heard so much of the depravity and corruption that reigns at
Ottawa, that we hardly know what sort of a place we looked for. We ex-
pected something very disagreeable to say the least. Therefore we are quite
surprised when we find that this much-slandered place is as pretty and
peaceable a city as one would wish, even if it is not as beautiful or stately
as others in Canada.*

*Of course the Parliament buildings are the centre of attraction here.
So in the afternoon we go up to them and under the guidance of a kind old
veteran senator, we explore all their halls and windings. We are quite lost
in the labyrinth of rooms and follow our guide blindly wondering where in
the world we are ever going to come out. The House adjourned so we go
through the commons and the senate chambers and the long halls with por-
traits of departed worthies. We sit a moment in the Governor general's
chair and feel at least two inches taller after this, of course. Then we ex-
plore the magnificent library and finally go into the Common's gallery and
hear Sir Richard Cartwright speak on the census. Then we go out and*

ramble around beautiful Parliament Square, see the trunk of a tree that was 150 years old when Columbus discovered America, catch a glimpse of the glistening white Chaudiere Falls in the distance and, in open defiance of the rules, gather a tiny bouquet to carry away as a relic! Then in the evening we go again, and listen to a debate on the census and watch the brilliant scene below and around us. It is amusing to notice how, when someone is speaking, the members of the opposite side thin out to a meagre few to come back in redoubled force when one of their own party has the floor. We, in our innocence, supposed that nothing frivolous ever disgraced the members of the House of Commons. That they all sat in solemn conclave, or at least gave strict attention to all that was in progress. But alas! they don't! They laugh, talk, doze, and throw paper balls at each other on the sly, till the bullets fall about us thick as leaves in an autumn gale.

We are very insignificant ourselves in that crowded gallery! But, nevertheless, we feel a thrill of exultant pride as we hear it whispered behind us that the finest speaker in the House of Commons comes from little Prince Edward Island. We feel as if some of his glory must be reflected on his countrymen.

Doubtless, it is unpatriotic, — but we cannot find the census debate very interesting. We are stupid enough to get very sleepy even in that temple of our country's greatness (or weakness), so we finally come away just as some energetic politician begins to pulverize the arguments of the previous speaker.

The next afternoon we bid good-bye to Ottawa and by night we are in Montreal — stately, brilliant Montreal — where we stay till morning. In leaving the city we cross the famous Victoria Bridge — an experience not soon forgotten. How very long it seems. All is dense darkness save when, now and then, we pass a loophole and a flash of ghostly light flits down the car, and all hands breathe more freely when we are once more out in the clear sunlight. The ride from Montreal to Quebec is very uninteresting. There is little to be seen save some sterile stony little farms and what we had never thought to see in Canada, cutting grain with the primitive reaping hook. We catch a glimpse of the Montmorency Falls, looking at that distance like a moveless white snowbank, and a few minutes after we reach Point Levis. Opposite us, across the blue river, is 'historic Quebec,' and we get a peep at the Plains of Abraham, where long ago was fought the famous battle which decided the destiny of Canada. It is dark when we reach Dalhousie, and then a dreary ride through the long, cold night ensues. Morning finds us at Moncton, where we improve a delay by inspecting the pretty little town, which is growing rapidly. At ten we leave and are at Point du Chene by noon where the dandy little Northumberland *is waiting for us.*

It is rather rough crossing over, but we do not mind that, and, as the fresh breeze comes dancing up the Strait, bringing the echo of the salt seas, we realize, with a happy thrill, that we are very near home. Somebody says, 'see, there is Prince Edward Island,' and we eagerly rush on deck to catch a glimpse of the old sod! Yes; there it is — the long red line of cliffs, sloping to the green uplands with villages nestled here and there — dear P. E. I. at last! Never, Canada over, have we seen a lovelier, fairer spot than this! We feel like the old Scotch Islander in Winnipeg did. He said he was from 'the Island!' What Island? queried a listener. 'What Island,' repeated our honest countryman, in amazement? 'Why, Prince Edward Island, man? What other Island is there?' Nearer and nearer we come till Summerside lies before us. Slowly we steam up beside the wharf, and then, amid the bustle and the noise, we descend the ladder, realizing that our long journey is over at last and our destination reached. And as our feet press the dear red soil once more we exclaim, with heart-felt delight:-
'This is my own, my native land.'[35]

Lucy Maud had been waiting anxiously for a whole year for the happiness associated with her return to Prince Edward Island. Like the Scottish Islander quoted in her story, the only Island there ever was for Lucy Maud Montgomery was Prince Edward Island. During her sojourn in Prince Albert she had remarked to a friend that "the day on which I set foot in Cavendish once more will be the happiest one of my life."[36] A year's absence from her grandparents' home in Cavendish made her realize that, despite its rigidity, it was *really* home. Her educational experiences in the West, made her yearn for a return to Cavendish school — that whitewashed, low-eaved building in a spruce grove on the other side of the road from her grandfather's gate — that she had attended from age six to fifteen. "Yes" — Lucy Maud resolved — "you can bet when once I get to Cavendish, I stay there."[37] Such determination demands a closer examination of her year in Prince Albert.

FOOTNOTES TO CHAPTER II

[1] L. M. Montgomery's Scrapbook, 1890-1898. This scrapbook is kept, with other personal memorabilia, in the house where she was born in New London, Prince Edward Island.

[2] *Ibid.*

[3] L. M. Montgomery, "The Alpine Path," *Everywoman's World*, Vol. VIII, No. II, (August, 1917), p. 16.

[4] *Ibid.*

[5] *Ibid.*

[6] *Ibid.*

[7] *Ibid.*

[8] *Ibid.*

[9] *Ibid.*

[10] *Ibid.*

[11] *Ibid.*

[12] *Ibid.*

[13] *Ibid.*

[14] L. M. Montgomery to Ephraim Weber, 28 June, 1905, *op. cit.*, p. 34.

[15] L. M. Montgomery, "The Alpine Path," *Everywoman's World*, Vol. VIII, No. II, (August, 1917), p. 32.

[16] *Ibid.*

[17] *Ibid.*

[18] *Ibid.*

[19] *Ibid.*

[20] *Ibid.*

[21] L. M. Montgomery, "The Alpine Path," *Everywoman's World*, Vol. VIII, No. II, (August, 1917), p. 32. Lucy Maud spells the legend in two ways, Leforce and LeForce. I have used LeForce.

[22]L. M. Montgomery, "The Alpine Path," *Everywoman's World,* Vol. VII, No. VII, (July, 1917), p. 33.

[23]L. M. Montgomery, "The Alpine Path," *Everywoman's World,* Vol. VIII, No. II, (August, 1917), p. 32.

[24]*The Daily Patriot,* Charlottetown, L. M. Montgomery, "On Cape LeForce," 26 November, 1890. Provincial Archives, Charlottetown.

[25]L. M. Montgomery, "The Wreck of the Marco Polo," February, 1891, *The Montreal Witness.*

[26]L. M. Montgomery, "A Western Eden," 12 June, 1891, Prince Albert *Times,* 17 June, 1891. Saskatchewan Archives, Regina, Saskatchewan.

[27]*Ibid.*

[28]*Ibid.*

[29]*Ibid.*

[30]*Ibid.*

[31]*The Daily Patriot,* Charlottetown, L. M. Montgomery, "June," 12 June, 1891.

[32]L. M. Montgomery, "The Alpine Path," *Everywoman's World,* Vol. VIII, No. II, (August, 1917), p. 32.

[33]*The Saskatchewan,* Prince Albert, 2 September, 1891. Saskatchewan Archives, Regina, Saskatchewan.

[34]L. M. Montgomery, "Farewell," 25 August, 1891, *The Saskatchewan,* 2 September, 1891.

[35]L. M. Montgomery, "From Prince Albert to P. E. Island," 22 October, 1891, in *The Daily Patriot,* Charlottetown, 31 October, 1891.

[36]L. M. Montgomery to Penzie Macneill, 3 November, 1890. L. M. Montgomery Collection, Kelley Memorial Library, Charlottetown.

[37]*Ibid.*

CHAPTER III

WITH THE MONTGOMERYS IN PRINCE ALBERT

In a caption beneath a photo taken in Prince Albert, Saskatchewan, Lucy Maud Montgomery wrote: "This picture was made when I was sixteen and the flame of an ambition to write something big was beginning to sear my soul."[1] Lucy Maud's literary accomplishments at Prince Albert gave tremendous momentum to her career. The serene atmosphere of the Montgomery home situated in the heart of Prince Albert — graphically described by Lucy Maud as "a pretty little town nestling at the foot of the terraced hills with a noble river flowing past ..."[2] — proved to be an excellent environment for her literary pursuits. Perhaps Lucy Maud wanted to prove something to her father. It was now nearly seven years since he had testily reminded his young daughter that her verses were "very blank indeed."[3] At any rate, Lucy Maud soon won her father's admiration with her talented literary works written in his home at Prince Albert.

Hugh John Montgomery, Lucy Maud's father, was born at Park Corner, Prince Edward Island on August 28, 1841, the oldest son of the Honorable Donald and Ann Montgomery.[4] He began his varied career by assisting in the operation of his father's large farm in Park Corner. After serving as a sea captain for a few years on cruises to England, the West Indies and South America, he established a merchandise business in New London and also carried on an extensive wholesale and retail trade with the West Indies. After his young wife's death in September, 1876, Hugh John lost much of his entrepreneurial zest for business with the dire result that his whole enterprise collapsed financially. After serving for a year as Chairman of a Commission to evaluate lands between the tenants and the Government of Prince Edward Island, in accordance with the terms of the compulsory Land Purchase Act of 1875, he decided to try a new career in Western Canada. Here he found ample scope for his indomitable, if sometimes financially questionable, business acumen. Within ten years of his arrival in the West, he was one of the leaders in the economic, social, religious and political activities of the growing and thriving pioneer town of Prince Albert.

He spent two years in Prince Albert prior to his establishment of a permanent residence there. During the year 1882, he was employed as an agent by the Forks Colonization Company until the collapse of that Company.[5] In April of 1883, Hugh John returned to Prince Albert from Winnipeg and entered private business. He opened a real estate agency and auctioneer's office. Although the Prince Albert *Times* indicates that Hugh John did a thriving business, especially as an auctioneer, he decided to close

out his mushrooming undertakings in October, 1883, and to return to Prince Edward Island.[6] Here his father, the Senator, once again came to his financial rescue. The position of Crown Timber Ranger and homestead inspector under the Department of the Interior for the district of Prince Albert became vacant, and Senator Montgomery made use of his political influence with the Minister of the Interior in John A. Macdonald's Government to secure the seven hundred-dollar-a-year appointment for his unemployed son. Consequently, Hugh John arrived back in Prince Albert in May, 1884, firmly ensconced in a lucrative governmental position.[7]

He soon assumed a role of leadership in his adopted town. While in Prince Edward Island, he had been an active member of Mount Zion Masonic Lodge in New London. He maintained his connection with the Masonic Order and became one of the most active members of the Kinistino Lodge in Prince Albert.[8] From the outset he was a faithful and dedicated member of St. Paul's Presbyterian Church, and served for nearly two decades on its board of management.[9] Hugh John was always appreciative of the "Scottish blood" that pulsed through his veins. Shortly after he settled in Prince Albert, he organized a meeting of the "Sons of Scotland," and, under his chairmanship, an organization, called the "St. Andrew's Society of Prince Albert," was formed.[10] He remained one of its guiding and driving forces throughout his life. He was on the management committee of the prestigious Saskatchewan Curling Club, and an ardent supporter of the Lorne Agricultural Association. Prince Albert had inherited a real "bundle of social energy" in the person of Hugh John Montgomery.

But he had scarcely got his roots firmly implanted in Prince Albert when serious difficulties loomed on the horizon. The problem arose over a serious disagreement between Hugh John and his immediate supporter, D. J. Waggoner, the Crown Timber Agent. Essentially, the reason for the altercation was that, Waggoner, an apparently insecure and rather pompous civil servant, concluded that Hugh John was not being sufficiently attentive to his duties as Forest Ranger. He resented especially his engaging in the auctioneering business while retaining his governmental appointment. Hugh John's response was that his governmental responsibilities were not sufficiently onerous to preclude him from engaging in auctioneering on a part time basis. When Hugh John, after repeated warnings, adamantly refused to desist from auctioneering, Waggoner asked the Department of the Interior to remove him from his position.[11] The response of the Department was the temporary suspension of Hugh John Montgomery, and the launching of a formal investigation into the charges proffered against him by D. J. Waggoner. Both gentlemen were ordered to appear before the senior Homestead Inspector in Prince Albert on October 17, 1885, and to

present evidence under oath by themselves and witnesses to substantiate their charges and countercharges.[12]

The cases for the plaintiff and defendant were presented with considerable vigor. On the whole, Montgomery's defence was quite brilliant, and his witnesses were people of higher social standing in the town, better educated and more credible than those introduced by Waggoner.[13] But Montgomery's aplomb was to no avail. The Homestead Inspector, R. S. Park, in making his recommendation after the trial, noted that "Hugh John Montgomery was a very active and energetic man, and would take hold of any business that came his way, so it was quite possible if there was not much to do in the Crown Timber Office, that he employed himself in making an addition to his salary."[14] He emphasized that "several of the towns' people objected to this, as it, in some way, interfered with those who depended on their several callings for a living."[15] Park, however, considered as much more serious the charge, substantiated during the trial, that Montgomery had made derogatory remarks both verbally and in writing on Waggoner's ability to fulfill his role as Crown Timber Officer. Park expressed the view that "Montgomery should be severely censured for making remarks against his superior officer, calculated to destroy his influence in connection with his office, and for belittling him in the eyes of his townspeople and in the eyes of those with whom he had business connections."[16] In the light of the evidence presented, Park suggested "that while he would be sorry to see Mr. Montgomery suffer for his indiscretions,"[17] he was of opinion, "that the business connections between Mr. Waggoner and Mr. Montgomery should be severed, and some means taken to place Mr. Montgomery under some other officer."[18] Early in November, 1885, the evidence presented at the investigation and Park's recommendations were reviewed by the Department of the Interior at Ottawa. The Minister of the Interior "decided that while Montgomery had been guilty of insubordination, the extreme penalty of dismissal would not be imposed, but that he should be severely reprimanded and warned against a repetition of the offence, and reinstated."[19] Accordingly, Hugh John Montgomery received a reprimand from the Minister and, in addition, was transferred from Prince Albert to Battleford, Saskatchewan.[20] Waggoner got his "pound of flesh," and Hugh John an unwanted transfer to Saskatchewan's first capital.

Hugh John's move to Battleford was deeply regretted by the general citizenry of Prince Albert. Prior to his departure, a large number of his personal friends including the Mayor, several members of the Town Council, lawyers, doctors, farmers and businessmen, met at his home to tender him a farewell reception. The leading journal in Prince Albert noted that "Mr. Montgomery was made the recipient of a very handsome and valuable dres-

sing case and brushes as a token of their appreciation of his worth as a cit-
izen and friend."[21] Needless to say, D. J. Waggoner did not suscribe to
these sentiments. There is no doubt but that Hugh John Montgomery was
highly respected and quite popular in Prince Albert. J. D. Maveety, the
editor of the *Times*, expressed the sentiments of most people when he wrote
that "all were sorry to see Monty leave as he has done much to building up
our town, and all hope that his residence in Battleford would be of short
duration and that before long he would be back in our midst."[22]

He accepted the transfer philosophically; indeed, the move to Battle-
ford may have been the key factor, although accidental, to his future domes-
tic happiness. Hugh John had built a commodious new residence in Prince
Albert in 1885 which he called Eglintoune Villa. When he was transferred
to Battleford, he rented his home to John McTaggart who had recently been
appointed Dominion Land Agent in Prince Albert.[23] McTaggart had a
stepdaughter named Mary Ann McRae, and within a short period of time,
she and Hugh John were engaged. They were married on April 5, 1887, at
the Knox Presbyterian Church in Cannington, Ontario, the former home of
the McTaggarts and McRaes.[24] After a honeymoon in Ottawa, highlighted
by their attendance at a Vice Regal reception tendered by Lord and Lady
Lansdowne in the Senate Chamber, the forty-six-year-old former widower
and his young and beautiful bride of twenty-four returned to Battleford by
way of Prince Albert.[25] This marriage, while of prime importance to the
principals, was not without profound significance to Lucy Maud Mont-
gomery since she was destined to spend a year with them in Prince Albert.

Hugh John and his wife were not completely happy in Battleford, and
he frequently requested a transfer to Prince Albert. But there was not the
slightest hope so long as the tedious D. J. Waggoner remained Crown Tim-
ber Agent in Prince Albert. His wife was also anxious to be near her mother
and stepfather. Both of them resented the payment of rent in Battleford
while at the same time being precluded from residing in their comfortable
home in Prince Albert. At length, Hugh John decided to cut the Gordian
knot. In March, 1890, he resigned his position with the Department of the
Interior, and moved back to Prince Albert with his wife and Kate, their two-
year-old daughter.[26]

The industrious Hugh John soon assumed various positions of import-
ance in Prince Albert. Early in May, 1890, he reopened the real estate
agency and auctioneering service that he had begun in 1883. He also was
appointed local agent of the Confederation Life Insurance Company for
the district of Prince Albert.[27] In addition, he was right-of-way purchaser
for the Regina and Prince Albert railway pushing rapidly toward Prince
Albert and Battleford.[28] His office in his home at the corner of First and

Church Street was a veritable hub of activity. When a whole spate of social and political activities is added, it is evident that Hugh John was a busy man indeed.

Hugh John and Mary Montgomery were just comfortably settled in their home in Prince Albert when welcome visitors arrived from the East. "Senator Montgomery of Prince Edward Island," the *Times* reported, "arrived here on August 20, 1890. The Hon. Gentleman is delighted with our town. He is accompanied by Miss Maud Montgomery, daughter of our esteemed townsman, H. J. Montgomery."[29] After spending a few days with his son and daughter-in-law, the Senator left by train for Vancouver, British Columbia. Lucy Maud could have accompanied her grandfather, but since school was opening early in September, she elected to be on hand for the beginning of the fall term. In mid-September the Senator returned to Prince Albert, and after spending a few more days with the Montgomerys, left for his home in Prince Edward Island leaving a very lonesome granddaughter behind in Prince Albert.[30]

The year that Lucy Maud spent with her parents in Prince Albert was a memorable one as she kept pace with a plethora of activities. Only two weeks after her arrival, the first through-train shunted and steamed its way into Prince Albert from the C.P.R. main line at Regina. On October 22, 1890, a large crowd watched with appreciation as Lieutenant Governor Royal drove the last spike.[31] To the homesick Lucy Maud the significance of the event was that her mail would arrive faster from Prince Edward Island! Lucy Maud's preoccupation, of course, was with her education. She enrolled at the public high school shortly after her arrival in Prince Albert. Her educational experience did not prove very satisfactory. The young principal of the school, J. M. Mustard, seems to have chosen, temporarily at least, the wrong vocation. While he was eminently capable as a Sunday School teacher and as choir director in St. Paul's Presbyterian Church, he proved to be an absolute minus in the classroom of his high school. Lucy Maud experienced considerable personal difficulty in communicating with "old Mustard," as she referred to him. She developed a deep personal animosity towards him, occasioned largely by her stepmother's insistence that she respond favorably to a courtship she unsuccessfully tried to promote between Lucy Maud and the very-much-interested J. M. Almost weekly, Mary Montgomery invited him to her house, and then went out, leaving the entertaining to Lucy Maud. She confessed later that she detested him both personally and professionally. For these reasons, Lucy Maud's year at Prince Albert was almost a total loss academically. When she was a student at Prince of Wales College some two years later, she wrote the following interesting article on her impression of her high school career in the West:

High School Life in Saskatchewan

It did not in the least resemble our life at Prince of Wales. Nothing could be more dissimilar. The building itself was about as large as our college, but only one of its rooms — an apartment about half as large as Prof. Caven's room — was devoted to the use of the High School students, of which there were about sixteen. The remaining rooms served a variety of uses. The one above ours was the public ball-room, and on the occasion of a ball, our room was utilized as a ladies' dressing room. On the next morning we would find numerous hair-pins, feathers, flowers etc., strewn over the floor, with very probably, a hand-mirror or two! On the other side of the big hall was The Council room and above it the Free Masons Hall. Beside these, in the back of the building were the patrol quarters where two or three red-coated Mounted Policemen were always stationed to patrol the town. When they arrested a drunken man they brought him in there, taking him through the hall outside our room, where very often there would be a lively scuffle and language strong enough to stand alone. Finally they would lock him up in one of the small, dark cells, a row of which ran directly back of our room. I remember venturing too rashly into an empty cell, one day, out of curiosity, and of being locked in by a Policeman, who did not know I was in it. There I had to stay too, for a mortal hour, till he returned and the teacher told him of my whereabouts. I did not go exploring again in a hurry.

We had but one teacher and he was a firm believer in Solomon's doctrine. He had a violent temper, and, as many of the High School boys had a fair share of the red man's nature, we occasionally had lively times. The master, when thrashing anyone, used a murderous-looking "raw-hide" whip, as long as yourself, and if the victim broke free and assumed the defensive and offensive with a stick of firewood, the thing got quite sensational, especially if, as usual, he had locked the door before beginning operations.

He could not punish the girls in this manner, but he would keep us in an hour or so after time, and give us terribly long compound interest sums to work. But, if I remember aright, very few were ever worked.

Our amusements were limited. At dinner time and recess the boys played football, while we girls (there were only two of us) wandered around the dusty old place, or sat on the balcony and watched the game. The school was beautifully situated on a hill outside of the town. The noble river rolled its blue tides before it, past the mighty dark pine forests of the north land on one side, and the willow-clad banks on the other. Away to our back extended undulating sweeps of prairie, pink and golden with

roses and sheets of prairie sunflowers, and dotted with groves of slender white-skinned poplars. Or perhaps we watched the passers-by on the road beneath us — Indians for the most part, "braves" with their dirty blankets over their shoulders, or chattering dark-eyed squaws, with their glossy, blue-black hair, and probably a small faced papoose strapped to their backs.

As for our studies, they were simply nowhere! We had a list of them as long as the Moral Law, but I cannot recall ever having opened a book out of school. The work was allowed to drift along as it liked. Learning anything did not seem to be expected at all. I remember of having but one exam. — in Latin — and the results of it were never known. We never heard anything more of our papers after they were given in.

I do not know what makes the memory of those times so pleasant. We did not learn anything, and they were very dull and stupid, but for all that it will be long ere I forget my High School days on the broad, fertile, wind-swept prairies of the far North-west — the "Great Lone Land."[32]

A few weeks after Lucy Maud's arrival, considerable excitement was engendered in the Montgomery household because of Hugh John's foray into municipal and federal politics. On January 5, 1891, elections were held in Prince Albert for the Town Council. Hugh John nominated for the position of Councillor in Ward III.[33] The election in that ward was a three-way contest between H. J. Montgomery, F. C. Baker and T. J. Agnew, the latter two gentlemen being distinguished and wealthy merchants of the town since the early 1880's. Hugh John won a notable victory garnering 52 votes, while Baker and Agnew received 37 and 32 respectively.[34] Hugh John proudly took his seat on the Town Council, and at the first meeting of the new municipal government, he was appointed chairman of the Board of Works.[35] The street that ran past D. J. Waggoner's house remained mired in mud, of course, so long as Hugh John was chairman of the Board.

He had no sooner embarked upon his career in municipal politics than he was approached to enter the federal field. The Liberals of the federal constituency of Saskatchewan prevailed upon him to contest the general election of March 5, 1891. Hugh John reluctantly, and seemingly, unfortunately, agreed to nominate. He, like his father, and most of the Montgomerys, had been staunch supporters of the Conservative Party. Indeed, it was largely due to his father's influence with Conservative Governments that Hugh John had received various lucrative governmental appointments. In the 1887 general election he had campaigned vigorously for the Conservative candidate, D. H. Macdowall.[36] While Hugh John never revealed the reasons for his conversion to Liberalism, the violently Conservative

organ, the Prince Albert *Times* did not hesitate to proffer its partisan viewpoint:

Hugh John Montgomery was induced by stuffed telegrams to enter the contest. Four years ago he fought hard for Mr. Macdowall's election: today he opposes him. The electors fully understand his action and realize that the only difference between then and now is that four years ago, he fed at the Government expense and now they refuse to employ him. Interested people worked upon his vanity, the consequence of which is that he must now pay a large electioneering account, and Mr. Macdowall will continue to represent the district in the councils of our country.[37]

Hugh John was not allowed the luxury of insisting, like many politicians, that he might simply have wanted to serve his constituents and his country.

Hugh John did not really have even an outside chance of defeating the incumbent Conservative, D. H. Macdowall. Macdowall, a successful lumber merchant in Prince Albert since 1881, was an extremely popular and efficient parliamentary representative. In the election of March 15, 1887, he had easily defeated the Honorable David Laird, a former Lieutenant Governor of the North-west Territories, who had been *parachuted* into the district from his native Prince Edward Island to represent the Liberals.[38] Macdowall had few difficulties with the second native Prince Edward Islander although Hugh John campaigned vigorously throughout the constituency. Lucy Maud commented, with some enthusiasm, to one of her friends on her father's campaign: "Well P.A. is of course in a great state of excitement over the coming elections, and both Grits and Tories are raising heaven and earth and a little of the other place too I think to get their man in. Papa is running as a Liberal candidate this year, and is at present away in Battleford on a campaign. This leaves me commander-in-chief of things, so of course I am tremendously busy ..."[39] The press in Prince Albert was especially vitriolic towards Hugh John: "Monty is a renegade," the *Times* remarked bitterly, "and, only a few months a renegade — therefore not even a very intelligent renegade."[40] The national Conservative slogan in the 1891 election — "The old flag, the old man, the old policy" — was not effective enough to elect Hugh John Montgomery. Macdowall polled some 948 votes to Montgomery's 666, for a majority of 282.[41] Thus, Hugh John was back wielding the auctioneer's gavel within a week. But he stood tall in defeat. Even the Prince Albert *Times* commented that "Mr. Montgomery made a strong fight and unlike many of his supporters took his defeat like a man."[42]

Meanwhile, Lucy Maud found herself caught up in the swirl of activities that seemed inescapable for anyone living in the Montgomery household in Prince Albert. Hugh John, his wife, Mary, and, of course, Lucy Maud were active participants in all the social activities sponsored by St. Paul's Presbyterian Church. Indeed, their whole social life seemed to revolve

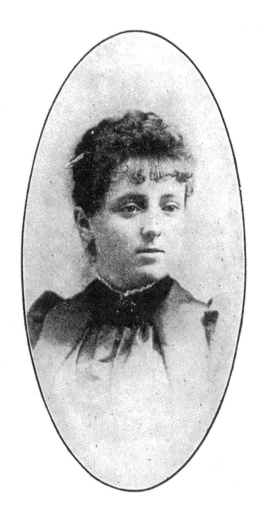

L. M. Montgomery at Sixteen

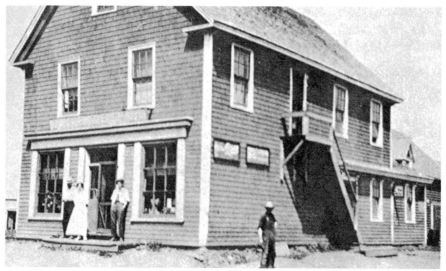

H. J. Montgomery's Store in New London
(Courtesy Helen Lockhart)

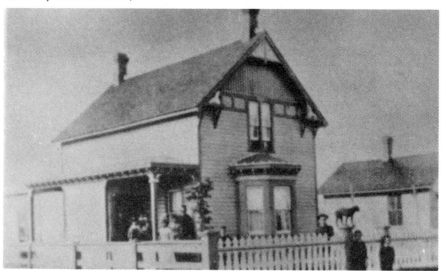

Hugh John Montgomery's Home in Prince Albert (Eglintoune Villa during L. M. Montgomery's 1890-91 visit) (Courtesy Dr. Stuart Macdonald)

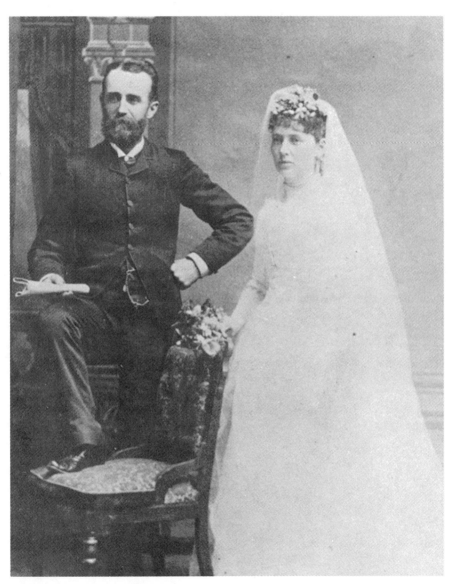

Hugh John and Mary Montgomery
(Courtesy Mrs. Garnett Campbell)

Kate and Bruce Montgomery
(Courtesy Mrs. Garnett Campbell)

Prince Albert in the 1890's
(Courtesy Dr. Stuart Macdonald)

Prince Albert (Hugh John Montgomery's home in left foreground)
(Courtesy Albert Agnew)

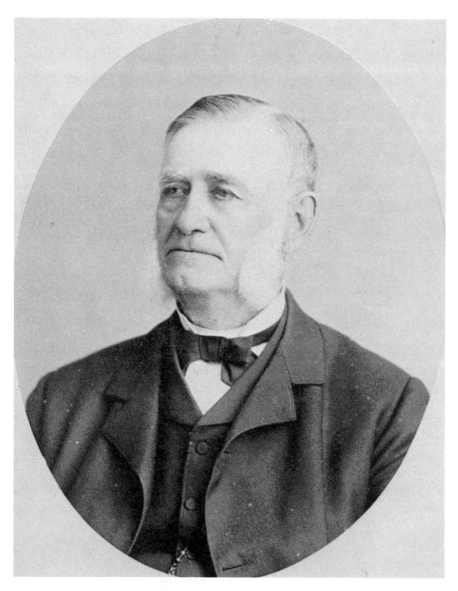

Senator Montgomery in 1890
(Courtesy Dr. Stuart Macdonald)

around St. Paul's. Thus, the accomplished singing talents of Mary Montgomery, and the equally celebrated talents of her stepdaughter were frequently exercised. In December, 1890, the Sunday School pupils of St. Paul's presented a concert which demanded tedious practices for nearly three weeks. Lucy Maud participated, with great success, in a dialogue called, "The Census Taker."[43] In February, 1891, the ladies of St. Paul's Church held an entertainment in the Town Hall in aid of their new church which would be started in the spring, and Lucy Maud gave a recitation entitled, "The Polish Boy."[44] Commenting on her performance to one of her friends, she noted with justifiable enthusiasm, that if "I believed all the pretty compliments paid me, I'd be too vain for anything. Such a puff as they gave me in the paper."[45] At a concert in March in aid of the Temperance Division of Prince Albert, she delivered a recitation entitled "The Christening."[46] The enthusiasm for her effort was even more pronounced. "I thought," she wrote to a friend, "they'd clap the Church down. They encored me so loudly I had to get up again and recite another piece for them called the "Other Side." You ought to have seen the puff they gave me in the paper the next day."[47] During the remaining months that she lived with her parents, Lucy Maud participated in many other social functions. Prince Albert thus enabled her to develop her artistic as well as her literary talents.

But under the circumstances that prevailed, it would have required much more than dramatic and literary successes to acclimatize Lucy Maud to living permanently with her parents in Prince Albert. She simply could not make the adjustment to life in Prince Albert; she so missed Cavendish and Park Corner that life was almost unbearable in Saskatchewan. The situation was rendered even more difficult by the domestic atmosphere in the Montgomery home. On January 31, 1891, Mary Montgomery gave birth to a new son, who, in the finest Scottish tradition, was called Donald Bruce.[48] Although Lucy Maud was deeply attached to her new half brother, he was an added responsibility. Her parents could not obtain a housekeeper, so Lucy Maud largely filled that role. "The baby," she wrote home, "is *so* cross. Oh my! he is a terror. One of us has to have him in our arms the whole time. Then we haven't been able to find a servant girl yet. They are awful scarce out here, so I have a lot to attend to."[49] Lucy Maud was even obliged to remain home from school for nearly two months to assist with the domestic chores. Her dreams of getting an education were dispelled. She claimed in later years that "in plain English, she had to stay home and be Mrs. Montgomery's household drudge." In addition, the personal relationship between Lucy Maud and her stepmother was always rather strained. Perhaps the mere ten-year differential in their ages made

it difficult for Lucy Maud to accept her new mother *qua* mother. More-over, Mary Montgomery was domineering, and, naturally, much more indul-gent with her own children, Kate and Bruce, than with her stepdaughter. L.M. reached the conclusion that she would never have a *real* home in Prince Albert despite her deep attachment to, and love for, her father. "I need not pretend," she wrote in her journal, "that I have been happy here. I tried my best to please Mrs. Montgomery. I worked myself to the bone." But her efforts were apparently to no avail. She kept pleading with her father to allow her to return to Prince Edward Island. At length he relented and Lucy Maud bid farewell to Prince Albert on August 25, 1891, and returned to Cavendish to live, once again, with her grandparents.

Hugh John and Mary Ann Montgomery continued to live in Prince Al-bert. The birth of two more children, Ila May and Hugh Carlyle, brought the complement of Lucy Maud's half siblings to four. Hugh John remained in private business until November 2, 1897, when he was appointed warden of the new penal institution officially opened in Prince Albert in October, 1898.[50] His wife, at the same time, was appointed matron of the new jail.[51] Their joint salaries of some one thousand dollars seemed to result in a new measure of opulence. The Montgomerys moved into a beautiful new resi-dence on 21-19 St. East in the most exclusive residential district of Prince Al-bert. But their good fortune was short-lived. Early in January, 1900, Hugh John developed pneumonia, the result of a chill caught when engaged in a curling game at the Saskatchewan Curling Club.[52] The disease proved fatal and Hugh John died on January 16, 1900.

Hugh John's death was a great shock and loss to his family and many friends. Lucy Maud was completely crushed when she received the news of her beloved father's death. She remarked six years later that life had never seemed the same since her father's demise. After a large Masonic service in the court house, Hugh John was buried in the Presbyterian Cemetery in Prince Albert.[53] The sentiments of the people of Prince Albert were fitting-ly expressed by the editor of the *Advocate* who wrote that "Hugh John Mont-gomery's lamented death has left a void in this community which will long be felt, being a man of extraordinary energy, enterprising ability and of ster-ling uprightness and strength of character."[54] His wife, Mary Montgomery, interestingly enough, continued on as matron of the jail and with his real es-tate and insurance business, until her premature death in 1910 at the age of forty-seven. Lucy Maud was not aggrieved by the death. She had remarked bitterly after leaving Prince Albert that she did not "wish to see Mrs. Mont-gomery again." The Prince Albert *Advocate* commented: "Mrs. Mont-gomery, who made a fortune in the real estate boom here three years ago, died suddenly today of diabetes."[55] How much the speculative Hugh John

would have liked to have participated in that boom! Lucy Maud's half brothers and half sisters moved to Winnipeg and Vancouver, and the Montgomery home was sold by them in 1924.[56] Although she kept in touch with them throughout her life, the Montgomery connection in the West was never so intimate after the death of her beloved father. His influence upon her had been significant, and she always expressed appreciation and gratitude for her "memorable year" in Prince Albert. Some thirty years after her father's death, she stood beside his grave in Lower Boot Hill cemetery in Prince Albert, and recalled that "I loved my father very deeply. He was the most lovable man I ever met." The passage of time had done nothing to erase a beautiful memory.

FOOTNOTES TO CHAPTER III

[1]L. M. Montgomery, "The Alpine Path," *Everywoman's World*, Vol. VIII, No. III, (September, 1917), p. 8.

[2]L. M. Montgomery, "A Western Eden," 17 June, 1891 in Prince Albert *Times*.

[3]L. M. Montgomery, "The Alpine Path," *Everywoman's World*, Vol. VIII, No. II, (August, 1917), p. 16.

[4]H. H. Simpson, *op. cit.*, p. 253.

[5]Hugh John Montgomery to Minister of the Interior, 6 December, 1884, Record Group 15, B. 1, Box 1089, File 137340, p. 1.

[6]*Ibid.*

[7]Hugh John Montgomery to Minister of the Interior, 17 June, 1885, *ibid.*, p. 5.

[8]Prince Albert *Advocate*, 22 January, 1900. Saskatchewan Archives, Regina, Saskatchewan. This issue contained a two-column article on Hugh John Montgomery's death.

[9]*Ibid.*

[10]Prince Albert *Times*, 3 October, 1883.

[11]D. J. Waggoner to A. W. Burgess, 9 September, 1885, Record Group 15, B. 1, Box 1089, File 137340, p. 13.

[12]R. S. Park to Hugh J. Montgomery, 13 October, 1885, *op. cit.*, p. 20.

[13]*Ibid.*, pp. 25-65. All the evidence is presented on those pages.

[14]R. S. Park to H. H. Smith, 21 October, 1885, *op. cit.*, p. 21.

[15]*Ibid.*, pp. 21-22.

[16]*Ibid.*, p. 22. Montgomery made these charges while replacing Waggoner who was on a temporary leave of absence. Undoubtedly, Montgomery hoped to receive Waggoner's position if he should be removed from office.

[17]*Ibid.*, p. 23.

[18]*Ibid.*

[19]T. R. Burpee to the Secretary of the Department of the Interior, 13 January, 1886, *Ibid.*, p. 60.

[20]*Ibid.*, pp. 60-61.

[21]Prince Albert *Times*, 25 December, 1885.

[22]Prince Albert *Times*, 18 December, 1885.

[23]Prince Albert *Times*, 13 August, 1886.

[24]*Ontario Gleaner*, Cannington, Ontario, 6 April, 1887.

[25]Prince Albert *Times*, 6 May, 1887.

[26]Prince Albert *Times*, 4 April, 1890.

[27]Prince Albert *Times*, 23 May, 1890.

[28]*Ibid.*

[29]Prince Albert *Times*, 22 August, 1890.

[30]Prince Albert *Times*, 12 September, 1890.

[31]Prince Albert *Times*, 24 October, 1890.

[32]L. M. Montgomery, "High School Life in Saskatchewan," May 1894. Prince of Wales *College Record*, May, 1894.

[33]Prince Albert *Times*, 9 January, 1891.

[34]*Ibid.*

[35]*Ibid.*

[36]Prince Albert *Times*, 4 March, 1891.

[37]*Ibid.*

[38]Prince Albert *Times*, 6 May, 1887. Macdowall defeated Laird by some 100 votes.

[39]L. M. Montgomery to Penzie Macneill, 25 February, 1891. L. M. Montgomery collection in Kelley Memorial Library, University of Prince Edward Island. Charlottetown, P.E.I.

[40]Prince Albert *Times*, 4 March, 1891.

[41]Prince Albert *Times*, 11 March, 1891.

[42]*Ibid.*

[43]L. M. Montgomery to Penzie Macneill, 16 December, 1890.

[44]L. M. Montgomery to Penzie Macneill, 10 February, 1891.

[45] *Ibid.*

[46] L. M. Montgomery to Penzie Macneill, 14 March, 1891.

[47] *Ibid.*

[48] Prince Albert *Times*, 11 February, 1891.

[49] L. M. Montgomery to Penzie Macneill, 14 March, 1891.

[50] Report of the Minister of Justice, Appendix N — Prince Albert Jail, July 30, 1899: Canada, *Sessional Papers*, 1900.

[51] *Ibid.*

[52] Prince Albert *Advocate*, 22 January, 1900.

[53] *Ibid.*

[54] *Ibid.*

[55] Prince Albert *Advocate*, 14 April, 1910; in Stella Campbell's scrapbook; loaned to writer by Pamela Campbell.

[56] Registrar of Deeds, The Prince Albert Land Registration District, Land Titles Office, Prince Albert, Saskatchewan.

CHAPTER IV

LETTERS FROM PRINCE ALBERT

During the twelve months that Lucy Maud Montgomery lived in Prince Albert, Saskatchewan, she conducted a voluminous correspondence with her many friends in Prince Edward Island. In addition to the weekly letters to her Grandmother Macneill, she corresponded on a regular basis with her three closest friends in Cavendish, Amanda Jane Macneill, Lucy Macneill and Penzie Maria Macneill. By good fortune, the sequence of letters with Penzie Macneill are still extant, and are reproduced here exactly as they were written in 1890-1891. These letters were retrieved recently from the attic of Penzie's son's home in New Glasgow, Prince Edward Island, some seventy years after her death. Their interest and importance lies partly, of course, in the fact that they were written in Prince Albert during a critical and influential year in the rise of Lucy Maud as a famous author. But the correspondence with Penzie Macneill has an even deeper significance. The letters, and the long poem in Penzie's honor enclosed with them, can be appreciated in themselves for their literary flavour and value. In page after page Lucy Maud bares her soul to Penzie, the most intimate of her three companions. The result is a portrait of a sensitive, understanding, lively, temperamental, observant, and often insecure personality. Thus, the reader of these letters is favoured with a glimpse of a side of Lucy Maud Montgomery's character not otherwise revealed.

Penzie Maria Macneill's lineage was deeply rooted in Cavendish.[1] In 1804, her great-grandfather, Charles Macneill, emigrated from Perthshire, Scotland, and settled on a farm approximately three-quarters of a mile east of Cavendish corner. His youngest son, Alexander, married Helen Macneill, daughter of "Speaker" William Macneill and Eliza Townsend Macneill.[2] Since Helen was a sister of Lucy Maud's grandfather, Alexander, Penzie and Lucy Maud were second cousins. Mary Lawson, Lucy Maud's favourite grandaunt, commented on Penzie's grandparents:

My second sister Helen married Alexander Macneill, no relation of her own, but a man of big soul, kind and generous. He scorned meanness and would almost lay down his life for a friend. He was a very successful man in his own business and died comparatively young. His wife, my sister, had the brain and beauty of the family, but she had a large family and it required all her exertions to attend to them which she faithfully did, and left behind her a family of six daughters and two sons who have all been distinguished for honesty and uprightness of character and have helped to make the world better for having lived in it.[3]

If Penzie's father, Charles, was representative of the family, then Mary Macneill Lawson's glowing assessment was not far off the mark.

Charles Macneill, Alexander's youngest son, married Mary Buntain of Rustico on March 15, 1860.[4] They immediately moved into a new home that Charles had built on the old Macneill homestead that year. Because of Lucy Maud's intimate friendship with their youngest daughter, Penzie Maria, their residence became almost her second home. She expressed her sentiments in a poem she sent to Penzie from Prince Albert entitled, "My Friend's Home," one stanza of which is:

> " *'Tis not my home though almost 'tis as dear*
> *And next to home the fairest spot on earth*
> *That little cottage in a far-off land*
> *In that blue-circled Isle that gave me birth.*"[5]

Lucy Maud's close association with Penzie also resulted in close ties of friendship with the whole family which comprised the following members:

Charles Macneill (1832-1908); married *Mary Buntain* (1833-1916).

Children: 1. Albert Walter, b. December 25, 1860; died 1928. Married Bessie Stevenson (1867-1950).

2. Leila Ada, b. May 20, 1863; died 1942. Married Oliver Bernard (1864-1943).

3. Robert Buntain, b. May 30, 1865; died?. Married Grace ?; he lived in Portland, Oregon.

4. Minnie May, b. August 13, 1867; died 1933. Married Lorenzo Toombs (1865-1930).

5. Alexander Charles, b. March 2, 1870; died February 17, 1951. Married May E. Hooper (1876-1947).

6. Penzie Maria, b. July 16, 1872; died February 28, 1906. Married William B. Bulman (1871-1947).

7. Russell Herbert, b. October 23, 1874; died August 31, 1950. Married Margaret E. Warren (1880-1946).[6]

It was because of Lucy Maud's deep attachment to families like that of Charles Macneill that life was almost unbearable in Prince Albert.

Another Cavendish family that figured quite prominently in the Prince Albert letters was that of John Franklin Macneill. John Franklin, the second son of Alexander and Lucy Woolner Macneill, was Lucy Maud's

uncle. He lived on a lush seventy-five acre farm which he purchased in 1877 from the Reverend Isaac Murray situated immediately adjacent to, and east of, his father's home. As his father advanced in years, he restricted himself largely to his postal duties, and John Franklin gradually assumed responsibility for the operation of the two farms. One year prior to his death, Alexander Marquis Macneill made provision for the disposition of his holdings. He willed his forty-acre farm to John Franklin with the provision that he pay one hundred dollars to each of his two sisters, Annie (Mrs. John Campbell), and Emily, widow of John Montgomery. He left the buildings, household effects, monies, and mortgage on the John F. Macneill property to his wife Lucy Woolner Macneill.[7] When Alexander died in 1898, John Franklin honored his obligation to his sisters, and after his mother's death in 1911, and Lucy Maud's subsequent marriage, he incorporated the old Macneill homestead into his holdings. Because of the close proximity of the two farms it was quite natural in their earlier years that there should have been much intermingling between the two families. Lucy Maud remarked in later years that although her Uncle John Franklin never missed an opportunity of being unkind to her, she loved his wife, Aunt Anna Maria, and always considered their sons and daughters as brothers and sisters rather than as first cousins. This most interesting family was composed of the following members:

John Franklin Macneill (1851-1936);
married *Anna Maria McLeod* (1848-1933).

Children: 1. Lucy, (1877-1974). Married Benjamin Simpson.

2. Prescott, (1879-1910); did not marry.

3. Frank, (1882-1963). Married Margaret McQuarrie.

4. Ernest, (1884-1969). Married 1. Elva Jean Nicholson (1890-1915), 2. Winnifred McLeod (1892-1984). Their son John, married to Jennie Moore, lives in the old home.

5. Katie, (1884-1904); did not marry.

6. Annie, (Tot), (1889-1970). Married Louis Davies Warren (1889-1950).[8]

These were the relatives with whom Lucy Maud had very close associations during her Cavendish years and with whom she corresponded frequently during her visit with her father in Prince Albert.

The sixteen letters written in Prince Albert by Lucy Maud Montgomery to Penzie Maria MacNeill are allowed here to tell their own story with minimal comment. The sole intrusion will be a series of notes at the end of each letter in order to identify people and to clarify events. These comments, it is hoped, will amplify the flavour, interest and significance of the letters.

THE LETTERS

Prince Albert
Aug. 26th/90.

My own dearest Penzie,
You see I have not forgotten you and I am writing to you to prove the fact. I arrived here a week ago after an exceedingly pleasant trip. I tell you I saw a good deal that was new to me. I'm sure if I wished it once I did a hundred times that you and Lucy[1] and Amanda[2] were with me. Wouldn't we have had a rumpus? I saw St. John, Montreal, Ottawa, Winnipeg and Regina besides hosts of smaller towns. Grandpa Montgomery[3] is going through to Vancouver and I could go if I liked but the High School opens here next week and as I wish to attend I want to be there at the start.
Prince Albert is an awful pretty little place and is beautifully situated on the Saskatchewan River. I like it very much but it isn't Cavendish. The country around Prince Albert is a farming one and very beautiful. If it were a little more settled it would very much resemble Prince Edward Island and that is the highest praise I can give. There are plenty of poplar, willow, juniper, wild cherry and balm of gilead trees and over on the other side of the river there are plenty of spruces in the dense forests there. But there are no birch trees or maple and I miss them very much.
There are plenty of Indians to be seen here. They look so funny. The men all wear their hair long and in two braids hanging down their backs. It looks so queer. Their hair is pretty being very straight and glossy and of a beautiful blue-black. They don't look a single bit like our Indians down home but are much handsomer. Some of them are very good-looking and the half-breed girls are the prettiest ones going.
How is Fauntleroy[4] coming on? I hope he is well and growing fat. Tell him to behave well and be a credit to his bringing up. I do so wish I could see my own poor pussies. I hope they won't forget me.
There was a big thunderstorm here the other night and it made me think of the one you and I were caught in down home. Dear me! I cannot

realize that I am over 3,000 miles away from the dear fields where we used to have such fun, wish I could get down to the shore with you and go in for a bathe. There is no chance for bathing here as the river is too swift and has such big banks. I was out for a drive Saturday evening all around P.A. and had a very nice time. The water they have here isn't very good but it is better than what they have in Regina. That is horrible. It is more like frog-pond water than anything else.

My little sister Katie[5] is the dearest sweetest prettiest little angel you can imagine. She has a head covered with silky curls of the palest gold and big dark blue eyes so bright and sparkling. She is awful fond of me already and tags around wherever I go. There are two girls here now besides me. Edith Skelton[6] who is boarding here and going to school is just my age — only 2 days difference and is a capital girl. Mary McKenzie[7] is on a visit here and is going to stay the winter. She is a nice girl. But I never can have three as good friends as you and Lucy and Amanda and I will never forget you.

Annie McTaggart[8] who lives in the next house is also a fine girl but most awful conceited. I got a letter from Lucy last night and it made me pretty homesick I can tell you.

Now dear Penzie I have told you all I can think of just now and so I must end for the time. Write me right away at once and I will answer you. Give my love to your mother and to Lillie[9] and Minnie[10] when you see them. So now with piles of love and kisses to my own dear Penzie I will close

Maudie

P.S. How are you and Quil Rollings[11] (or is it Rolands) getting on.

M.

[1]Lucy (Macneill)	: She was the daughter of John Franklin and Anna Maria Macneill. He was a brother of Clara Woolner Macneill, Lucy Maud's mother. Lucy and Lucy Maud were thus first cousins. Lucy was born in 1877. She married Benjamin Simpson. One of Lucy Maud's three best friends. She died in August, 1974.
[2]Amanda (Macneill)	: She was the daughter of William Macneill and Christy Ann Cameron. She was born on September 10, 1874. She married George Henry Robertson. She died September 24, 1949. One of Lucy Maud's three best friends.
[3]Grandpa Montgomery	: Senator Donald Montgomery (1808-1893), Lucy Maud's paternal grandfather.

[4]Fauntleroy : Penzie's cat.

[5]Katie (Montgomery) : Lucy Maud's half sister. Hugh John Montgomery married Mary Ann McRae on April 5, 1887, in Knox Presbyterian Church, Cannington, Ontario. Kate was the first of their four children.

[6]Edith Skelton : Edith was from Battleford. Her father, J. M. Skelton, was a great friend of Hugh John Montgomery.

[7]Mary McKenzie : Mary was a niece of Lucy Maud's stepmother.

[8]Annie McTaggart : John McTaggart's daughter. Lucy Maud's stepmother was his stepdaughter.

[9]Lillie (Macneill) : She was Penzie's sister. She was born on May 20, 1863. She married Oliver Bernard. She died in 1943.

[10]Minnie (Macneill) : She was Penzie's sister. She was born on August 13, 1867. She married Lorenzo Toombs. She died in 1933. William Toombs, their son now lives on the home place.

[11]Quill Rollings : He was the son of John Rollings and lived at Rustico Harbour. His real name was Aquilla John Rollings. He lived from 1868-1935.

Saturday

Prince Albert
Sept. 20th
1890

My own dear Penzie
Oh don't I wish that instead of writing to you I could go to you and get my arms around you and kiss you. I am waiting with the greatest impatience for a letter from you. By this time you must have received the first letter I sent you and I hope you have answered it right away so as I will get it soon. I have just finished a letter to Amanda[1] and I have to write to Grandma[2] and Lucy[3] yet so I will have to scribble down this letter pretty fast.
And even now I have begun there doesn't seem very much to write about that will interest you. I am going to school regularly and I like it very well but it is a little slow sometimes and I get homesick. Mustard[4] is always easy on us girls but I tell you he sometimes gives the boys awful canings. Sometimes funny things happen which give a little spice to the work. For instance the other day when school was called in after the afternoon recess Douglas MacVitae[5] and Willie Macbeth[6] weren't to be seen.

Arthur Jardine[7] was sent out to hunt them up and soon came back saying that "MacVitae is a-coming but I can't find Macbeth." Sure enough "MacVitae" soon put in his appearance and sneaked to his seat while the other boys began to snicker. Mustard asked him if he didn't know school was in. MacVitae mumbled out that he did. "Well then" demanded Mustard in a voice enough to have bleached MacVitae freckles and all. "Why didn't you come before?" "Well" shouted MacVitae (he really did shout he was so excited) "Macbeth locked me up in the backhouse and I couldn't get out." Oh how those boys howled with laughter and Mustard laughed fit to kill. I guess he didn't like to ask any more questions so he dropped the matter as if it were a hot coal. I never felt so horrid and queer in my life. I wanted to laugh but I was too ashamed to so I had to choke down my mirth and look as shocked as possible.

We have had a horrid fall here and there is every prospect of an early winter. Ever since I came there has been nothing but cold and rain. Papa[8] says I must have brought the rainy weather for they hadn't any of it before I came. Perhaps I did for rains always follow me. I never could go anywhere down home without its raining on me as you know to your cost. I think I told you in my last letter we were going to have a big spree here the next night. Well we did have it and a fine time I had you can bet. But my stars! wasn't I tired the next day. Dancing till three o'clock doesn't tend to make one very brisk the day after. Most of the dances were waltzs [sic] or lancers or polkas but there was one or two reels and as I danced them I thought with a homesick feeling of that night down at Ben's[9] last winter and the reel I danced with Stanton Macneill.[10] I'd a good time at our party but I believe I'd a still better time down there that never-to-be-forgotten night.

Grandpa Montgomery[11] left here Thursday morning for home. You bet I felt bad to see him go and I'd have given my eyes to have been going with him. Mamma and Papa and Katie[12] went as far as Saskatoon with him and did not get home till last night. Edie Skelton[13] (the girl who stays here and goes to school. I told you about her didn't I) and I kept house all alone and I tell you we'd a racket. I guess the neighbours must have thought the place was haunted or something.

This is Saturday morning and I am sitting all alone up here in the cosy little room where Edie and I sleep. We call it Southview because it looks south and we spend most of our spare time up here learning our lessons writing doing our sewing and knitting gossipping [sic] and having our homesick crys — and we do have the last pretty often I can tell you.

Every evening just at sunset after we get the tea dishes washed up Edie and I go for a walk down town and along the Saskatchewan River. I just

love to walk by the river. It is so very lovely just below Prince Albert and has such lovely scenery. And then too it puts me in mind a little of the dear old seashore at home where you and I have had such fun in bygone summer-tides. Do you ever go to the shore now and do you ever try to row a boat? I laugh every time I think of that evening when you and I tried to help Uncle Leander[14] row the boat while Lucy[15] huddled up in the stern and how we got shipwrecked off Cawnpore.[16] Oh dear me! What fun you and I have had together. I wonder if we ever will have any more. I hope so anyway.

I hope your mother is well. Give her my love and tell her I think of her very often and of her kindness to me. I wish I could see her and you and all my friends but that can't be I suppose so I must try my best not to fret. I wish you would get your picture taken if it was even only a tintype and send it to me. I have got the one you gave me before with me and oh how often I look at it and long to see the one it represents.

Now dear it is tea time and I must say good bye. Be sure to write me regularly because I am very lonely and think of me ever as

Your own loving friend
Maudie

[1]Amanda (Macneill)	:	William Macneill's daughter. One of Lucy Maud's three best friends together with Lucy Macneill and Penzie Macneill.
[2]Grandma (Macneill)	:	Lucy Maud's maternal grandmother, Lucy Woolner Macneill who married Alexander Marquis Macneill. Lucy Maud made her home with the Macneills.
[3]Lucy (Macneill)	:	John Franklin Macneill's daughter, and Lucy Maud's first cousin.
[4]Mustard	:	J. M. Mustard was the principal of the high school that Lucy Maud attended while she was in Prince Albert. He was also the only teacher in the school.
[5]Douglas MacVitae	:	One of Lucy Maud's classmates. His father was J. D. Mavetty, publisher of the Prince Albert *Times*. Lucy Maud spelled the name phonetically!
[6]Willie MacBeth	:	One of Lucy Maud's classmates.
[7]Arthur Jardine	:	One of Lucy Maud's classmates. His father, Dr. Robert Jardine, was minister of St. Paul's Presbyterian Church, the church that the Montgomerys attended.
[8]Papa	:	Hugh John Montgomery, Lucy Maud's father.

[9]Ben (Woolner)	:	Son of Fred Woolner who lived in North Rustico.
[10]Stanton Macneill	:	He was the son of George Macneill and Eliza Rollings.
[11]Grandpa Montgomery	:	Lucy Maud's paternal grandfather.
[12]Katie (Montgomery)	:	Lucy Maud's half sister.
[13]Edie Skelton	:	The girl that boarded with Hugh John and Mary Ann Montgomery.
[14]Uncle Leander	:	Leander Macneill was a son of Alexander and Lucy Macneill and, therefore, Lucy Maud's uncle. He became a minister. He died in 1913.
[15]Lucy (Macneill)	:	Lucy Maud's first cousin, daughter of John Franklin Macneill.
[16]Cawnpore	:	Common name for Cavendish beach.

Monday

Eglintoune Villa
Prince Albert
Oct. 6th
1890

My dearest Penzie
 Whatever has come over you in the wide wide world. Have you got married and left Cavendish? Have you gone to Boston? Or have you as seems more likely forgotten all about me and your promises of writing. Oh Penzie dear why don't you write. Why I wrote to you the same time I wrote to Lucy[1] and Amanda[2] and I got an answer from them a fortnight ago but no word from you yet. I was so sure I would get a letter from you this mail but I was doomed to disappointment for none came from you though I got letters from Lucy, Grandma[3] and Prescott.[4] I want to tell you that when you get a letter from me try and answer me the next mail if you can because a single day's delay down there makes a whole week's difference up here where we only get a mail once a week. Well I have finished scolding you and now I am going to torment you with another long tedious letter.
 To be sure I have next to nothing to tell you for things are pretty much the same here as when I wrote last. Every morning I plod to school which is pretty dull. Now and then we have a little fun. To-day Douglas MacVittie[5] went out at recess and came across a skunk and killed it. I suppose you have heard what an unendurable smell a skunk makes and how if any-one gets their clothes to smell of it they have to burn them at once. Well when Douglas returned to the school everyone fairly went wild. There

we all sat with our faces buried in our handkerchiefs and trying not to throw up while poor Douglas sat up in the corner as much shunned and avoided as if he had had the smallpox. At last he went home to get rid of his clothes but the smell didn't go out of the room all day.

There was a lecture down at the Town Hall the other night I was to it but it was only on farming and not very interesting.

You will see that at the top of my letter I have put "Eglintoune Villa." That is what papa calls his place. A pretty name isn't it. He called that after our ancestors the earls of Eglintoune. Nearly all the houses in Prince Albert are named. Mr. MacTaggart[6] calls his Riverview and there is Glenburnie Villa and Southview and Westview and Northview and Eastview and River Villa and Poplar Villa and Maplewood and Beechhurst and Woodlands and Willow Grange and ever so many more.

Were you up at the blind man's concert in the hall. Lucy wrote me she was at it but that it wasn't much. It ought to have been something good for it was dear enough. I think 25 cts. is a ridiculous price to charge.

Lucy and Prescott both sent me a big piece of gum and it is just delicious. Don't you mind the fun we used to have picking gum in the woods back of your place. If I ever go back you and I will have some more fun. Do you go down to Lillie's[7] often and to Minnie's?[8] Give them both my love when you see them. Oh how I wish I could see you all. I am so lonesome and homesick at times and I always have a good cry after I get letters from home. I never cry after I read yours though for the simple reason that I never get any from you. Oh Penzie do write to me or I shall think you are offended at me or something.

Edie Skelton[9] and I are all alone to-night for Papa and Mamma have gone out to tea and I am just too lonesome to live. I am enough that at any time but it's worse when there is no one around to talk to you.

We are having lovely weather here now. Sunday and Saturday were rainy but with that exception the last fortnight has been beautifully fine. We have preaching every morning and evening on Sundays and Sunday school in the afternoon. I hate going to Sunday School here. It is all so new to me and then I hardly know any of them and oh well its just horrid. There is prayer meeting on Thursday night and Bible class on Friday night. I don't go to prayer meeting. The young folks never do but I always go to Bible class and it is very nice.

Now dear Penzie I am awfully sleepy and I think I will end. I send lots of love to you and your mother[10] and remain

Your ever-loving friend
Maudie

[1]Lucy (Macneill)	:	Lucy Maud's first cousin, John Franklin Macneill's oldest daughter.
[2]Amanda (Macneill)	:	Amanda Jane Macneill, William Macneill's daughter. She lived where the sixteenth hole of the present Green Gables Golf Course is located.
[3]Grandma (Macneill)	:	Mrs. Alexander Macneill, Lucy Maud's grandmother.
[4]Prescott (Macneill)	:	John Franklin Macneill's oldest son (1879-1910). He was Lucy Maud's first cousin.
[5]Douglas MacVitae	:	Lucy Maud's classmate in Prince Albert high school.
[6]Mr. McTaggart	:	John McTaggart, Mrs. Hugh John Montgomery's stepfather.
[7]Lily (Bernard)	:	Penzie Macneill's sister, now married to Oliver Bernard. They lived on the Shore Road which ran beside the Gulf between Cavendish and North Rustico.
[8]Minnie (Toombs)	:	Penzie Macneill's sister, now married to Lorenzo Toombs. They lived on the Cavendish road leading to North Rustico.
[9]Edie Skelton	:	She boarded with Hugh John Montgomery.
[10]Mother	:	Mrs. Mary Buntain Macneill, Penzie's mother.

Saturday

Eglintoune Villa
Prince Albert
Oct. 18th,
1890

My own dearest Penzie

Last Monday evening when the mail came in I was too overjoyed for anything for there were actually five *long delicious letters for me and one was from my own dear Pen. I think I was gladder to get that than any of the rest for I was beginning to think you had forgotten all about me. Your letter must have been delayed on the way for it took so long to come.*

My other four letters were from Olive Eby,[1] Miss Gordon,[2] Lucy[3] and Bessie Fraser[4] and they were all just the right letters for a homesick girl to get.

I have read your letter through so often that I know it off by heart and I am going to answer it to-night though it can't go before Wednesday because I'm dreadfully lonely and homesick and it will be some comfort to write to my dear old chum.

I have just been having a good old-fashioned cry over your picture (for I brought it with me) and wishing I could see the original. Oh Pen

I'd give all I possess if I were with you to-night.

Now for your letter! First I must thank you heartily for that gum. It was just delicious and it did so put me in mind of the piles of fun you and I used to have gum-picking in the dear old days. I am chewing a bit of the gum now and I assure you it is just to-to.

So you still go to prayer-meeting. Oh don't I wish I were there to go with you. We have a prayer meeting here but it is just horrid and I very seldom go as I don't like going alone and it is so dull anyway. Don't you mind the last prayer-meeting we were at down home. I have that sprig of sweet clover that you gave me down at your place that night yet. It is carefully laid between the leaves in my Bible and when I get tired of the sermon in church I open it at the place and dream of all the happy home scenes and amusements.

I'm glad Fauntleroy[5] is growing well. Does he still drink that funny way. Give him a kiss for me.

Yes indeed I do mind the night we were down at Minnie's[6] and the one at Rolling's[7] too. That poor cat! It must have been scared most to death. Now Pen you needn't say Rogerson[8] kissed me when we were walking the cedar swamp[9] for he didn't. How are you and Quill[10] getting on? Do you ever see Betty Bullman[11] now? When you do give her my love and tell her not to forget how the squaws hang up their babies.

Talking of that I've seen them hang up their pappooses [sic] here lots of time and it isn't a bit like the way old John Rollings[12] said it was. The way they do they take a big strip of flannel and roll the baby right up tight so the poor little thing can't move and then they tie a shawl around it and fling it over the backs upside down or anyway and go around like that. I don't see how the pappooses [sic] ever live through it but they do all the same.

Gracious yes I do miss the apples. An apple out here is as rare and expensive as an orange down in Cavendish. We pay ten cents for three measly little apples that don't taste any too good either. When I think of how we used to give bushels to the pigs down home and sell them to the schoolboys six for a cent I wonder how ever we could have been so careless about them. As for sending you my picture I will when I get some taken you may be sure.

As for news there is none to tell you. Things are awful dull here now. Papa left this morning for Battleford. He is to be away a fortnight and it is just dreadful lonesome when he is away. The weather is abominable — cold and rainy all the time and the mud — Oh dear me! You don't know what mud is down there.

I am sitting writing to you with the cat in my lap. It is a dirty black

horrid little beast but it's the only thing I've got to pet so I am kind to it.

Give my love to your mother and remember me kindly to your father and the boys. Give my love to Lillie[13] and Minnie[14] when you see them and tell them I often think of them. Write me often dear Penzie for I am very very lonely and homesick and am half-crying most of the time when I'm alone. Good-bye darling. Love and kisses unnumbered [sic] from your

*own loving
Maud*

P.S. I guess I'll go home next summer all right. Papa says he will try to go. So we'll see each other yet but oh it seems such an awful long time to wait till then.

[1]Olive Ebby	:	Music teacher in Cavendish. Lucy Maud took voice and instrumental lessons from her.
[2]Miss Gordon	:	Hattie L. Gordon. She taught in Cavendish School in 1889-1890. She held a second class license and taught 45 pupils, one of whom was Lucy Maud. She also taught from 1890 until 1892. Lucy Maud dedicated *Anne of Avonlea* to her.
[3]Lucy (Macneill)	:	John Franklin Macneill's daughter, Lucy Maud's first cousin.
[4]Bessie Fraser	:	She was the daughter of William Fraser. She lived on the Mayfield Road near St. Ignatius School
[5]Fauntleroy	:	Penzie's cat.
[6]Minnie (Toombs)	:	Penzie's sister, married to Lorenzo Toombs. William Toombs, their son, has the home today.
[7]Rollings	:	John Rollings who lived at Rustico Harbor.
[8]Rogerson	:	Friend of Lucy Maud and Penzie. He worked in North Rustico.
[9]Cedar Swamp	:	Parlour game in which participants walk out from the corners of the room and kiss the person they meet in the centre of the room.
[10]Quill (Rollings)	:	Aquilla John Rollings, Penzie's current boyfriend.
[11]Betty Bulman	:	Reuben Bulman's daughter from New Glasgow.
[12]John Rollings	:	He owned a large merchandise and hotel business at Rustico Harbor.
[13]Lillie (Bernard)	:	Penzie's sister, married to Oliver Bernard.
[14]Minnie (Toombs)	:	Penzie's sister, married to Lorenzo Toombs.

Monday
Nov. 3rd
1890

Eglintoune Villa
Prince Albert
N.W.T.

My own dearest Penzie
 I am only too glad to take up my pen once more to acknowledge the receipt of your delightful letter a week ago. I cannot tell you how glad I was to get it and how it brightened me up. I think of all the letters I get your's are the ones most welcome and when among my batch of letters I see one addressed in your handwriting it is the one I snatch up and open first.
 But even letters are a poor substitute for the sender and nothing would make so perfectly happy as just to get my arms around you and have one of our good old-time talks. And we will have them too for papa says he is pretty sure of going down to the Island next summer and if he does of course I go to and I bet you when I once get there I stay there. I tell you Pen if you know when you are well off you will stick to dear old Cavendish. I've seen a good many places since I left home and I tell you I haven't seen one prettier or nicer than Cavendish and the day on which I set foot in it once more will be the happiest one of my life.
 The other day in school when I was too lazy to do my sums I scribbled a lot of rhymes on my slate and as they were about you I shall send you a copy of them in your letter. The "cottage" described is your house and the "wildwood rose" is you yourself dear Penzie. I done you up pretty well didn't I? But you mustn't get conceited over it. But honour bright now Penzie you mustn't show it too [sic] a soul. If you do I'll never forgive you.
 I often think of that night when we went for the cows and got caught in that awful rain shower and whenever I look at that tear in my dress I take a hearty laugh — that is to say as hearty a laugh as I can take at all when I feel so lonely and homesick all the time. And my laugh often ends in a sigh and even tears as I think of all the happy times we have had together. And I hope we will have many more yet before you and H.T.[1] go off together.
 Give Lillie[2] and Minnie[3] my warmest love. I think if Lillie calls her baby Cora May she will have a very pretty name indeed and I admire her choice very much.
 How is your mother? I hope she is well. Give her my love. And I suppose it would be high treason to forget Fauntleroy[4] who is I hope grow-

ing well and learning his letters nicely. I have got Kate's[5] kitten curled up in my lap at this minute purring away like mad. It is a dirty black little thing and not very nice or pretty but I pet it because there is no other around and because I am so lonesome and it is the only thing that I have for company for Edie Skelton[6] the girl who was staying here has gone home and I feel like a lost sheep. She was such a nice girl and we always contrived to have a little fun and comfort each other in our homesick hours so I miss her awfully and oh dear I wish I'd never left home or rather that I'd gone back with Grandpa Montgomery.[7]

Do you go to prayer meeting often and do you ever have any fun at it. I suppose prayer meeting is scarcely the place to have "fun" at but we always managed to get considerable didn't we. I'm rather afraid that we thought more of our own designs than of what poor Mr. Archibald[8] was saying.

I am pegging away at school as usual and I tell you it is slow work. I hate it and I heartily wish Mr. Mustard[9] and his High School were in Venezuela. Not but what he is a nice enough teacher but then the school itself is so detestably dull. There is no fun to brighten it up nothing but the dull routine day after day just the same of tedious lessons and drills. I am ready to cut my throat in despair.

This is a pretty blue letter but I feel blue tonight and in no mood for fun. So you will have to excuse me this time, dear, if this epistle is not very interesting. It is pretty tough writing when you have no news and there is — has nothing happened worth telling you of. Wough! the room is getting cold as a barn for the fire has gone black out — so I think I will have to draw this to a close. I send you piles of love and kisses and write me often for a letter is such a comfort.

> I remain
>
> your loving friend
>
> Maud.

[1]H.T.	: Hammond Toombs: he lived on the North Rustico Road between Cavendish and North Rustico opposite Lorenzo Toombs. He was an uncle of Lorenzo's. He married Flora Woolner.
[2]Lillie (Bernard)	: Penzie's sister, Mrs. Oliver Bernard.
[3]Minnie (Toombs)	: Penzie's sister, married to Lorenzo Toombs.
[4]Fauntleroy	: Penzie's cat.

⁵Kate (Montgomery) : Lucy Maud's little half sister.

⁶Edie Skelton : Lucy Maud's roommate at Hugh John Montgomery's home.

⁷Grandpa Montgomery : Senator Donald Montgomery, Lucy Maud's paternal grand-
father.

⁸Mr. Archibald : **Rev. W. P. Archibald: He was minister of the Presbyterian
Church in Cavendish for 18 years — 1878-1896.**

⁹Mr. Mustard : J. M. Mustard, Lucy Maud's high school teacher and prin-
cipal.

MY FRIEND'S HOME

There is a cottage far away from here
Where I would give the world and all to be
Divided from me by three thousand miles
Of mountain, prairie, forest, lake, and sea.

'Tis not my home though almost 'tis as dear
And next to home the fairest spot on earth
That little cottage in a far-off land
In that blue-circled isle that gave me birth.

Far from that spot —far far from all I love,
Far from my blue-skyed breezy island home
'Neath cold gray skies, 'mid faces strange and new
A stranger in an alien land I roam.

That little cottage! Ah, I see it now
As last I saw it in fair summertide
When all things blushed in gracious leaf and bloom
And birds sang songs each dreaming brook beside.

Above it bent tall branching willow trees
Half-hiding it within their green embrace
While robins rested in their cool sweet shade
And every leaf swayed with unlanguished grace

I see the garden cool and dim and sweet
A wilderness of flower and shrub and tree
Where often with my friend I gayly ran
In all the innocence of girlhood's glee.

I see the swaying field of rippling grain —
A golden sea in August's rosy hours
Where shadows chased each other all the day
And cornflowers bloomed amid the tasselled bowers.

I see the pasture fields with clover white
Where saucy lambkins played their evening games
Where calm-eyed cows in peace and plenty fed
At eventide all answering to their names.

I see the winding lane beneath the shade
Of graceful birch and rustling poplar trees
Where in the sunset dusk the cows were milked
While birds and leaves sang choral harmonies.

And there she blooms my own sweet wildwood rose
Her sweetness and her beauty but for few
And all the lovelier that her blushing grace
In Nature's freshness and concealment grew.

My dearest friend! As when I saw you last
I see you now in all of girlhood's grace
Though others claim to wealth and higher rank
None — none could justly claim a fairer face.

A queenly little head where silken bright
Luxuriant gold-shot auburn ringlets clung
And o'er a cloudless brow of purest white
In bright mischievous sunny fringes hung.

And eyes that now were mirrors of the sky
Soft, thoughtful, tender, smiling, yet so bright
Now darkening orbs of flashing liquid fire
Now silvery wells of sparkling mirthful light.

Cheeks were the rose alternate blushed and paled
Through their thin covering of transparent white
A dimpled chin where love himself might hide
And teeth like moistened rows of pearly light.

Lips like a curving trembling Cupid's bow
Dimpled and glowing as a dewy rose
Now rippled o'er with sunny mirthful smiles
Now chiselled sweetness in their calm repose.

Her slender form whose soft and graceful curves
A sculptor's highest ideal would fulfil
Her laugh like some clear chime of ringing bells
Her voice — the call of some untramelled rill.

But even had her face and form been plain
Her spirits' beauty would have made them fair
The sweetness of her soul shone in her eyes
And scorn and anger ne'er were mirrored there.

The gracious sympathy the kindly tact
The loving sweetness that her face expressed
And though a lovely face is to be praised
A lovely spirit is by far the best.

My own dear friend! though far away from you
Oft in my dreams thy fair sweet face I see
And in a moment cross the continent
That intervenes between my home and me.

And once again I walk with you beside
The wave-kissed seashore on bright-summer days
Or roam among the spruce and maple groves
Or gather berries in the pasture braes.

Or walk the quiet lanes on summer eves
When all sweet sounds were blended into one
When gentle breezes kissed the sleepy flowers
And birds flew westward at the set of sun.

And all the manifold delights and joys
Of those sweet bygone days whose every hour
Seemed full of promises and rosy hope
When Youth's bright bud was bursting into flower.

I wake! and find myself alone — alone
In this far land to me so strange and new
I wake to bitter tears and longings vain
For home for friends and, dearest one, for you.

So in my bondage here I sigh and fret
For that sweet time when I shall say good-bye
To this cold land and hasten back again
To my dear hillslopes and my own blue sky.

This is the hope that brightens all for me
The time must someday come when I shall go
Back to my home my friends my loves my hopes
And all the fair sweet scenes I used to know.

And when dear friend I clasp your hand once more
Hopes and ambitions will again be sweet
My happy gladness will return again
In that sweet future when once more we meet.

Lucy Maud Montgomery

Tuesday
Dec. 2nd, 1890

Eglintoune Villa
Prince Albert
N.W.T.

My dear old darling
　　I got your letter week before last and it was as welcome as your letters always are. I must say it for you that you are a splendid hand to write regularly. Your letters always come to hand at the expected time. First of all I must thank you ten times over for that gum. It was so sweet. I hadn't got any for a long time so it was doubly delicious. You always do get such lovely-flavoured gum.
　　Well as I have said I got your letter and on reading it I was much amused to think that in the letter I had written a week before to you I had put a good deal of stuff nearly the same as what was in yours — all about our walk to Lily's[1] and to John McKenzie's[2] and the rest of it. Wasn't it funny we should both write about the same things before we saw each other's letters.
　　Don't I wish I was down home to go and help you quilt your quilt. Wouldn't we have fun though. It makes me sigh to think of it. Now see here Pen I am going to give you a little scolding. I think you are too awfully mean for anything to keep teasing me eternally about that detestable pig Nate Lockhart.[3] You know I hate him and if you ever mention his name in your letters again I'll never write to you again. So there. Now isn't that an awful threat. But I'm in earnest.
　　Oh you dear old soul wouldn't I like to see you to-night and get my arms around you and have a long talk about old times. Last Sunday was my birthday and a pretty lonesome one it was. It wasn't like a birthday at

all, just exactly like other days only perhaps it was a little duller. Do you remember the time we had at my birthday six years ago (dear me it doesn't seem a day does it) when you and Lucy[4] and Amanda[5] were at our place and it rained so hard you had to stay all night. And how sick Amanda was and how we kept racing out to the kitchen all night for drinks for her and apples out of the barrel. And how grandma[6] came in and caught us when we were up making the bed by moonlight. And before we went to bed too the fun we had playing blind-man's buff out in the kitchen. And sleigh-riding night too, when you and Russell[7] and I hid behind the dykes and saw Ewen McKenzie[8] pass with a pig between his legs. Oh haven't we had a lot of fun together though. And we'll have some more yet too so cheer up darling and don't be lonesome for as the old song says

> *Summer will come again*
> *Roses will bloom again*
> *Friends will all meet again*
> *By and by.*

And we will meet again when roses bloom next summer I hope.

Well we've got winter up here now and no mistake. All through November we had charming weather warm clear and bright but on my birthday night it came up a snowstorm and when we got up in the morning everything was froze to pokers. Oo - o - o - o - o! (Fancy a dozen shivers now) and hasn't it been cold since.

Why does your mother never send me any message. I hope she hasn't forgotten me altogether. Give her my love and tell her I think of her and all my friends very often.

How is Fauntleroy[9] coming on? Give him a kiss and a pat or two for me and tell him to be a good cat and catch lots of mice. We have a dirty little black thing here but it never does anything but take fits. It isn't a cat at all in my opinion. Katie[10] pretty near mauls the life out of it. She just worships it and yet she is so cruel to it, sits on it, puts it on the hot stove and dear knows what not.

It is awful lonesome here tonight as mamma is out to a party and Papa has gone down town to the station house. I expect a letter from you to-night and three or four more but I don't suppose they will be here till the middle of the night as the train never gets in till late.

Well you dear girl I must say good bye now for I have written five letters and I am getting awful sleepy. So I guess I'll stop scribbling for this time. Lots of love and kisses from

Your loving friend

Maud.

[1]Lily's (Bernard)	:	Penzie's sister, Mrs. Oliver Bernard.
[2]John MacKenzie	:	John MacKenzie (1815-1891), married Margaret Mary Woolner (1822-1919). He lived at the east end of Cavendish on the road to North Rustico.
[3]Nate Lockhart	:	A classmate of Lucy Maud's at Cavendish school. "Me thinks the lady doth protest too much." Lucy Maud liked Nate Lockhart. He was her first serious boyfriend. He wrote to her in Prince Albert. He became a lawyer and practised in Estevan, Saskatchewan.
[4]Lucy (Macneill)	:	John Franklin Macneill's daughter, Lucy Maud's first cousin.
[5]Amanda (Macneill)	:	Amanda Jane Macneill, Lucy Maud's close friend. This close friendship did not last beyond adolescence. Lucy Maud claims that she became a new and unrecognizable Amanda.
[6]Grandma (Macneill)	:	Mrs. Alexander Macneill, Lucy Maud's grandmother.
[7]Russell (Macneill)	:	Penzie's youngest brother. He was a good friend of Lucy Maud. He married Margaret Warren, and had two children, Ralph and Clive.
[8]Ewen MacKenzie	:	Son of John MacKenzie and Margaret Woolner. He was born in 1854 and died in 1945. He married Margaret Bell in 1881.
[9]Fauntleroy	:	Penzie's cat.
[10]Katie (Montgomery)	:	Lucy Maud's half sister.

Tuesday
Dec. 16th, 1890.

High School
Prince Albert
N.W.T.

My own dearest love
As you will see by heading I am at present in the dreadful place they call the high school. It is recess and Mustard[1] is scowling at his desk and the boys are rowing and quarrelling around me upsetting desks raising dust and making such a noise I hardly know what I am writing. But noise or no noise I must try to answer your last letter for I won't get time again. Well I received your letter a week ago and it isn't any use telling you how glad I was to get for you know all that well enough now so I will just start right in to answering it.
So poor Stanton [2] has gone has he. I suppose he is going out where Robbie[3] is. Did Bob McKenzie[4] go too. I shall not be able to dance any

reels with Stanton this winter and you won't either.

I am glad Fauntleroy[5] is growing well and I hope he will turn out a fine gentleman. So you want me to give you a name for your new cat. Well all right but as you did not tell me what sex it belonged to I am rather at a loss. If it is a lady call it Firefly and if it is a Tom call it Roswal or Lufero whichever you like. Is it the same colour as Fauntleroy?

Papa had to kill our cat because it took fits. I was awful sorry. He was not extra pretty or smart but he was an affectionate little creature and he and I used to sit together in the evenings. He seemed just like a real being and I miss him so. I used to talk to him about dear old Cavendish and all my chums and everything. He was great company for me and now he is dead. I feel lonesomer than ever. Oh dear I do so wish I was back on the dear old Island. We Sunday school folks are busy practising for our concert which is to come off to-morrow week. I think it will be pretty good. We have collected $140 for our Christmas tree. Pretty good isn't. A hundred and forty dollars ain't picked off every gooseberry bush. I shall be heartily glad when our concert is over for I am well sick of tramping to practises every night even if we do have a good deal of fun. We are going to have the same dialogue that we had down at our concert at home the "Census Taker". It makes me so homesick when we are practising it for I can't help thinking of the schoolmates who took part in it with me before and all the fun we had while practising it.

We have an awful large Sunday school here but it isn't a bit interesting though. All the scholars nearly are kids between six and seven and of course awfully stupid. I teach a class of ten little girls and I do have most awful times with them. It seems impossible to do anything with them. They never know a single thing about the lesson not even where it is and they never bring any Bibles or anything. I hardly know how to get along sometimes. And the worst of it is you can't get them to do any better no matter what you say or how hard you try. I wish I could see you today and have a good long talk over old times. Wouldn't our tongues go though. When we see each other again won't we have a jolly time though. Do you ever go to the shore to pick mussels now? Don't you remember poor old Gyp[6] and the hole in the rock. Well well poor Gyp is only a memory now as well as a great many other things. Oh you dear darling girl how I would love to see you now. You can't tell how much I long to see you and have a talk with you. I am always so glad to get your letters and after I have read each of them about 20 times I put it away in a pretty little box at the bottom of my trunk and every now and then I read them all over again. Well I see Mr. Mustard is going to ring the bell so I will have to stop writing to you and turn to work not half so nice I can tell you. Good by darling. Lots of

Penzie Maria Macneill
(Courtesy Dr. Stuart Macdonald)

Charles and Mary Buntain Macneill's Family: (Front seated L-R Chester Stanfield, Lettie Macneill, Lorne Macneill; second row, L-R Margaret Warren, Penzie Macneill, Leila (Lily) Macneill, Mary Buntain, Minnie Macneill, Bessie Stevenson, Mae Hooper; third row, L-R Russell Macneill, William Bulman, Oliver Bernard, Charles Macneill, Lorenzo Toombs, Robert Macneill, Albert Macneill, Alex Macneill)
(Courtesy Alvah and Margaret Macneill)

John Franklin and Anna Maria Macneill
(Courtesy Mrs. Ernest & Mrs. John Macneill)

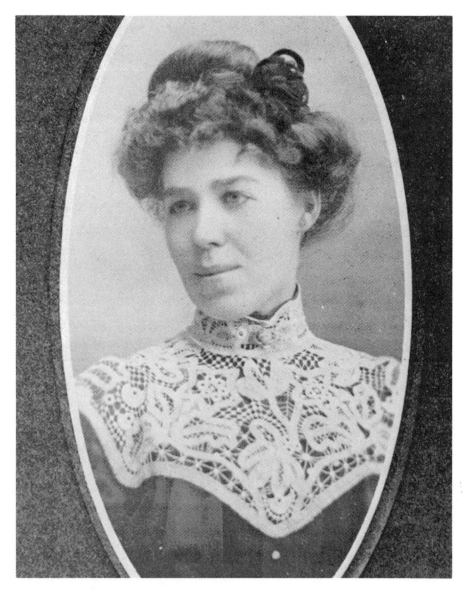

Lucy Macneill, wife of Benjamin Simpson
(Courtesy Mrs. Ernest & Mrs. John Macneill)

Penzie Macneill's Parents' Home
(Courtesy Ralph and Irene Macneill)

Amanda Macneill's Parents' Home
(Courtesy Dr. Stuart Macdonald)

love and kisses. I close by wishing your mother and yourself a Merry Xmas and a Happy New year.

Maud

[1]Mustard : J. M. Mustard, Lucy Maud's principal and high school teacher.

[2]Stanton (Macneill) : Stanton Macneill, George Macneill's son. He lived two farms east of Penzie's father, Charles Macneill.

[3]Robbie (Macneill) : Robert Buntain Macneill, b. May 30, 1865; he was a brother of Penzie Macneill. He moved to the West and eventually settled in Portland, Oregon, where he owned and operated a prune farm.

[4]Bob MacKenzie : Robert MacKenzie, son of Angus MacKenzie and Emma Jane Hooper. He was born in 1864 and died in 1952. He married Jennie Stevenson.

[5]Fauntleroy : Penzie's cat.

[6]Gyp : Alexander and Lucy Woolner Macneill's dog.

Last two pages of an undated letter: First two pages missing: Written between December 25 and December 31, 1890.

at the door with a slip of paper bearing the words "with Xmas wishes for Miss Montgomery from a friend." Who the "friend" is I can't imagine. All of Mr. McTaggarts[1] say it wasn't them and who else it could be I don't know. Dear me I just dread going to school again this week. Those boys are such a rude set. They gave me not a minute's peace for the last fortnight because one day at recess I was writing to cousin Frankie[2] and Morrison McKoy[3] (the mean little sneak) looked over my shoulder and seeing "dear Frank" at the beginning of my letter went and told all the rest "Miss Montgomery is writing to her fellow and his name is Frank Macneill" and since then I haven't had a quiet moment. They write his name and mine all over the walls and blackboard scribble it over my slate and put notes in my desk signed with his name. Poor little Frank! It doesn't do any good for me to protest he is my cousin. It only makes them worse so I don't say anything but submit in silence to the torture. They are always at Annie McTaggart[4] about something too and contrive to keep us both in misery.

Oh dear me! I am just as homesick and lonesome as ever and particularly so to-night. Oh don't I wish I could see you you dear old darling. I had such a lovely dream last night and I was so disappointed when I found it was "only a dream." I thought I was in Montana[5] picking berries and you came back and I thought our poor old Gyp[6] was with you and you were talking to him about the hole in the rock and the time he followed us. But you didn't know me and refused to believe it was me. You said Maud Montgomery had black eyes and yellow hair and wasn't a bit like me but after awhile you became convinced and we were just having a lovely time when alas! I woke up and there I was far far enough away from you and Montana.

Have you been to the Hall yet and have they had any concerts there yet. I wish I was home to go. Give my love to your mother and the girls when you see them and kiss Lily's[7] baby for me. I suppose it is too late now to wish you a Merry Christmas but not too late to wish you a very very happy New Year and may the New Year re-unite us is my prayer.

Ever your loving friend

Maud

[1]Mr. McTaggarts	: Family of John McTaggart; this family lived next door to the Montgomerys in Prince Albert.
[2]Frankie (Macneill)	: Son of John Franklin Macneill and Lucy Maud's first cousin. He was born in 1882 and died in 1963. He married Margaret McQuarrie. He lived in St. John, New Brunswick.
[3]Morrison McKoy	: A schoolmate of Lucy Maud in Prince Albert.
[4]Annie McTaggart	: John McTaggart's daughter. She was a stepsister of Lucy Maud's mother, Mrs. Mary Montgomery.
[5]Montana	: The name given to 14 acres of woodland that belonged to Charles Macneill, Penzie's father. It is still called Montana by the present owner, Ralph Macneill, a grandson of Charles Macneill.
[6]Gyp	: Alexander and Lucy Macneill's dog.
[7]Lily (Bernard)	: Penzie's sister, Lily, had a new baby. Her name was Laura. When she grew up she married Granville Buntain.

Tuesday
Jan. 18th, 1891

Eglintoune Villa
Prince Albert
N.W.T.

My own darling friend
 I received your lovely letter over a week ago and as I was beginning to get uneasy at your long silence you may be sure it was welcomed even more eagerly than usual if that is possible. I am expecting a letter from you to-night but I do not think I will get one as the mails have been so irregular crossing the straits. Isn't it dreadful? You seem to be having pretty tough weather down there. Well we are having a delightful winter here but I could put up with bad weather or anything else if I were only home again. I hate Prince Albert more every day I stay in it. And going to school gets worse every day. Annie McTaggart[1] has left here and gone to teach school out at Lindsay and I am left all alone now in school with those rough boys. It is horrid. I just sit there day after day never a soul to speak to never a bit of fun. And it's just the same out of school too. You may think it is lonesome in Cavendish but if you were out of it for awhile you would change your opinions. At least I have.
 Lucy[2] tells me they have started a division in Cavendish. Will you be joining. Amanda[3] has, hasn't she. Oh if I were only home I would join too and you and I could go together and have lots of fun. But never mind "There's a good time coming" and when I do get back we will go in for things lively and make up for lost time. But sometimes I almost despair of getting home next summer even and the thought fairly kills me. But I can't give up hope and if I can't get it won't be my fault. Oh I couldn't live another year in this place if I were paid a thousand dollars an hour.
 Have you been to singing school yet? Yes if I were home (oh that horrid "if") you and I would go and have piles of fun. So Rogerson[4] is still in Rustico. Do you remember when he and I were walking the cedar swamp how he asked me if I liked candy and I thought he said herring and how you all laughed so when I explained. Is that poor cat alive yet? I never can believe it possible that it was in the sleigh with us all the way up there. Unless do you suppose one of those boys or perhaps Letty[5] herself might have had it holding all the time and never let on. We never thought of that but I believe that must have been the way of it.
 Do you ever try to count stars now. I have been trying ever since November and I got them out just a fortnight ago. And alas! after all my

*trouble the first fellow I shook hands with was an engaged fellow who was
married the next night. His name was Cann[6] and he married Miss Fannie
Mair.[7] I was at the wedding. It was a very swell one. They were married
in the Episcopal church at 7 o'clock in the evening. At a quarter to seven
Cann and his best man walked in and sat down by the altar. Soon after
the organist struck up the wedding march and the bridal party entered
the bride leaning on the arm of her father. She was beautifully dressed in
white satin and wore a veil of tulle fastened on her head by orange blossoms
and falling all over her like mist. She was attended by two bridesmaids one
dressed in blue silk the other in pink satin. Then we all drove to Mr.
Mair's[8] and had a ball. I tell you some of the dresses were pretty. Mrs.
Sproat[9] wore white silk lace over rose pink silk. Mrs. Agnew[10] wore white
lace over cardinal plush. Miss Northgraves[11] wore silver tulle over pale
blue crepe. Mrs. Jardine[12] wore scarlet tulle over a silver satin. Mrs.
Scott[13] wore white lace over lemon crepe. Mrs. McCarthur[14] wore black
lace over white silk and oh ever so many more and of course all had low
necks and short sleeves. But you will be getting tired of all this nonsense
and I know this letter is not a bit interesting but I've nothing else to tell
you. If we could get together I could find lots though you bet. Oh Pen
you don't know how I long to see you. It is dreadful to be among strangers
all the time. I hope you never will be in the same state but if you ever are
I shall know how to sympathize with you.*

*Well darling write soon and tell me every bit of news. Give my love to
your mother and remember me to Uncle Charles[15] Albert[16] Alex.[17] Russell[18]
and the girls. Lots of love and kisses for yourself from your devoted friend*

Maud

[1]Annie McTaggart	:	Daughter of John McTaggart, Dominion Land Agent in Prince Albert.
[2]Lucy (Macneill)	:	John Franklin Macneill's daughter, and Lucy Maud's first cousin.
[3]Amanda (Macneill)	:	**Amanda Jane Macneill, daughter of William and Christy Ann MacNeill.**
[4]Rogerson	:	Friend of Lucy Maud; he worked in North Rustico.
[5]Lettie (Macneill)	:	Lettie Macneill. She married John Milton MacKenzie.
[6]Cann	:	Edward J. Cann, who came to Prince Albert during the 1885 Rebellion and stayed. He operated a book and stationery business which prospered.

[7]Fannie Mair	:	She was a daughter of Charles Mair Esq., he was the "famous" Charles Mair, instigator of the Riel Rebellion of 1869, the author of *Tecumseh*, and a large and successful merchant in Prince Albert. He was one of the pioneers in the founding of Prince Albert, arriving there in 1877.
[8]Mr. Mair's	:	Charles Mair's beautiful residence on the outskirts of Prince Albert.
[9]Mrs. Sproat	:	Wife of Lt. Col. R. Sproat, Registrar of Lands in Prince Albert. He commanded the Prince Albert volunteers during the North-West Rebellion of 1885.
[10]Mrs. Agnew	:	Wife of T. G. Agnew, prominent merchant. Lucy Maud dedicated *Anne's House of Dreams* to Laura Pritchard Agnew, who married his son, Andrew.
[11]Miss Northgraves	:	Daughter of G. D. Northgraves, watchmaker and jeweller, and caretaker of the courthouse and jail in Prince Albert.
[12]Mrs. Jardine	:	Wife of Dr. Robert Jardine, minister of St. Paul's Presbyterian Church.
[13]Mrs. Scott	:	Wife of Thomas Scott, a successful cattle rancher outside Prince Albert.
[14]Mrs. McCarthur	:	Wife of James McCarthur, owner of an extensive sheep ranch outside Prince Albert.
[15]Uncle Charles	:	Charles Macneill (1832-1908), Penzie's father.
[16]Albert (Macneill)	:	Albert Walter Macneill (1860-1928), Penzie's brother. Lorne Macneill of Cavendish is a son. He also had a daughter, Mrs. Milton McKenzie. Lucy Maud maintains Albert was the neatest farmer in Cavendish.
[17]Alex (Macneill)	:	Alexander Charles Macneill (1870-1951), Penzie's brother. Lucy Maud and Alex kept company for a few years. The relationship, according to Lucy Maud, was merely platonic.
[18]Russell (Macneill)	:	Russell Herbert Macneill (1874-1950), Penzie's brother.

Tuesday
Jan. 27th, 1891

Eglintoune Villa
Prince Albert
N.W.T.

My own dear friend
I am very glad to be once more able to say I got a letter from you and of course it was very very welcome indeed as all your letters are. It came Saturday night along with seven others — eight in all so you may guess I was

up in high C about it. Oh Pen love do please get your photo taken if it's only a tin-type and send it to me. I'm just dying to get a glimpse of you. To be sure I have your old photo but it is not like you now and I want one that is. It would cheer me up so much in my lonely and homesick hours to have a picture of my dear friend to look at.

Well I am awfully busy these days preparing for a swell social which is to come off in aid of our church Friday evening. Among other things I have to recite "The Polish Boy". It is a splendid piece if I can only do it well. I declare my knees are stiff from the energy with which I have practised the kneeling scene in it. I hope we will have a good time at our social. We have the concert first you know and then refreshments.

Prince Albert is a little livelier now than before but it could be lots more yet without hurting itself. Mr. Fish¹ one of my gentleman acquaintances took me to an entertainment up at the barracks last Wednesday night. It was just splendid. Coming home Mr. Fish's horse took fright at a clothes line and ran away. Scotts but I was scared! At last the cutter upset and out we tumbled. But luckily we were not a bit hurt and the horse stopped then and we got in again and got home all right not a bit the worse.

So you went around with the mission card! Did you have to climb any brush fences or jump any brooks or get nearly lost in Angus McKenzie's² field. If I had only been home we would have gone together and had any amount of fun I'll be bound. But alas! I wasn't home and don't know when I will be. Oh Pen don't you wish we could just be together for even one night and have a long talk over old times. I know I do. I think if you were only here now (for I am all alone in the house) sitting by the stove with me and chatting in our old time way I would be perfectly happy.

How is Fauntleroy³ getting on? And the other cat too. You did not tell me which of the two names I suggested you had decided upon. Tell me in your next.

Oh you need not be afraid I am getting too saintly even if I do have a class at Sunday school instead I often feel like swearing or doing something dreadfully wicked. I had a class of girls at first but now I have changed to little boys and oh mercy such a horrible time as I have with them. For impudence and stupidity they take the cake.

If there is so much ice in Cavendish it must be good sliding. There is nothing of that sort out here and I wish there was. My legs often ache for a good slide. Do you remember the night Lucy⁴ and I went down and came up with you and what fun we had sliding. You and I used to have awful times getting to prayer meeting. Either we never got there or else when we did there was no meeting. Don't you mind the time you were up at our place and we went across our field and how it blew and what a shocking

time we had climbing the fence. And another rainy night too when Lu and I went down to Robertson's[5] gate with you and my bonnet blew off in the mud and we saw Toffie[6] going to spark Hattie.[7] Oh those were happy days.

Well I must write to Lucy and Clara McKenzie[8] yet to-night so I think I will have to end this letter. Be sure and write me a good long letter next time and tell me all the news. Give my love to your mother and remember me to your father and the boys. Ever I remain

Your loving friend

Maud

[1]Mr. Fish
: Walter R. Fish was a young man who moved to Prince Albert from Winnipeg. He operated a large general store in Prince Albert. He later became a town councillor (1892). He was fond of Lucy Maud and frequently dated her.

[2]Angus MacKenzie
: Son of Alexander MacKenzie. He was a brother of John and Ewen MacKenzie. He married Emma Jane Hooper. He had three sons and two daughters. He lived in the east end of Cavendish.

[3]Fauntleroy
: Penzie's cat.

[4]Lucy (Macneill)
: John Franklin Macneill's daughter, and Lucy Maud's first cousin.

[5]Robertson
: Henry Robertson: his farm was equidistant between the farms of Alexander Macneill and Charles Macneill.

[6]Toffie (MacKenzie)
: Theophilus MacKenzie (1843-1915), son of John B. MacKenzie and Margaret Mary Woolner. He apparently did not win Hattie's heart. He died unmarried.

[7]Hattie (Gordon)
: Hattie L. Gordon; she taught in Cavendish between 1889-1892.

[8]Clara MacKenzie
: Daughter of Angus and Emma Jane MacKenzie. She married Richard Stevenson. She was born in 1876.

Tuesday
Feb. 10th, 1891

Eglintoune Villa
Prince Albert
N.W.T.

My own dear chum
 I was the happy recipient of a welcome letter from you last Sunday and you may be sure I was very very glad indeed to hear from my dear old friend of "auld lang syne" with whom I have had so much fun in bygone days and hope to have more too some happy day in the future — though I am sorry to say that future seems further off than ever.
 And so you are having good fun down there. I only wish I was there to share it. But P.A. is livelier now than it has been and I have a good deal of fun. I must tell you about our concert. We had a boss time. I recited "The Polish Boy" and if I believed all the pretty compliments paid me I'd be too vain for anything. Such a puff as they gave me in the paper.
 Last night Mary McKenzie[1] and I went up to the barracks to a toboggan spree. Oh such a lark as we had. Tobogganing is grand I tell you. Coasting is nothing to it. But I'm not going back on coasting though. You and I used to have good fun coasting didn't we so I will stick to it. But tobogganing is splendid. Whew but it takes your breath away when you are spinning down the "chute" as they call the sliding place.
 Since I last wrote to you I have a new relation in the shape of a little brother[2] a fine big boy who keeps us all busy. Mamma's cousin Mary is staying with us when mamma is sick. She is a splendid girl and you bet she and I have No. 1 times. She looks awful like Winnie McLeod[3] and is a great girl for beaux. She has two or three calling on her every night. I've got a sweet little fellow up here but you mustn't tell. He is very shy though but then he is so nice and pretty.
 I like P.A. a little better now but I'm very homesick very very often and you bet I often have good homesick crys. Oh how I would love to see you all no words can say. Wouldn't it be splendid if I could pounce in on you some evening and we'd play dominoes and "keep your temper" in the parlour and go to sleep in the dear cunning little bedroom where we've slept so often and had such happy chats or else go out and coast by moonlight. Do you mind the time you and I and Russell[4] hauled the big wood sleigh up to the top of the field and came sailing down in her? And the fun you and I had coasting with that dog "Watch"[5] that was at your place. Oh I shall never never forget it. How often in my dreams do I see the sunny fields

and beautiful groves where you and I have roamed so often.

I dreamed last night I was home and you and I were back picking berries in that field where we were the last time I was down. But oh you had changed so much I thought. Your hair and eyes were black and you would hardly speak to me and kept muttering away to yourself about "not lowering yourself to talk to such a person."

How is poor old Caroline McNeill?[6] Amanda[7] said once a long while ago that she was very sick but she never said a word about her since though I have asked her several times.

Have you been down to Minnie's[8] and Lily's[9] lately. Give them my love when you see them and tell Lily to call her baby after me.

Do you remember the time you and I were in Laird's Woods[10] eating gooseberries and I got stuck trying to crawl under the fence. I often laugh when I think of it.

High School is just the same as ever dull and prosy. There is never any fun and I often feel half-desperate. It gets so stupid and horrid. Mustard[11] is a fool of a teacher and he and the boys are everlastingly rowing. Sometimes they have regular fights. Well I guess I must scamper off and nurse the baby. I don't like the job a bit for I hate minding babies but it "has ter be did"! So good bye sweet for this time. Write me a good long letter next time for it will do me more good than anything else.

Ever your loving chum

Maud

P.S. Remember me kindly to your father and mother and the boys.

[1]Mary MacKenzie	:	Mary was a first cousin of Mary Ann Montgomery, Lucy Maud's stepmother. Mary later married G. R. Stouvel, a dental surgeon in Prince Albert.
[2]Brother	:	Donald Bruce, son of Hugh John and Mary Ann Montgomery, born January 31, 1891. He was Lucy Maud's half brother.
[3]Winnie McLeod	:	Daughter of James McLeod of Bay View.
[4]Russell (Macneill)	:	Penzie's brother, Russell (1874-1950).
[5]"Watch"	:	Charles Macneill's dog.
[6]Caroline Macneill	:	Caroline Macneill (1822-1898); she was a daughter of Malcolm Macneill and Sarah Campbell. She was a sister of Amanda Jane Macneill's father and thus, Amanda's aunt.

[7]Amanda (Macneill)	: Amanda Jane Macneill, daughter of William and Christy Ann Macneill.
[8]Minnie (Toombs)	: Penzie's sister, married to Lorenzo Toombs.
[9]Lily (Bernard)	: Penzie's sister, married to Oliver Bernard.
[10]Laird's Woods	: James Laird, son of Alexander Laird. He lived on the Mayfield road next to Lucy Maud's Grandfather Macneill's farm. The children spent many hours in the Laird's Woods.
[11]Mustard	: J. M. Mustard, Lucy Maud's teacher.

Wednesday
Feb. 25th, 1891

Eglintoune Villa
Prince Albert
N.W.T.

My dear old Pen
 Your last letter came to hand yesterday morning and you may be sure that it was eagerly welcomed by yours truly. So now I am snatching a few minutes while Mrs. Cassie[1] (the nurse) is eating her breakfast to reply to it.
 I haven't very much news to tell you so don't expect a very interesting letter but "I'll do my best, angels can do no more". Well P.A. is of course in a great state of excitement over the coming elections and both Grits and Tories are raising heaven and earth and a little of the other place too I think to get their man in. Papa is running as Liberal candidate this year and is at present away in Battleford on a campaign. This leaves me commander-in-chief of things so of course I am tremendously busy and have to stay home from school. Mamma is quite well but the baby is very fretful and keeps us all in a fuss.
 I was up at a toboggan frolic on the hill last night. Oh I'd a glorious time. A fellow named Will Pritchard[2] drove me up and we'd a jolly time. It was a lovely moonlight night and we went for a drive away out into the country and when we got back the fun was just beginning. The slide was all arched over and the arches were hung all over with chinese lanterns and we had a big bonfire. It was like a fairy scene. Oh it was such fun to whiz down. I only got upset once. Laura[3] and Katie Fulcher[4] and I consented to go down on Lieutenant Mountain's[5] toboggan. It was so narrow we could not sit square but had to sit all bunched up on our ancles [sic] and as there was no ropes to hold on to we had to hold on to each other. I knew the minute we started we were in for it for their [sic] was some awful bounces on the slide but it was too late. Down we spun with a whirl of

snow in our faces (excuse blots. It was Katie's[6] fault) and a dazzle of col-
oured lights over head till we reached the first bump (or "dip" as it is called).
There was one awful bounce that made us see stars. Over we went in one
grand spill. I was dragged two or three yards and got my neck back and
arms all packed full of snow but I got off easy to what the rest did. Laura
was almost buried in a big bank and poor Katie was bunched up in a heap
with the toboggan on top of her. But the poor Lieutenant fared worst of all
for he fell right in the middle of the slide and a big toboggan with about a
dozen on it ran right over him. Well sir we'd the fun. At ten o'clock we
went up to the barracks had a lunch and a dance and came home after hav-
ing the jolliest old time going.

But with all my fun I'm very homesick yet and oh how I would love to
see you all no words can say. Don't you wish you and I were going berry-
ing in Montana[7] or bringing the cows home in the rain or helping Uncle
Leander[8] row a leaky boat. Oh do you mind that night. The other day in
church the choir sang the hymn "Sailor pull for the shore" and I remember
how Uncle Lea always told us to think of that night when we heard that
hymn sung. And I did think of it and of all the other fine times you and I
have had in the days of "Auld lang syne".

We are having very cold weather up here just now. Feb. has been cold
ever since it came in but that don't stop us from having glorious fun sleigh-
driving, snow-shoeing etc. I wish you were here or that I was with you so
we could have some more of our old romps and go to the shore for mussels.
Give my love to Lily[9] and Minnie[10] and your mother and also to Faunt-
leroy[11] and Firefly.[12] Remember me to your father and the boys and tell
Alex,[13] that I hear he is awfully sweet on Bessie Fraser.[14] I wish him suc-
cess.

Piles of love and kisses to your own dear self from your ever loving old
chum.

<div style="text-align: right">

Lucy Maud Montgomery
Prince Albert
N.W.T.

</div>

[1]Mrs. Cassie : She was the nurse employed by the Montgomerys during
 Mary Ann Montgomery's confinement.

[2]Will Pritchard : Son of R. L. Pritchard, owner of a large cattle ranch outside
 Prince Albert. Will was Lucy Maud's favourite boyfriend.
 They corresponded until his premature death while still in his
 early 20's. Lucy Maud claims if he had lived they would
 not have married even though they exchanged rings. She
 wore the one he gave her until her death in 1942.

[3]Laura Fulcher	:	A friend of Lucy Maud.
[4]Katie Fulcher	:	A friend of Lucy Maud.
[5]Lieutenant Mountain	:	A friend of Lucy Maud. He was stationed with the North West Mounted Police in Prince Albert.
[6]Katie (Montgomery)	:	Lucy Maud's half sister.
[7]Montana	:	Charles Macneill's woods.
[8]Uncle Leander	:	Leander Macneill, son of Alexander and Lucy Woolner Macneill, and Lucy Maud's Uncle.
[9]Lily (Bernard)	:	Penzie's sister, Lily Bernard.
[10]Minnie (Toombs)	:	Penzie's sister, Minnie Toombs.
[11]Fauntleroy	:	Penzie's cat.
[12]Firefly	:	Penzie's cat.
[13]Alex (Macneill)	:	Alexander Charles Macneill (1870-1951). Penzie's brother.
[14]Bessie Fraser	:	Daughter of William Fraser; he lived on the Mayfield Road.

Sunday
March 14th, 1891

Eglintoune Villa
Prince Albert
N.W.T.

My dear old Pen
 For the first time since I came here I have not written to you at the regular time. I should have written last Tuesday but I have good excuses for not doing so. In the first place the baby is so cross. Oh my! he is a terror. One of us has to have him in our arms the whole time. Then we haven't been able to find a servant girl yet. They are awful scarce out here so I have a lot to attend to. Then I have been horridly sick with a bad cold and cough. I am afraid it is the whooping cough which is very prevalent here now. And then owing to the train getting snow-blocked I did not get your last letter till just yesterday. So you see taking all things into account I haven't had much time for letter writing.
 Well we had a splendid concert here on March 11th in aid of the Temperance division. It was the best concert I ever was at I think. We had a

*great time and made 90 dollars by it. I gave a recitation called "The Chris-
tening" and I thought they'd clap the church down. They encored me so
loudly that I had to get up again and recite another piece for them called
the "Other Side". You ought to have seen the puff they gave me in the paper
next day.*

*I believe from all accounts you must have had a jolly time at your bas-
ket social. You got a nice little fellow anyhow but rather small sized. Poor
Amanda!*[1] *she would feel pretty cut up that she didn't get anyone to eat
with her. Didn't poor Miss Gordon*[2] *get an awful fellow. I guess she would
be tearing mad. And poor Sarah Jack!*[3] *oh dear what is the world coming
to when she had to take one. It must have been pretty queer cookery in it.*

Well I hear that you are going into the rodding *business. I presume
you will be Mrs. Rodd*[4] *when I see Prince Edward again. Don't forget to
send me an invite to your wedding and if I am there I'll be your bridesmaid
(that is if you will have me) and if I'm not there I'll send you the prettiest
present I can find.*

*I had a splendid dream last night and when I woke up I almost cried
when I found it wasn't true. I thought I was down at your place and you
and I were going up to Stanley with Geordie*[5] *and oh such fun as we had
on the drive. I remember you had on an immense big sunhat so you
couldn't see to drive Geordie so I had to drive him and oh dear what a
dreadful time I had of it. Oh well it was only a dream and I am so very far
away from you and the scenes of so much fun and happiness.*

*Have you got the lock of my hair I gave you yet. I have yours. Do you
remember that night over at Lu's*[6] *when we measured on the door and poor
Lu bumped her head on that big nail. And my birthday night when you
and I and Amanda and Lu were coming down our stairs in the dark and we
all fell about four steps from the bottom.*

Give my love to your mother and the girls and Fauntleroy[7] *and Firefly.*[8]
*Keep a big share for yourself and be sure and write me right away. I am
always so glad to hear from you you know*

*Ever your loving
friend of other days*

Maud

[1]Amanda (Macneill) : Amanda Jane Macneill (1874-1949), daughter of William
 and Christy Ann Macneill.

[2]Miss Gordon : Hattie L. Gordon, Cavendish school teacher, 1889-1892.

[3]Sarah Jack	: She lived on the Mayfield Road. She was famous for her lack of culinary expertise.
[4]Mrs. Rodd	: Penzie had a boyfriend by the name of Rodd.
[5]Geordie	: Charles Macneill's horse.
[6]Lu (Macneill)	: Lucy Macneill, John Franklin Macneill's daughter, Lucy Maud's first cousin.
[7]Fauntleroy	: Penzie's cat.
[8]Firefly	: Penzie's cat.

Wednesday

April 22nd
1891

My own dear Pen
　　You will see by this small sheet of paper that I am not going to write a very long letter this time and neither I am for I've just finished three long letters already and am so tired I can hardly hold a pen. But I usually write you pretty good long letters so I know you'll forgive me this time dear if I cut my letter rather short.
　　I have still this horrid cold and cough. It seems as if I'd never get well of it. But still I am ever so much better than I was and I think I'll soon be well.
　　We are having lovely weather here. It is just like July. It is so warm we never put on a fire only to cook with and we are wearing our light cotton dresses. The farmers have got the most of their crop in.
　　I think Lillie[1] has got a very pretty name indeed for her baby. What are they going to call it Laura[2] or May.
　　How are your cats? But it isn't much use to ask you for you don't answer half my questions. I should think you might.
　　Oh don't I wish I were home this spring and you and I could go down to the shore to get mussels. Don't you mind all the fun we had the different times we were down. Poor old Gyp[3] and crawling through the hole and losing our boots and stockings and catching hold of flatfish. Often in my dreams I see the dear old shore with its brown rocks and pebbled coves and the blue waters of the sparkling gulf. Oh Pen I hope you'll never know what it is to be as homesick as I am.

*Oh I have such a horrid headache. I can't think of anything to write.
I've been horrid sick all the spring with headaches and everything else.
Have you prayer meetings now and do you go. I suppose you and Mr.
Rodd[4] are having great fun. You needn't say you are not his flame for I
hear you have been going with him all this winter. Ha! Ha! I'm looking
out for an invite to the wedding pretty soon.*

*It is so lovely here now in the evenings after the sunset oh just delight-
ful. I always go out for a walk by the beautiful river but I mostly have to
go alone and how often I wish you were with me. Do you remember the
time we went for the cows and got caught in that awful rain storm and how
we ran through the woods and I fell and muddied all my parasol and you
carried the two hats. Oh dear don't you wish we could live all those happy
times over again. I know I do.*

*I feel as if I'll never get this letter written. I have to swing the baby's
hammock with one hand so that makes writing not very easy. I haven't
been in school for over two months. There are only five going to the High
School now I believe and no girls. So when I do begin to go again it will
be worse than ever for dullness.*

*Oh Pen I feel too sick and blue to write any more. I am ashamed to
send such a miserable letter but really I can't write any more. I know
you'll excuse me this time. Give my love to your dear mother and all and
write soon to your lonely and sick*

<div align="center">

Maud.

</div>

[1]Lillie (Bernard)	:	Penzie's sister, Lilie (Leila), who married Oliver Bernard.
[2]Laura (Bernard)	:	Lilie Bernard's daughter. She married Granville Buntain. She was Penzie's niece.
[3]Gyp	:	Alexander and Lucy Woolner Macneill's dog.
[4]Mr. Rodd	:	Penzie's boyfriend.

*Tuesday
May 12th, 1891*

<div align="right">

*Eglintoune Villa
Prince Albert
N.W.T.*

</div>

*My own dear Pen
I did not write to you last week although it was my regular week for*

*doing so but I'm sure you will forgive me for it since I have written you
pretty regularly ever since I came here. I did not get any letter from you
last week either but I would have written for all that if I had found time
which I could not do as we are awfully busy just now housecleaning.*

*Well I got your welcome letter Sunday and in the first place I must
thank you for that gum it was lovely. Only dear me it had run all over the
letter and I thought I'd never get it off. I finally got the most of it but I tore
the letter nearly into ribbons before I could. I went down to the station
Sunday night with Mr. Fish[1] to see the train come in and get my mail. I
was chewing some gum and Mr. Fish pretended he wanted a piece so I told
him if I got any letter on the train that night with some in it I'd give him a
piece and sure enough along came your letter with the gum in it so I gave
him a little bit of it and told him all about you and the fun you and I used
to have together going to the shore for mussels and hunting the cows in a
rainstorm.*

*All Mr. Pritchard's[2] family have moved out into the country for the
summer and as soon as we get the spring cleaning done I'm going out to
their farm to spend a week with Laura.[3] I don't know exactly what time
this summer I'll be home but probably some time in July. You and I must
have the fun then. You need never be afraid that I'll ever be too big to
speak to my old friends especially you.*

*Dear me there is no news at all to tell you. Everything is quiet here.
Our fine weather still continues but the crops are suffering very much for the
want of rain and if it doesn't soon rain I'm afraid they will be a failure. That
is the worst of this country there is so often not enough rain.*

*Have you got any mussels this spring yet? I suppose the mayflowers
are plenty now. They do not grow in this country but I wish they did.
There are plenty of blue violets and big blue bell-flowers out in bloom on
the prairies now and they are very pretty. I was out for a drive with Papa
three miles into the country yesterday and oh it was lovely. Everything was
so fresh and green and the prairies are so beautiful. There is some beautiful
scenery around Prince Albert. I shall be very sorry to leave it for all I am
so glad to be going home.*

*If I can tell the exact day that I will arrive home I'm going to get grand-
ma to invite you and Lucy[4] and Amanda[5] to tea the day I get there and if I
can't find out beforehand the exact day the very next one after I get there.*

*Do you remember the birch bark basket your father made for us to
pick berries in? It is a queer thing what became of that. How is Firefly?[6]
Give her my love and a kiss for me.*

*Well dear Pen I must end now as I've an engagement to go out this
evening. Write soon a good long letter. Remember me to Robbie[7] when*

you write to him. Give my love to your father and mother and the girls. Give Lily's⁸ baby a kiss for me. Piles of love to your own dear self from

Yours loving chum

Maud

¹Mr. Fish : Walter R. Fish, one of Lucy Maud's close friends.

²Mr. Pritchard : R. L. Pritchard. The Pritchards were great friends of the Montgomerys. Lucy Maud and Will Pritchard were extremely close.

³Laura (Pritchard) : Laura Pritchard, daughter of R. L. Pritchard. Laura and Lucy Maud were quite close friends. Laura later married Andrew Agnew. Lucy Maud dedicated *Anne's House of Dreams* to Laura.

⁴Lucy (Macneill) : John Franklin Macneill's daughter, Lucy Maud's first cousin and very intimate friend.

⁵Amanda (Macneill) : Amanda Jane Macneill, later Mrs. George Henry Robertson. Lucy Maud and Amanda were close companions.

⁶Firefly : Penzie's cat.

⁷Robbie (Macneill) : Penzie's brother, Robert Buntain Macneill. He had moved to Portland, Oregon.

⁸Lily (Bernard) : Lilie Bernard, Penzie's sister.

Tuesday
June 9th, 1891

Eglintoune Villa
Prince Albert
N.W.T.

My own dear Pen
I received your welcome letter last Tuesday but we have been so busy housecleaning and one thing and another that I really couldn't find time to answer it before so I know you'll forgive me won't you dear and anyway you know before very long we won't need letters at all — we can tell each other all we want to.

I'm writing this at half-past seven in the morning with Bruce lying on his stomach across my lap. My portfolio is resting on his back and I am trying to write but he is continually kicking and squirming so that my writing is a queer kind but you must excuse it.

Well mamma has taken Bruce[1] now so I can write now so you can read it. I feel sleepy this morning so that I can't think of anything interesting to write so I'm afraid this will be a very dull letter.

I'm awful glad your folks are going to have a boat this summer. You can bet I'll be down often and we'll have some jolly sails. We must go bathing and mussel hunting too as often as we can and berry-picking too. I'm longing to have a taste of strawberries aren't you but I suppose I won't be home in time for you and I to go berrying back to Montana,[2] but anyhow we must go raspberrying. Don't you remember the fun we had the day you and I and Lu were back picking them and how we got such a scare with the strange cows. I long to see those dear old lanes and woodland paths again under the maples and birches, beeches and poplars. Won't we have jolly fun when we get together again though.

Well I haven't very much more to tell you. The town is very quiet just now and nothing going on. A fortnight ago on the Queen's birthday I was out at a picnic at Mr. Macarthur's[3] farm. There were 52 of us altogether and we had a rousing time. The farm — Meadow Lea Farm is its name — is twelve miles out in the country and is awful pretty. I never enjoyed myself so much. We played baseball all the afternoon and a glorious game we had too although I was stiff as a poker the next three days. Mr. Macarthur has 1500 sheep on his farm. Just think of that. I tell you it was a sight to see them. I wished you had been with me many a time that day. We could have had such fun. Annie McTaggart[4] is teaching school out at Lindsay and she is going to have a school concert at her midsummer examination. She is going to have some of we townies to help it along and I am to give a recitation. I think I will say "The Christening".

Well I've nothing more to tell you of my doings. It's a dull little place here — not much fun. My principal amusement is teaching a class of kids in Sunday school. I tell you I've fun with them. To hear some of the questions they ask sometimes would double you up completely. I'd a terrible time with two of them Sunday. Percy McLellan[5] and Stewart Campbell[6] the two worst kids in the class raised a fuss while Dr. Jardine[7] was praying. Percy stuck a pin in Stewart and Stewart kicked Percy and then they both set up to cry. I yanked 'em both out on the front seat beside me and gave them a talking to that made them thoroughly ashamed of themselves so at last they begged each other's pardon promised never to do it again (but I'll bet they'll be at it again the very next Sunday) and went back to their places.

Are you planting any flowers in your garden this year. I hope you will have lots of those lovely pink roses when I come to see you. I have that spray of sweet clover in my Bible yet that you gave me the last night I was down with you just before I came away.

How are Firefly[8] and Fauntleroy?[9] Give them my love and a kiss from me. Do you ever milk "wooden cows" nowadays or get chaff all down your back. Don't you mind the time we were up in your loft rolling down on the straw and how we hit our heads such an awful clip together once. And the time we saw the fox tracks when we were picking gum in your back field.

Well I have nearly come to the end of this ugly sheet of paper and I'm sure your eyes will be aching trying to make it out so I will close. Give my love to your mother and the girls when you see them and remember me to Uncle Charles[10] and the boys. Ever so much love to your own dear little self and believe me to be ever

> *Your own loving chum*
> *"One of the three companions"[9]*

[1]Bruce (Montgomery)	:	Bruce Montgomery, Lucy Maud's half brother, son of Hugh John Montgomery and Mary Ann McRae. He was born January 31, 1891.
[2]Montana	:	14 acres of woodland owned by Charles Macneill and now in possession of his grandson, Ralph Macneill.
[3]Mr. McCarthur	:	James McCarthur, a very large sheep rancher 12 miles outside Prince Albert.
[4]Annie McTaggart	:	Daughter of John McTaggart, stepfather of Mary Ann Montgomery. Lucy Maud and Annie were great friends.
[5]Percy McLellan	:	Sunday School pupil in a class taught by Lucy Maud.
[6]Stewart Campbell	:	Sunday School pupil in a class taught by Lucy Maud.
[7]Dr. Jardine	:	Dr. Robert Jardine, M.A. B.D., minister of St. Paul's Presbyterian Church.
[8]Firefly	:	Penzie's cat.
[9]Fauntleroy	:	Penzie's cat.
[10]Uncle Charles	:	Penzie's father, Charles Macneill.

In the last letter that Lucy Maud Montgomery wrote from Prince Albert to Penzie Macneill she remarked with enthusiasm that "before long we

won't need letters at all — we can tell each other all we want to."[10] This
indeed, proved to be the case. After Lucy Maud's return to Prince Edward
Island there is only one letter extant between the two. It is a letter written
in October, 1894, when Lucy Maud was teaching school in Bideford, Prince
Edward Island. This letter, like the earlier sequence from Prince Albert,
reveals the attachment of a sentimental Lucy Maud to Cavendish and to her
friend Penzie:

Sunday
Oct. 28th
1894

The parsonage[1]
Bideford
P.E.I.

Dearest Penzie
 *Although as you may guess I haven't very much news to tell you yet I
am going to write to you right off to-day for I am so homesick and lonesome
that I must do something of the sort to keep away the blues as far as possible.
I tell you I expect I shall put in a pretty "tearey" time for the next two weeks
or so until I get over being homesick.*
 Well how did you and Lu[2] *get home? I'm dying to hear. It didn't
rain on you did it. I was so glad when it cleared up. It was quite a decided
drizzle when I got to Ellerslie Station and I thought of you two poor mortals
having to jog over those awful hills in the rain. When it stopped raining I
tell you I was glad for your sakes. When did you leave Kensington and did
you stop at Clifton? Did your Aunt Ellie*[3] *say anything about us not calling
there on our road up? You will think I have an awful number of questions
to ask but I've no news to fill up this letter with if I don't ask questions and
don't forget to answer them all on pain of death when you write. And I
hope that will be soon as I shall need a letter from home soon to cheer me
up a wee bit.*
 *Just as you and Lu left the train I heard somebody say "Why, Maud"
and when I looked up whom should I see but my cousin Nettie Mont-
gomery*[4] *on her way home to Alberton from Charlottetown. I tell you I
was glad to see her. I was just going to settle down for a real good hearty
cry but I changed my mind and sat with her. It was so nice to have some-
one to talk to and it kept me from thinking too much of the "girls I left be-
hind me". Mrs. Estey*[5] *and Maudie*[6] *met me at the station and soon after
I found myself back at the old stand. I was too busy all the afternoon*

getting unpacked and settled to think much of home but when dark came and I had nothing to do I tell you I just felt as lonely as I want to. To pass the time I got to work making up some "Cavendish Notes" and really I got up quite a list. I will send them in to-morrow but I don't know if they will print them or not. Oh while I think of it. Have you the last Guardian with those "Bideford Notes" in it? If you have would you mind cutting them out and sending to me. I thought I would be able to get them out of Mr. Esteys[7] but they have not got last weeks Guardian. I would like to have them for my scrapbook.

Mind you those rotten old trustees have never touched the school yet after all their promises. I really am quite in despair. I can't live in that school thro' the winter in the condition it is in now. I shall have to just make them have it fixed up right away. But don't for your life breathe a word of this to anyone down home not even to Lu for if grandpa and grandma found it out they would be in a terrible way.

What a beautiful day it is to-day isn't it. I wish I was home going to church with you and Lu.

⋄⋄

Night

Well here I am to-night feeling quite cured of homesickness and contented to face the winter. I have enjoyed myself greatly to-day. I went to Mr. Williams'[8] from Sunday school and stayed there till 8 o'clock. I have just got back and must finish this letter before I go to bed.

Is Emma Stewart[9] really going to the States do you think? I put a hint of it in my "Notes". How does Chesley[10] shine? Have known him.

Maud[11]

[1]Parsonage	: Lucy Maud boarded at the Methodist Parsonage, Bideford when she taught at Bideford School in the year, 1894-1895.
[2]Lu (Macneill)	: Lucy Macneill (1877-1974), daughter of John Franklin Macneill and a first cousin of Lucy Maud.
[3]Aunt Ellie	: Helen Macneill married to William McKay of Clifton. Helen (Ellie) was a sister of Penzie's father, Charles Macneill, and, therefore, Penzie's aunt.
[4]Nettie Montgomery	: Nettie Montgomery was the daughter of Donald Mont-

gomery and Anne Campbell of Alberton. Donald Montgomery was a nephew of Senator Donald Montgomery, Lucy Maud's grandfather. Lucy Maud and Nettie were second cousins.

[5]Mrs. Estey : Wife of the Methodist minister, J. F. Estey, who had responsibility for the Bideford charge. Lucy Maud boarded with Mr. and Mrs. Estey.

[6]Maudie (Estey) : Daughter of Rev. J. F. and Mrs. Estey.

[7]Mr. Estey : The Methodist minister at Bideford.

[8]Mr. Williams : Albert Williams, who lived across the road from the Parsonage in Bideford.

[9]Emma Stewart : Emma was the daughter of Alexander Stewart. She lived from 1872-1955. She married Robert Fulton Simpson in 1898.

[10]Chesley (Clark) : Chesley Clark was the son of William *Darnley* Clark and Jane Stewart. He lived from 1877-1968.

The passage of years and increasing responsibilities naturally changed the relationship between Lucy Maud and Penzie. Each of them charted quite different courses in life. Lucy Maud, more and more preoccupied with her literary career and with the care of her aging grandparents, saw less and less of Penzie. Then on July 13, 1898, Penzie married William B. Bulman and moved to New Glasgow, Prince Edward Island.[12] The birth of a son, Chester Stanfield, on November 7, 1899, increased Penzie's responsibilities.[13] Moreover, Penzie did not enjoy robust health. Lucy Maud states in her journal that she often visited her during the final months of her life and was saddened by Penzie's frail appearance. At length, her role as mother of a young boy and wife of an industrious and demanding husband, overtaxed her delicate health. She died on February 8, 1906, at the young age of thirty-four years.[14] Lucy Maud Montgomery's closest childhood friend, Penzie Macneill Bulman, lies buried in the Peoples' Cemetery in New Glasgow situated directly across the river Clyde from the Bulman home.

Approximately ten years later, on the occasion of Penzie's mother's death, Lucy Maud, now married herself, and living in Leaskdale, Ontario, wrote to Penzie's sister, Minnie Toombs. Lucy Maud's deep attachment to the Charles Macneill family and especially to Penzie is revealed in this letter.

The Manse
Leaskdale
February 15, 1916

Dear Minnie:

I want to write you a little note tonight to send you our sympathy in the loss of a kind mother. When I read of her death my eyes filled with tears. I thought of the old days when Penzie and I were so much together at your old home and your mother was so kind to me. I never heard her say a harsh word to anyone. That old home, like my old home, is sadly changed now. But your mother had attained a ripe old age and we know the change is a happy one forever. In spite of the kindness of you all to her she must have felt bitterly having to leave her old home. Now she has a better one where many of our dear ones have gone before her.

We are all well again. Mr. Macdonald has just got over a rather nasty attack of bronchitis. My boys are well and growing fast. Please give my sympathy to Lily, and Albert, and Alex.

Your old friend

Maud[15]

The years had certainly not dimmed the memories of the beautiful and meaningful friendship between Lucy Maud Montgomery and Penzie Maria Macneill.

FOOTNOTES TO CHAPTER IV

[1]Family Bible of Charles Macneill and Mary Buntain. This Bible is in the possession of Ralph Macneill, Cavendish, Charles Macneill's grandson, and a nephew of Penzie Macneill.

[2]H. H. Simpson, *op. cit.*, p. 73.

[3]Mary Lawson to Harold Macdougall, 8 July, 1909, quoted in Simpson, *op. cit.*, p. 78.

[4]Charles Macneill family Bible.

[5]L. M. Montgomery, "My Friend's Home," Penzie Macneill letters.

[6]Charles Macneill family Bible and H. H. Simpson, *op. cit.*, p. 246.

[7]Last will and testament of Alexander Marquis Macneill, dated, 1897; in possession of Mrs. Ernest Macneill and John Macneill.

[8]H. H. Simpson, *op. cit.*, p. 245.

[9]L. M. Montgomery to Penzie Macneill — 16 letters dating from August 26, 1890 to June 9, 1891. L. M. Montgomery collection in Kelley Memorial Library, University of Prince Edward Island, Charlottetown.

[10]L. M. Montgomery to Penzie Macneill, 9 June, 1891.

[11]L. M. Montgomery to Penzie Macneill, 28 October, 1894.

[12]William B. Bulman and Penzie Maria Macneill were married in Cavendish by the Reverend George C. Robertson on July 13, 1898. Marriage certificate in the home of their son, Chester Stanfield Bulman; this home is now owned by William V. Stevenson.

[13]Cemetery records, New Glasgow Peoples' Cemetery.

[14]*Ibid.*

[15]Lucy Maud Montgomery Macdonald to Minnie Toombs, 15 February, 1916. This letter is in the possession of Mr. and Mrs. William Toombs, North Rustico. William Toombs is the son of Minnie Toombs and a nephew of Penzie Bulman. The Toombs family kindly allowed me to quote this letter.

CHAPTER V

LUCY MAUD'S COLLEGE YEARS

Since classes had resumed in Cavendish school some seven weeks prior to Lucy Maud Montgomery's return from Prince Albert on September 4, 1891, she had no alternative but to remain out of school for the scholastic year, 1891-1892. There was absolutely no hope of her being able to make adequate preparation for the Entrance Examinations to Prince of Wales College, Charlottetown, after having lost so much valuable time. Lucy Maud did not, however, allow this temporary pause in her academic career to interfere with her literary progress. She tells us in "The Alpine Path," that she quite profitably spent the winter in Park Corner with her Uncle John and Aunt Annie Campbell giving music lessons to Clara and Stella, and writing verses for the *Patriot*.[1] Representative of her literary publications in the *Patriot* was a poem entitled, "The Wreck of the Marcopolo," 1883, based upon the story of the *Marco Polo* that she had published in the *Montreal Witness* and in the *Charlottetown Patriot* the previous year. The foundering of the famous 1,625-ton three-decker off Cavendish beach on July 25, 1883, had certainly made an indelible impression upon the observant Lucy Maud as she watched with intense interest from the heights of Cape LeForce.

THE WRECK OF THE "MARCOPOLO," 1883.

'Twas a wild day! The waves raced madly
up
'Gainst the unyielding rocks with sullen
roar
Or rotted in floods of foam that tossed the
spray
In angry showers across the long sand
shore!

Over the shuddering trees and meadows
bare
Hurtled the wind like some storm fiend set
free,
Shrieking its rage until its voice was lost
In the wild thunder of the impassioned sea!

Sudden! — was it a bird that spread its wing
Where the black cloud met with the blacker
wave!
Or was it — was it — some ill-fated ship
Riding so swiftly o'er that hungry grave!

It was no sea-gull dipping in the foam —
No darker wave upon the wind-torn gloom
It was a barque that flew before the wind
Straight where the breakers hid the reefs of
doom!

We watched with shortened breath — oh!
would she strike
Where death was certain on the rocky
strand!
Or where the yielding sands the shock might
break
And hope could whisper rescue from the
land!

A wilder wave — a wilder tempest shriek —
An echoing crash — she strikes — the waves
rush by!
'Tis on the sand! Now, if the vessel holds!
Brave hearts are eager, and the land is nigh.

Naught can be done while yet the wind is
wild
But signal hope and courage! We must
wait
Till the storm ceases and the wild seas calm
And pray that rescue may not come too late.

The sun set; one red shaft of sullen fire
Fell o'er the waters, stormier than before,
Then darkness and one long, wild, anxious
night,
But, when the dawning broke the storm was
o'er.

The sea was heaving yet in fitful swells,
Like some grieved child that sobs itself to
sleep,
While from the realms of the morn, the
light
Crept rose-hued o'er the chasms of the
deep.

And they were saved — those sailors who had
faced

Death in so many seas, so many forms.
But wrecked, dismantled lay the ship that
 had
Out ridden the fury of unnumbered storms!

Days came and went — long purple summer
 days —
Till hot-breathed August flung across the
 sea
The languorous enchantment of her smile
And wheat-fields ripened to their harvestry.

One eventide was fairer than the rest,
It seemed as if the world were born again
In all the rapture of a heavenly peace
Unmarred by sin, unsoiled by sorrow's
 stain!

The sun set in the sea. The western sky
Ran waves of fire to meet the waves of blue,
The purple headlands barred against the
 light,
The sands were dampened in the falling dew.

The sighing wavelets rippled on the shore.
The stars blinked shyly thro' the yellow
 haze,
'Twas Nature's vesper hour — earth, sky and
 sea
Joined in the universal hymn of praise.

But in the silent night an unseen hand
Drew a dark veil across the starry sky
The frightened waters tossed their gleanning
 crests
And dismal sea-born winds wailed weirdly
 by.

The morning came thro' skies of lurid red,
The gray light broke across the storm rent
 gloom?
We saw the ship half-shattered, thro' the spray
And knew the breakers rang her knell of
 doom!

What blanched our faces, chilled our hearts
 with dread.
Like wildfire ran the news from lip to lip
The bravest shuddered when the tidings flew
Lives — human lives were on that fated ship!

No strangers these but friends —
 we knew them all.
With helpless terror dumb we thronged the
 beach,
Powerless to rescue — o'er that furious sea
No hand could save, no human aid could
 reach.

One slender hope — one only — if the wreck
Could but withstand the billows and if they
Could cling until the storm its fury spent,
They might be rescued — we could only pray.

Slow crept the leaden-footed minutes by
And lengthened into hours that seemed like
 years
We lived a lifetime in that dreary day
Filled with despairing hopes and voiceless
 fears.

At last — at last — a lull; and thro' the storm
A band of brave men to the rescue went
Though great the danger not one stout heart
 quailed
And many a hope and prayer with them
 were sent!

In dread suspense we watched the little craft
Tossed madly up and down but still afloat,
Until — oh joy — the wreck is reached at last
And the drenched sufferers safe are in the
 boat.

Then back again, and never heroes came
More gladly welcomed from the jaws of
 death,
Men crowded round to clasp their comrades'
 hands,
Laughing and crying in the self-same breath.

*Yet there was mourning midst the general
 joy,
All were not there for one would come no
 more,
Drowned in the sight of land, in sight of
 home
In sight of friends upon his native shore.*

*Another day — the happy morn laughed out
O'er seas, blue, tender, as a baby's eyes
Where yesterday the stranded vessel lay
Blank wavelets sparkled under sunny skies.*

*And now when August gales are wild and
 fierce,
When waves leap high and cloudy heavens
 frown,
Men say with anxious glances seaward east,
"It was such a day the brave old ship went
 down."*

LUCY MAUD MONTGOMERY[2]

Cavendish, Aug. 20, '92.

When Cavendish school reopened after the summer vacation of 1892, Lucy Maud Montgomery was among the forty-five pupils enrolled. Preparations for the writing of the Entrance Examinations to Prince of Wales College, the supreme acid test for all Grade Ten pupils attending Island schools for over a century, left the seventeen-year-old Lucy Maud with little time to indulge in her literary career. Her year at Cavendish school was a decided academic success. When the results of the matriculation examinations were announced in mid-July, 1893, Lucy Maud attained 470 out of a possible 650, and ranked fifth on the Island.[3] In the autumn of 1893, she entered the second year program at Prince of Wales College studying for a teacher's license. Her father and grandmother Macneill underwrote the costs of her education. Lucy Maud responded to their generosity by taking two years work in one year. Realizing that a substantial increase of knowledge would contribute immeasurably to her literary success, Lucy Maud applied herself assiduously to her studies. She achieved noteworthy results. She obtained an honor certificate and led her year in English drama, English literature, Agriculture and School manage-

ment.[4] In addition, Lucy Maud delivered the graduation essay at the Commencement Exercises held at the Opera House in Charlottetown on June 9, 1894.[5] Each year the best essay written in the English drama course was read at the Convocation Exercises. It seemed fitting that the essay of the future international author should have been chosen.

The editor of the Charlottetown *Examiner* commented quite glowingly on both the quality of Lucy Maud's essay on "Portia," the heroine of William Shakespeare's play, *The Merchant of Venice,* and on her eloquent reading of it at the Prince of Wales College Convocation:

The program was unique among the bills of fare served at functions such as this. True, it followed the hoary, orthodox custom of reserving the greatest names for the finale, but it placed the best and most attractive features first. There is no room to doubt that the *pièce de resistance* of the evening was Miss Lucy Montgomery's essay on "Portia." It was a character-sketch such as might have come from George Eliot in her 'teens. It was not only a subtle, analytical study; it was a literary gem. Miss Montgomery began with the girl Portia in meditation but not free; bound by the mystery of the caskets of lead and silver and gold, "the stately, graceful heiress of a long past ago."

In phrases of almost perfect art, Miss Montgomery praised the beauty of the Portian type of heart and mind and soul. Especially heart; for that was where the humanity lay, was it not? And Portia, by a little touch.of human frailty, now and then, endeared herself to every heart. In fine, this sweet, strong heroine of Shakespeare's greatest thought was, toward the suitor of her choice, "a perfect marvel of maidenly delicacy and womanly love." But it was in her capacity as the "possessor of a magnificent intellect" that Portia won the young essayist's most enthusiastic words of praise. To say that Miss Montgomery in this analysis did justice to Portia's intellectual worth may seem a strong statement and undue praise; but it is simple truth.[6]

This tribute by the editor of the *Examiner* must have been especially gratifying to Lucy Maud who had had most of her earlier poems and short stories coldly rejected by that newspaper.

Lucy Maud Montgomery's descriptive powers, which would later establish her as one of the world's greatest creators of childrens' fiction, is already evident in the portrait of "Portia" that she depicts in her graduation essay:

"PORTIA" — A STUDY

Of all Shakespeare's many delightful plays surely the "Merchant of Venice" is the most delightful. The scenes of this charming comedy are for the most part laid in that fairy city of romance, Venice, the queen of the Adriatic; and some of its characters are ranked among the great dramatist's master pieces. Of these characters, Portia the beautiful heroine is, perhaps,

*the one who appeals most strongly to our sympathies, and, from first to last,
fascinates us by her beauty, grace and intellect.*

*There are three female characters in this play, all perfect portraits after
their mind, but there is a great difference in the kind. Jessica, the pretty,
dark-eyed Jewess, is indeed, piquant and sprightly, but too heartless and
deceitful to win our love; and Nerissa, the confidential waiting maid has all
of an indulged servant's garrulity in her sharp tongue. But who will find
a fault with Portia — this stately, graceful heiress of a long-past age? An
age far removed from us now, in customs and in manners as in time and
yet here brought vividly near to us in these pictured passions of the human
heart, which is the same to-day as it was when Venice was in her glory's
prime.*

*And yet Portia is not absolutely without a flaw, — a little touch of
human frailty now and then endears her still more to our hearts. For one
thing, she is somewhat sarcastic and does not at all spare the weaknesses of
the suitors, whom her golden tresses, and no less her golden ducats, have
brought to her feet. When we first see her in the play, she is gaily dis-
cussing with Nerissa the faults and virtues of her unfortunate admirers,
with a sportive carelessness which tells us that her heart is as yet untouched.
But withal, her sparkling wit is without malice or bitterness — it is merely
that of a light-hearted, joyous girl, with no cares to trouble her, except,
perhaps, those same lovers whom she may neither accept nor refuse, being
bound by the terms of her father's will, to marry whoever chooses from
three caskets the one containing her picture.*

*But Portia, though quick to see their foibles, is never anything but per-
fectly considerate and thoughtful of them. In her interviews with her
princely suitors we are always impressed by her delicate tact and graceful
courtesy. Affection for any she never simulates — there is no affectation of
an interest she does not feel, but never, by word or look, does she wound the
feelings or hurt the vanity of any aspirant for her hand. And even if after
they fail in their choice and depart, she expresses her relief in some laugh-
ing jest with Nerissa, who shall blame her?*

*But still in time to Portia comes the true fairy prince — he who, alone
of all others, has the power to awaken in her heart a woman's tenderest love.
No titled lover with princely retinue or haughty lineage only a handsome
young Venetian, with no fortune and nothing save his noble birth, courtly
manners and manly spirit to recommend him. But Portia's wayward heart
has found its master, and her speech to Bassanio in the casket scene is a
marvel of mingled maidenly delicacy and womanly love. Our hearts thrill
with sympathetic joy when Bassanio chooses the right casket and wins both
the picture and the beautiful original.*

But over their bridal happiness comes a sudden chill — ill tidings for Bassanio. Antonio, his dearest friend, is in danger, and his presence is requested at once. Portia nobly rises to meet the occasion. With gentle firmness she tells Bassanio that he must go at once — with no word or look does she seek to keep him by her side, when duty calls him away. With true thoughtfulness, she conceals her own sorrow at the parting and strives to encourage him with her hopeful assurance and sympathy.

Then comes the grand climax of the play — the famous trial scene where all the tragic issues find their centre. And here we see Portia in a new light. We have beheld and loved her as the happy maiden, the loving woman and the gentle bride, now she claims our admiration as the possessor of a magnificent intellect. The friend to whom her husband owes most is in danger of his life at the hands of relentless Shylock. All efforts to save him have been fruitless. Never was woman's quick wit more sorely needed and never did it come more promptly to the rescue. Disguised as a doctor of laws, Portia enters the court. Her pleading for mercy is unrivalled — grandly eloquent, tenderly sublime. And when it is of no avail, her subtle logic and keen judgment succeeds where all the learned heads in Venice have failed, and Antonio is saved.

Then comes the last beautiful scene, where, in the moonlit gardens of her home, Portia welcomes back her husband. A charming picture she presents in truth, this sweet bride of long ago, than whom no nineteenth century maiden can find a higher ideal of womanhood to emulate.

And as we turn away from the fairy scene of light and music with which the play concludes, we feel that Bassanio has indeed, won for his bride a woman worthy of his love. For as long as the English language is spoken or read, as long as genius is admired and womanly sweetness praised, the character of Portia will be regarded as one of the truest, noblest, fairest creations of Shakespeare's master genius.

Lucy Maud Montgomery.[7]

The editor of the *Patriot* remarked that "Miss Lucy Maud Montgomery's analysis of "Portia" was of the highest order and that the essay was read with good effect."[8] Lucy Maud certainly received heady commendations for her award-winning *pièce de resistance*.

Although Lucy Maud's principal preoccupation at Prince of Wales College was her studies, she was able to set aside some spare moments for writing. While there, she and a small coterie of enterprising students launched a monthly college magazine called, *The College Record*. Lucy Maud, in addition to her editorial responsibilities, contributed a number of poems, plays and short stories.[9] It was also while she was a student at

Prince of Wales College that a very significant breakthrough occurred in her literary career. Lucy Maud vividly recalls the event in "The Alpine Path:"

In the fall of 1893, I went to Charlottetown, and attended the Prince of Wales College that winter, studying for a teacher's license. I was still sending away things and getting them back. But one day I went into the Charlottetown post office and got a thin letter with the address of an American magazine in the corner. In it was a brief note accepting a poem, "Only a Violet." The editor offered me two subscriptions to the magazine in payment. I kept one myself and gave the other to a friend, and those magazines, with their vapid little stories, were the first tangible recompense my pen brought me.[10]

Fittingly enough, this poem, which appeared in *The Ladies' World*, under the title of "The Violet's Spell," was based upon Lucy Maud's appreciation of the beauty of nature.

For The Ladies' World
THE VIOLET'S SPELL

By Lucy Maud Montgomery

Only a violet in the trodden street
Breathing its purple life out 'neath the tread
Of hundreds, restless, eager, hurrying feet.
Ere set of sun the frail thing will be dead;
"Only a violet," so its loser said.

As in a dream the dusty street passed them,
Unheeded on my ear its tumult fell;
I saw a vision from the past again
That wove across my heart a nameless spell —
Fond memories of a spot I once loved well.

A woodland lane where ferns grew green and tall,
And beeches wove their branches overhead,
All silence save some wild bird's passing call
Or the swift echoing of a rabbit's tread;
'Neath those green arches fear and strife were
dead!

Blue smiled the sky where, thro' the fir trees green
The summer sunshine fell in golden sheaves,
And shyly from beneath their mossy screen
With half averted face as one who grieves,
Blue violets peeped thro' last year's withered
leaves.

And one was there with me whose voice and smile
 In keeping seemed with those fair joyous hours!
A face where Nature set her every wile
 And laughing eyes blue as the sweet spring flow-
 ers
 When wet with tear-drops of the May-time show-
 ers.

Dear friends were we and hand in hand we went
 Down the green lane where sunshine thickly lay,
The soft, low voices of the woods were blent;
 A drowsy cow-bell tinkled far away
 Heart spoke to heart that far, fair, sunny day!

For us the sunshine laughed, the wild birds sang,
 The purple darlings of the spring were fair;
For us each vagrant note of music rang,
 And every passing breeze was like a prayer,
 Heart-whisperings of Nature everywhere.[11]

Lucy Maud was encouraged by the reception of a tangible reward for her literary efforts. "It is a start and I mean to keep on,"[12] she wrote in her diary. "Oh, I wonder if I shall ever be able to do anything worth-while in the way of writing. It is my dearest ambition."[13] Lucy Maud could hardly be expected to foresee that in slightly more than a decade she would enjoy world-wide recognition as a famous author.

When Lucy Maud attended Prince of Wales College, she took the requisite courses for a teacher's license at the affiliated Normal School. In the final examination for her license she obtained a quite respectable aggregate of 1034 out of a possible 1400, and ranked fifth out of eighteen on the Island.[14] Her first school was at Bideford in Prince County, Prince Edward Island, a pleasant rural community situated quite close to the famous Yeo, Ellis and Richards shipyards. Although Lucy Maud greatly enjoyed the year with her pupils, she was not pleased with the one-room structure that served as a school. She wrote pessimistically to her friend Penzie Macneill in the fall of 1894:

Mind you those rotten old trustees have never touched the school yet after all their promises. I really am quite in despair. I can't live in that school thro' this winter in the condition it is in now. I shall have to just make them have it fixed up right away. But don't for your life breathe a word of this to anyone down home, not even to Lu, for if grandpa and grandma found it out they would be in a terrible way.[15]

One can almost imagine Lucy Maud Montgomery having an altercation with the school officials reminiscent of the one portrayed by Robert Harris

in his famous portrait of the teacher and the school trustees.

While teaching in Bideford Lucy Maud boarded at the Methodist parsonage, a beautiful mid-nineteenth century home located about one-quarter of a mile from the school where she dispensed knowledge. The minister was the Reverend J. F. Estey who was the incumbent from 1892 until 1895. His wife, a charming young woman, and Lucy Maud became very close friends. Lucy Maud informs us in "The Alpine Path," that the notable incident of the liniment cake, a humorous chapter in the novel, *Anne of Green Gables*, was suggested by an event that occurred when she was boarding at the parsonage. A strange minister was invited to tea at the manse one evening, and for the occasion, Mrs. Estey made a layer cake which she flavoured with anodyne liniment by mistake. "Never shall I forget the taste of that cake, and the fun we had over it," related Lucy Maud, "for the mistake was not discovered until tea-time. The minister ate every crumb of his piece of cake. What he thought of it we never discovered. Possibly he imagined it was simply some new-fangled flavoring."[16] It was largely the lively companionship of the Esteys that made the year in Bideford quite pleasant for the lonesome-prone Lucy Maud.

During her year in Bideford, Lucy Maud continued to write in her available spare time. But it was not a particularly productive year. In fact, according to Lucy Maud herself, only a high degree of assiduity and dedication prevented her from entering a state of complete despair. She often experienced such a state of mind during her life. She always had a slight tendency towards depression. She wrote of her frustration in Bideford:

After leaving Prince of Wales College I taught school for a year in Bideford, Prince Edward Island. I wrote a good deal, but still my stuff came back, except from two publications the editors of which evidently thought that literature was its own reward, and quite independent of monetary considerations. I often wonder that I did not give up in utter discouragement. At first I used to feel dreadfully hurt when a story or poem over which I had laboured and agonized came back, with one of those icy rejection slips. Tears of disappointment *would* come in spite of myself, as I crept away to hide the poor, crimpled manuscript in the depths of my trunk. But after a while I got hardened to it and did not mind. I only set my teeth and said, "I will succeed." I believed in myself and I struggled on alone, in secrecy and silence. I never told my ambitions and efforts and failures to any one. Down, deep down, under all discouragement and rebuff, I knew I would "arrive" some day.[17]

Lucy Maud's closing thoughts were prophetic indeed, because within a year she did "arrive."

Anxious to increase and broaden her intellectual horizons, Lucy Maud decided, after only one year in the teaching profession, to further her formal education. The one hundred dollars she saved out of the princely one

hundred and seventy-five-dollar salary she received at Bideford, plus the
eighty dollars given her by her grandmother Macneill, enabled her to fi-
nance one year of advanced studies. In the autumn of 1895, she went to
Halifax and registered at Dalhousie College. She boarded at Ladies' Col-
lege which she found quite confining. She did not enroll in the regular
undergraduate course, but rather followed selected courses in English
literature. At the time the Professor of English Language and Literature
at Dalhousie was Archibald MacMechan who already enjoyed a notable
reputation as a distinguished essayist and poet. Lucy Maud registered in
two of his courses in one of which she led the class and in the other attained
first class honors. She always maintained that her contacts with Professor
MacMechan inspired her, and enabled her to write with greater facility and
effectiveness than before. The year that Lucy Maud spent at Dalhousie
proved to be a memorable one indeed. It was during the winter of 1896
that in a single week she received three separate acceptances from editors
to whom she had sent poems and short stories.

Lucy Maud describes that unforgettable week quite graphically:

In the autumn of 1895 I went to Halifax and spent the winter taking a selected course
in English literature at Dalhousie College. Through the winter came a "Big Week"
for me. On Monday, I received a letter from *Golden Days*, a Philadelphia juvenile,
accepting a short story I had sent there and enclosing a cheque for five dollars. It was
the first money my pen had ever earned; I did not squander it in riotous living, neither
did I invest it in necessary boots and gloves. I went up town and bought five volumes
of poetry with it — Tennyson, Byron, Milton, Longfellow, Whittier. I wanted some-
thing I could keep forever in memory of having "arrived."

On Wednesday of the same week I won the prize of five dollars offered by the Halifax
Evening Mail for the best letter on the subject, "Which has the greater patience — man
or woman?

My letter was in the form of some verses which I had composed during a sleepless night
and got up at three o'clock in the wee sma' hours to write down. On Saturday the
Youth's Companion sent me a cheque for twelve dollars for a poem. I really felt quite
bloated with so much wealth. Never in my life, before or since have I been so rich![18]

It is quite easy to appreciate the stimulating sense of accomplishment ex-
perienced by Lucy Maud on the occasion of her long-awaited "arrival."

In addition to the purchase of new and attractive copies of the books
of the poets who had inspired her, Lucy Maud marked the occasion by hav-
ing a photograph taken of herself. In a caption beneath a copy of this photo
reproduced in "The Alpine Path," Lucy Maud wrote: "My 'red letter day'
came when I was nineteen and received my first cheque for a short story."[19]
The story published in *Golden Days* which occasioned her "red letter day"
was entitled, "Our Charivari." It was based upon a time-hallowed custom
on Prince Edward Island of honouring a newly wed couple on their return

from their honeymoon with a mock serenade enlivened by horns, kettles, pans and other bizarre noisemakers. This story is one of the few that Lucy Maud wrote under the pseudonym — Maud Cavendish:

OUR CHARIVARI

By Maud Cavendish

When Jerry Boirier, Uncle Lyman's French servant-boy, told us there was to be a charivari at Roderick Brown's that night, we were wild to go.

"We," were Allison Hillier, of New York; Algernon Keefe, from Nova Scotia, and myself, Fred Harvey, from Quebec. We were cousins, and we were spending our vacation at Uncle Lyman Harvey's farm, on Prince Edward Island. We were having a splendid time, but we were chiefly notorious for our scrapes. Our average was two and a half a week, and Aunt Maria said, time and time again, she never had a minute's peace, lest one or the other of us should be brought in a corpse. And I'm obliged to confess that we generally got into trouble through our own headstrong doings and willful disregard of Uncle Lyman's advice. He was very patient, except in cases of outright disobedience; but he warned us solemnly every day, that we would learn a lesson sooner or later, if we didn't mend our ways. And Uncle Lyman's words came true to the letter, though we used to wink and grin at each other whenever his back was turned.

But about this charivari! Ever heard of one? Well, it is an old French Canadian custom, and is kept up in a good many places in Canada yet. Whenever there's a wedding the young fellows of the settlement call at the house, dressed in every queer costume they can contrive, with horns and bells and so on, and keep up a racket for hours.

When a charivari is well-conducted and respectable it is real fun. Sometimes the costumes are well got up and the charivariers don't do anything worse than make a noise; and mostly the people of the house invite them into the kitchen and treat them with cakes, which the bride herself comes out and hands around. Then they go off, peaceably and orderly. That's one kind of charivari. But there are two kinds, as we afterwards discovered.

Well, we were crazy about the affair, but when we asked Uncle Lyman's permission we got a decided "No!" He told us he didn't approve of charivaris, anyhow, and he knew from what he'd heard that this was going to be one of the worst kind. A lot of roughs from the "back road" were going, and there'd be liquor in the crowd, and we'd be certain to get into trouble.

Uncle Lyman isn't one of the coaxable kind, so we went off pretty sulky,

and sat down on an old bench behind the barn to hold an indignation meeting.

"Say, you fellows, I'm going to that charivari yet!" This was my contribution.

"How'll you manage it?" asked Allison. "If we could hit on a plan, I'd go in for it, for it's likely the only chance we'll ever have of seeing a real charivari. It'd be no end of fun to tell the folks at home."

Then we made our plans in cold blood. We agreed to smuggle the necessary things up to an old shed back of the barn, during the day, each being responsible for so much. Algie was to get the lantern, two horns, an old tin pan and a pot — to get black off of, you see.

I agreed to bring two old dresses of Veronica's — Veronica Gallant was Aunt Maria's big, fat French girl — and Allison was to get Jerry's working clothes. Jerry and Veronica had gone home. It was a holy-day, so we had a fine chance.

Every now and then through the day you'd see a boy sneaking into the house when Aunt Maria wasn't round, and rushing out again by the back way with something. We knew no one would go near the old shed. How to get out at night bothered us most.

Uncle Lyman not only locked all the doors at bedtime, but carried the key off with him, because he'd discovered that Jerry had a habit of getting up and going out apple-stealing after every one was in bed.

All the downstair windows made too loud a noise in opening to think of getting out of them, for uncle and aunt slept on the ground floor. The only up-stairs one that would serve, was a little one in the clothes-room; it opened on the steep kitchen-roof at the back of the house.

We resolved to climb out of this, slide down the roof and jump off on a pile of seaweed that had been used for banking in winter and hadn't been removed.

When we went to bed at night we could hear horns blowing up all the roads, and it just made us tingle. It was a dusky, starlit night, and a new moon was low in the west, looking like a little crescent of reddish gold.

After what seemed a dreadful long time, Allison and I concluded uncle and aunt were asleep, and we got up. When we crept into Algie's room, of course he was sound asleep — and such a time as we had to wake him! And then he was sleepy and stupid for half an hour.

We took our shoes in our hands and tiptoed down the hall to the clothes-room door. Then Allison tripped on a rag and fell against the door. It flew open with a bang, and his shoes went skating over the floor. We were sure every soul in the house would be up at the noise, but, as all was still, Allison got up, and after we had a laugh we got to the window.

I thought we'd never get it up. It stuck, and Allison shoved and shoved. All at once it gave way, and went up so suddenly he nearly went through it. We fired our shoes down first, giving them a good fling to send them clear of the roof, and then Allison went.

He slipped out and went down the roof like an eel. We heard him jump, and then whistle softly, as a signal. It was Algie's turn next. He crawled out boldly, but the roof was slippery from the dew, and first thing I heard him give a scramble and a yell, and then he was gone!

I heard him and Allison giggling below, so I knew he wasn't hurt, but I thought Uncle Lyman would certainly hear the yell, and for quite ten minutes I didn't dare to climb out. When I did I forgot about the window; and when I had wriggled half-way down, the contrary thing fell with a force that fairly jarred the house. I suppose things sounded worse to us in the dark and silence, but at the time I couldn't see why every one didn't wake up. I lay there quaking, till I heard Allison below.

"Say, you up there! Are you going to get down to-night?"
So I crept down and jumped off on the seaweed.
When I got it all out of my mouth and ears, I said:
"Have you fellows got all the shoes?"

And it turned out they couldn't find one of mine. So we had to waste about fifteen minutes rooting around for it, till we discovered Algie had it with the rest, after all.

I relieved my feelings by saying:
"Well, you idiot!"

And we started, taking a short cut through the spruce grove, and nearly tearing our eyes out on the low boughs. Just then old Gyp, who was chained in the orchard, began to bark furiously, ending of each series with a long, quivering howl.
"I'd like to choke that dog dead," snarled Allison.
I don't want to give you the impression that Allison was always this bloodthirsty, mind. Generally he was quite amiable, but his patience had been tried that night.
Gyp had stopped barking when we reached the shed, and we lit the lantern and hurried to work. Algie put on Jerry's trousers, hitched nearly to his shoulders, and turned up to his knees, Jerry's coat wrong side out, and an old straw hat. Then he blacked his face and hands with pot-black, and took a tin pan.
Allison and I had a fearful time getting into Veronica's dresses. They were a mile too big for us and no matter how much we tucked down in at

the waist, we were sure to trip and fall every minute, and have to pick each other up. It's a mystery to me how girls ever get around.

I blacked my face and hands, but Allison was too nice for that; so he put on a headdress he had made of foolscap. It came down over his face and went up in a big peak with two long horns. He had blacked it in stripes, and looked perfectly wild in it.

We laughed at each other for a spell, and then took a horn apiece and started. When we got to the house it was pretty late, and the charivari was in full swing. We agreed to keep together; but as soon as we mixed with the crowd, we were quickly separated.

There was a big crowd, and such an array of costumes you never saw. They all had torches of birch-bark and burning brooms, and such yelling and horn-blowing and pan-hammering! I got jostled around rather roughly, and, besides, I was beginning to be doubtful.

Some of the fellows were acting pretty wild; they had liquor, that was plain to be seen, and there was a good deal of fighting and pelting rocks at the house. And they kept getting worse. I was out of breath, blowing my horn, and, after I had been kicked and cuffed and knocked down once or twice, my taste for charivaris was a thing of the past.

Then some one fired a pistol, and I said to myself, "I'm for out of this," and looked around for the boys. I was just despairing of finding them, when the crowd opened before me and I saw Algie standing, bare-headed, at the other end of the space. He started across and got in the way of a big charivarier, who lifted his foot and kicked the child — Algie was only a little fellow.

Before I could move, Allison sprang out and struck the bully fair in the face. Then I shouted and sprang forward. Some one tripped me, and I fell; the next minute the whole crowd closed over me, mad with liquor, hooting and fighting. I thought the life was being trampled out of me, and then I felt some one grab me by the arm and drag me out. It was Allison; his headdress had fallen off, and he looked white and scared.

"Let's run," he panted.

"Algie!" I gasped.

"Wait for us up the lane! Quick, now, before they see us!"

We ran pell mell up the lane, Algie falling into rank as we passed him, and if you've ever tried to run in a girl's dress, you'll know it was a serious time. At the road I just dropped down to get my breath and take off that dreadful skirt.

"Tell you, we're lucky to get out of that," puffed Allison, as he struggled out of his. "Uncle was right, as he always is. What fools we've made of

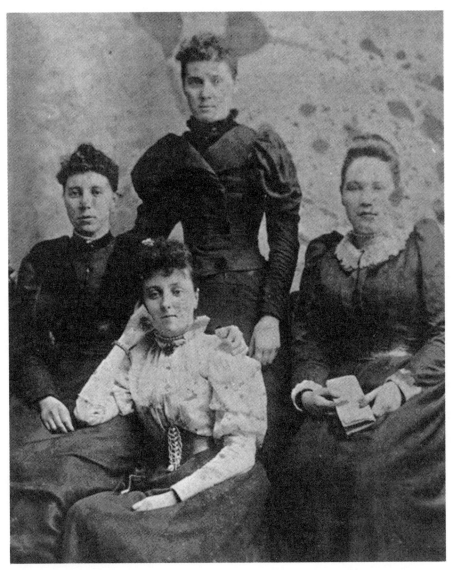

Lucy Maud Montgomery (Centre Front) With Three of Her Classmates at Prince of Wales College
(Courtesy Mrs. Irving Toombs)

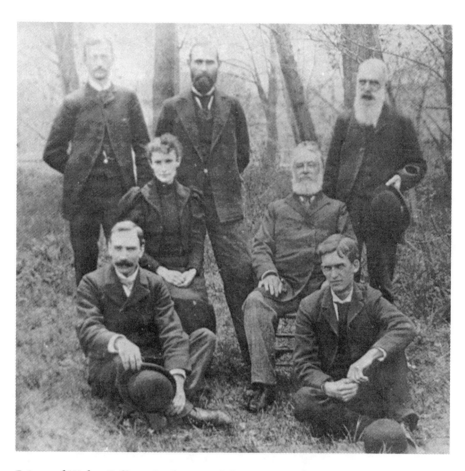

Prince of Wales College Professors while L. M. Montgomery was a Student
(Front row, L-R Professor Shaw, Professor Robertson; second row,
L-R Professor Scott, Professor Anderson; third row, L-R Professor Arsenault,
Professor Harcourt, Professor Caven)
(Courtesy Mrs. Irving Toombs)

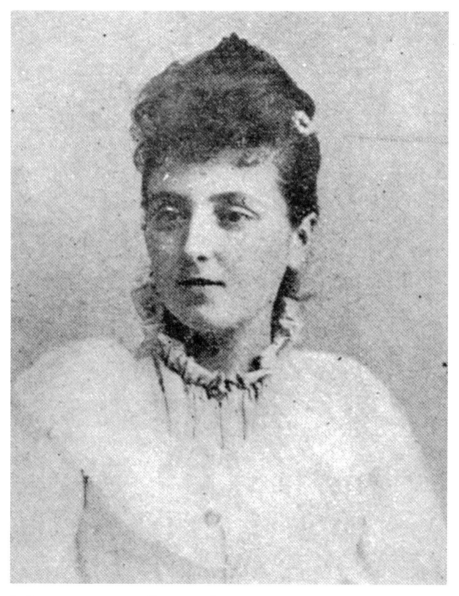

L. M. Montgomery at Dalhousie College

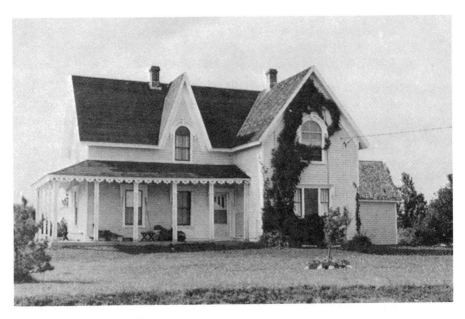

Parsonage at Bideford

Prince of Wales College in the 1890's
(Courtesy Dr. Stuart Macdonald)

Ladies' College, Halifax, Nova Scotia
(Courtesy Dr. Stuart Macdonald)

*ourselves! You're a brick, Fred! That fellow would have downed me —
he was a regular tough."*

"I guess we're quits," I said feebly. "Algie, did that chump hurt you?"

"My leg's pretty sore," he admitted. "I wish we'd minded Uncle
Lyman."

*Allison and I did, too; but that didn't mend matters, so we started
across the fields on the run. We were going at a furious rate, when we
came spang up against something. It was a barbed-wire fence, and we
hadn't seen it in the dark. Allison and I weren't hurt, as our heads came
above it. But it took Algie right across the face, and he said he was killed.*

*We knew he must be badly scratched, but the only thing to do was to
get home as soon as possible, and we had to go around by the road. We
didn't talk much, but when we got to the seaweed again, we stopped and
looked at each other, and Allison said:*

"Well!"

*It looks flat on paper, but I never realized before how much expression
could be crowded into a single syllable.*

*In all our scheming it had never occurred to us to ask how we were
going to get up and in again.*

*There was simply no way for it; we felt that we were sold. There was
only one thing to do. Allison and I might have braved it out till morning,
but Algie's face had to be attended to. We marched around to the door and
knocked. Soon we heard steps, and Uncle Lyman opened the door, holding
the lamp above his head and peering out in wonder. The wonder changed
to blank amazement when he saw us.*

*We pushed each other in and stood there a sorry trio — black, torn,
ragged, hats gone and blood all over Algie's face.*

Uncle set the lamp down and went to the hall door.

"Maria," *he called,* "get up and come out here, will you?"

Then he said, sternly:

"Now, boys, I want to know the meaning of this!"

*We stammered through it, piecing out each other's remarks, shame-
facedly. By the time we finished, Aunt Maria came in, and she took Algie
in hand, while Allison and I went out to scrub ourselves.*

"What do you suppose Uncle Lyman will do?" *questioned Allison, as
he helped me wash the back of my neck.* "Pack us off home to-morrow?"

"Like as not," *I answered, dolefully.* "It'll serve us right! But I'm sick
of this sort of thing, and I'm going to turn over a new leaf."

"Same here," *said Allison, energetically.*

And we went in to face our doom.

*But Uncle Lyman said not a word; he simply handed me the lamp and
pointed to the stairs.*

"We'll catch it to-morrow," whispered Allison, consolingly, as we went upstairs.

We were three pretty humble boys as we slipped down to breakfast next morning. We ached from our soles to our crowns. Allison had a black eye. I was all bruises. Algie came in after we did, and his face looked dreadful, and yet so comical — all patched with sticking-plaster. I didn't intend to laugh, but I happened to catch Allison's eye — nothing could keep that boy down long — and I snickered right out. Then I was more ashamed than ever.

Aunt Maria sat with her lips shut forbiddingly, but we were nearly through breakfast before Uncle Lyman spoke. Then he asked:

"Boys, have you had enough of this kind of fun?"

We said we had.

"Will you ever do the like again?"

"Never!" we all said; Algie said it twice.

And that was every word Uncle Lyman ever said, even when Jerry came in, and said a man had been seriously hurt the night before.

But we kept our word. Uncle Lyman had no reason to complain of our obedience the rest of the summer. He referred to the affair but once again. That was when he saw us off at the station. Just before the train started he came over to the edge of the platform.

"Boys," he said, "you've had some queer experiences this summer. Now, which one are you most ashamed of?"

As the train glided out we poked our heads out of the car window.

"The charivari!" we all replied together.

<div align="right">

Maud Cavendish.[20]

</div>

A prize contest sponsored by the Halifax *Evening Mail* provided the occasion for Lucy Maud's second coup during that memorable week in February, 1896. Dr. Archibald MacMechan, Professor of English Literature at Dalhousie College, judged the letters submitted during the contest on the subject — "Which has the most patience under ordinary cares and trials of life — man or woman?" Professor MacMechan informed the editor of the *Evening Mail* that "after careful consideration he judged the verses written by "Belinda Bluegrass" were the best expression of what he personally believed to be the truth."[21] He added that "they showed thought as well as point and vivacity."[22] The imaginative Lucy Maud Montgomery, writing under the pen name "Belinda Bluegrass," was thus the winner of the first prize of five dollars offered by the *Evening Mail*. The editor of the paper warmly congratulated her on "carrying off first prize in a competition

in which several hundred competitors appeared."[23] Her prize-winning opus was quite terse:

> As my letter must be brief,
> I'll at once state my belief,
> And this it is — that, since the world began,
> And Adam first did say,
> " 'Twas Eve led me astray,"
> A woman hath more patience than a man.
>
> If a man's obliged to wait
> For some one who's rather late,
> No mortal ever got in such a stew,
> And if something can't be found
> That's he sure should be around,
> The listening air sometimes grows fairly
> blue.
>
> Just watch a man who tries
> To soothe a baby's cries,
> Or put a stove pipe up in weather cold,
> Into what a state he'll get;
> How he'll fuss and fume and fret
> And stamp and bluster round and storm
> and scold!
>
> Some point to Job with pride,
> As an argument for their side!
> Why, it was so rare a patient man to see,
> That when one was really found,
> His discoveries were bound
> To preserve for him a place in history!
>
> And while I admit it's true
> That man has some patience too,
> And that woman isn't always sweetly calm,
> Still I think all must agree
> On this central fact — that she
> For general all-round patience bears the
> palm.
>
> **BELINDA BLUEGRASS.**[24]

The acceptance that gave Lucy Maud the greatest satisfaction was the publication of her poem, "Fisher Lassies," in the magazine, *Youth's Com-*

panion. From her earliest years, Lucy Maud seemed to want to prove that she could write acceptable poetry. There is some evidence to suggest that she was actually more interested in becoming a poet than a novelist. Most literary scholars are grateful that she did not become a poet. She had never been doubtful about her ability to weave satisfactory serials and short stories. Now the payment of twelve dollars by the editor of a quite respectable American magazine for her poem gave Lucy Maud tremendous encouragement. It is safe to say that from this moment Lucy Maud never looked back but, rather, advanced step by step to international success. The poem, like so many of her earlier efforts, was based upon life on the sea surrounding her beloved Cavendish:

FISHER LASSIES

The wind blows up from the nor'west waves,
Chill, salt, and strong from its ocean caves;
The sea glows yet in the sunset's hue
And the hollowing sky is a cup of blue.

But the sentinel rocks on the headland's right
Are black and grim in the waning light;
And, out in the west, a lone, white star
Keeps its steadfast watch o'er the harbor bar.

Over the waves where the red light floats
To the glooming shore come the fishing boats,
And the girls who wait for their coming in
Are something to wave and wind akin.

Born of the union of sky and sea,
Joyous, lithe-limbed, as the sea-birds free:
Fearless in danger and true as steel,
To friend unswerving, to lover leal.

No care is theirs — all the world they know
Is the sky above and the sea below.
Light o'er the waters their laughter floats,
As they wait on the sand for the fishing boats.

Brown are they, yet the tint that glows
In their cheeks has the hue of a crimson rose,
And never brighter or clearer eyes
Watched across the bar 'neath the sunset skies.

When the wearisome toil of the day is done
And the boats come in with the setting sun,

Sweethearts and brothers, tall and tanned,
Bend to the oars with a firmer hand.

Each one knows at the landing dim
Some one is waiting to welcome him.
Over the harbor the twilight creeps,
The stars shine out in the sky's clear deeps.

From far sea-caves come a hollow roar
And the girls have gone from the darkened shore;
For the crimson has died from the sky-line's bound
And the boats are all in from the fishing ground.

M. L. CAVENDISH[25]

During her year at Dalhousie College, Lucy Maud contributed many articles to the student newspaper called the *College Observer*. Actually, a close perusal of the paper for the academic year 1895-1896 reveals, that both in terms of quantity and quality, Lucy Maud was the leading contributor. Her most publicized article was entitled, "A Girl's Place at Dalhousie College," which was published in a four-page supplement to an April issue of the Halifax *Herald* devoted to Dalhousie College. The editor of the *Herald* was quite laudatory of Lucy Maud and of her literary effort. He wrote:

Wednesday's issue of the Halifax *Herald* was a Dalhousie College number. It contains a four page supplement with cuts of governors, professors and benefactors as well as a historical account of the college and description of the work done by the various college societies. Perhaps the most interesting article in the supplement is from the pen of Lucy M. Montgomery dealing with the higher education of women. Miss Montgomery has just completed her first year at Dalhousie and has already shown great literary ability. She is a native of Prince Edward Island and a granddaughter of the late Senator Montgomery. Miss Montgomery's reputation as a clever writer is well known. Last winter a few verses written in hurried and impromptu manner carried off the first prize in a competition in the Halifax *Herald* in which several hundred competitors appeared. Read her excellent article on "A Girl's Place at Dalhousie College."[26]

A GIRL'S PLACE AT DALHOUSIE COLLEGE

"Why, sirs, they do all this as well as we."
° ° ° ° °

"Girls,
Knowledge is now no more a fountain sealed;
Drink deep until the habits of the slave,
The sins of emptiness, gossip and spite,

And slander, die. Better not be at all
Than not be noble."
 o o o o o

"Pretty were the sight,
If our old halls could change their sex and
 flaunt
With prudes for proctors, dowagers for
 deans,
And sweet girl graduates in their golden
 hair."

Tennyson — "The Princess."

It is not a very long time, as time goes in the world's history, since the idea of educating a girl beyond her "three r's" would have been greeted with up lifted hands and shocked countenances. What! Could any girl, in her right and proper senses, ask for any higher, more advanced education than that accorded her by tradition and custom? Could any girl presume to think that the attainments of her mother and grandmother before her, insufficient for her? Above all, could the dream of opposing her weak feminine mind to the mighty masculine intellect which had been dominating the world of knowledge from a date long preceding the time when Hypatia was torn to pieces by a mob of Alexandria?

"Never," was the approved answer to all such questions. Girls were "educated" according to the standard of the time. That is they were taught reading and writing and a small smattering of foreign languages; they "took" music and were trained to warble pretty little songs and instructed in the mysteries of embroidery and drawing. The larger proportion of them, of course, married, and we are quite ready to admit that they made none the poorer wives and mothers because they could not conjugate a Greek verb or demonstrate a proposition in Euclid. It is not the purpose of this article to discuss whether, with a broader education, they might not have fulfilled the duties of wifehood and motherhood equally well and with much more of ease to themselves and others.

OLD TRADITIONS DIE HARD

and we will step very gently around their death bed. But there was always a certain number of unfortunates — let us call them so since the world would persist in using the term — who, for no fault of their own probably, were left to braid St. Catherine's tresses for the term of their natural lives; and a hard lot truly was theirs in the past. If they did not live in meek dependence with some compassionate relative, eating the bitter bread of unappreciated drudgery, it was because they could earn a meagre and precarious subsistence in the few and underpaid occupations then open to women. They

*could do nothing else! Their education had not fitted them to cope with
any and every destiny; they were helpless straws, swept along the merciless
current of existence.*

*If some woman, with the courage of her convictions, dared to make a
stand against the popular prejudice, she was sneered at as a "blue-stocking,"
and prudent mothers held her up as a warning example to their pretty, friv-
olous daughters, and looked askance at her as a not altogether desirable
curiosity.*

*But, nowadays, all this is so changed that we are inclined to wonder
if it has not taken longer than a generation to effect the change. The "high-
er education of women" has passed into a common place phrase.*

A GIRL IS NO LONGER SHUT OUT FROM THE
TEMPLE OF KNOWLEDGE

*simply because she is a girl; she can compete, and has competed, success-
fully with her brother in all his classes. The way is made easy before her
feet; there is no struggle to render her less sweet and womanly, and the
society of to-day is proud of its "sweet girl-graduates."*

*If they marry, their husbands find in their wives an increased capacity
for assistance and sympathy; their children can look up to their mothers for
the clear-cut judgment and the wisest guidance. If they do not marry, their
lives are still full and happy and useful; they have something to do and can
do it well, and the world is better off from their having been born in it.*

*In England there have been two particularly brilliant examples of what
a girl can do when she is given an equal chance with her brother; these
are so widely known that it is hardly necessary to name them. Every one
has read and heard of Miss Fawcett, the brilliant mathematician, who came
out ahead of the senior wrangles at Cambridge, and of Miss Ramsay, who
led the classical tripos at the same university.*

*In the new world, too, many girl students have made for themselves
a brilliant record. Here, every opportunity and aid is offered to the girl
who longs for the best education the age can yield her. There are splen-
didly equipped colleges for women, equal in every respect to those for men;
or, if a girl prefers co-education and*

WISHES TO MATCH HER INTELLECT WITH
MAN'S ON A COMMON FOOTING,

*the doors of many universities are open to her. Canada is well to the front
in this respect and Dalhousie college, Halifax, claims, I believe, to have been
the second college in the Dominion to admit girl students, if we can use
the word "admit" of an institution which was never barred to them. Girls,
had they so elected, might have paced, with note-book and lexicon, Dal-
housie's classic halls from the time of its founding. When the first applica-*

tion for the admission of a girl to the college was received, the powers that were met together in solemn conclave to deliberate thereon, and it was found that there was nothing in the charter of the college to prevent the admission of a girl.

Accordingly, in 1881 two girls, Miss Newcombe and Miss Calkin, were enrolled as students at Dalhousie. Miss Calkin did not complete her course, but Miss Newcombe did and graduated in 1885 with honors in English and English history, — the first of a goodly number who have followed in her footsteps. Miss Newcombe afterwards became Mrs. Trusman and is now on the staff of the Halifax Ladies' college. In 1882 Miss Stewart entered, took the science course and graduated in 1886 as B.Sc. with honors in mathematics and mathematical physics.

In 1887 three girls graduated, Miss Forbes and Miss MacNeill each took their degree of B.A., the latter with high honors in English and English history. The third, Miss Ritchie,

THE MOST BRILLIANT OF DALHOUSIE'S GIRL GRADUATES

took her B.L., she then took her Ph.D., at Cornell university and is now associate professor of philosophy in Wellesley college. Then occurs a hiatus in the list, for we find no girls graduating till 1891 when there were four who received their degrees, Miss Goodwin, Miss McNaughton and Miss Baxter in arts; Miss Muir took her degree of B.L.

In 1892 Miss Baxter, who had graduated with high honors in mathematics and mathematical physics, took her degree of M.A., after which she went to Cornell and there gained a Ph.D.

Miss Muir took her M.L., in 1893 and has since been studying for a Ph.D., at Cornell. In 1892 three girls, Miss Weston, Miss Archibald and Miss Harrington, obtained their B.A. degree. Miss Archibald graduated with great distinction and took her M.A. in 1891. Afterwards she went to Bryn Mawr college, winning a scholarship at her entrance. Miss Harrington graduated with high honors in English and English literature and became M.A. in 1894. She also won a scholarship at Bryn Mawr, where she is at present studying.

In 1893 the two girl graduates were Miss McDonald and Miss Murray, the latter of whom took high honors in philosophy and is now on the staff of the Ladies college. The graduates of 1894 were Miss Hebb, B.A., Miss Hobrecker, B.A., Miss Jameison, B.A., and Miss Ross, B.A. Miss Hobrecker took honors in English and German. Miss Jameison and Miss McKenzie each took their M.A. in 1895. Miss Ross graduated with high honors in mathematics and mathematical physics.

IN 1895 THREE GIRLS GRADUATED B.A.

Miss McDonald took honors in mathematics and mathematical physics; Miss Ross was the second Dalhousie girl to graduate with "great distinction," and takes her M.A. this year. Miss Bent is at present studying for her M.A.

It will be seen, from those statements, that, out of the twenty-five girls who have graduated from Dalhousie, nearly all have done remarkably well in their studies, and attained to striking success in their examinations. This, in itself, testifies to their ability to compete with masculine minds on a common level. This year there is a larger number of girls in attendance at Dalhousie than there has been in any previous year. In all, there are about fifty-eight, including the lady medical students. Of course, out of these fifty-eight a large proportion are not undergraduates. They are merely general students taking classes in some favorite subject, usually languages and history.

In all, there are about twenty-nine undergraduate girls in attendance this session. The number of girls in the freshman class is the largest that has yet been seen at Dalhousie. Out of the twenty-six girls, at whom
DISDAINFUL SOPHS ARE PRIVILEGED TO
HURL ALL THE OLD JOKES
that have been dedicated to freshmen since time immemorial, there are nine undergraduates. In the second year are eleven girls, eight of whom are undergraduates; and in the third year six out of the nine girls are also undergraduates.

There are also nine girls in the fourth year, seven of whom graduate this session. This is the largest class of girls which has yet graduated from Dalhousie. Several of these are taking honors and will, it is expected, amply sustain the reputation which girl students have won for themselves at the university. No girl has as yet attempted to take a full course in law at Dalhousie. Not that any one doubts or disputes the ability of a girl to master the mysteries of "contracts" or even the intricacies of "equity jurisprudence;" but the Barristers' act, we believe, stands ruthlessly in the way of any enterprising maiden who might wish to choose law for a profession.

However, we did hear a different reason advanced not long ago by one who had thought the subject over. He was a lawyer himself, by the way, so no one need bring an action against us for libel. "Oh, girls," he said,
"GIRLS WERE NEVER CUT OUT FOR
LAWYERS."
"They've got too much conscience." We have been trying ever since to find out if he were speaking sarcastically or in good faith.

But, if shut out from the bar, they are admitted to the study and practise of medicine and two girls have graduated from the Halifax medical college as full fledged M.D's. One of these, Miss Hamilton, obtained her

degree in 1894 and has since been practising in Halifax. In 1895 Miss
McKay graduated and is now, we understand, practising in New Glasgow.
There are at present three girl students at the medical college. One will
graduate this year; of the other two, one is in the third, and one in the first
year.

Dalhousie is strictly co-educational. The girls enter on exactly the
same footing as the men and are admitted to an equal share in all the priv-
ileges of the institution. The only places from which they are barred are
the gymnasium and reading room. They are really excluded from the
former, but there is nothing to keep them out of the reading room save
custom and tradition. It is

THE DOMAIN SACRED TO MASCULINE
SCRIMMAGES AND GOSSIPS

and the girls religiously avoid it, never doing more than cast speculative
glances at its door as they scurry past into the library. We have not been
able to discover what the penalty would be if a girl should venture into the
reading room. It may be death or it may be only banishment for life.

The library, however is free to all. The girls can prowl around there
in peace, bury themselves in encyclopedias, pore over biographies and
exercise their wits on logic, or else they can get into a group and carry on
whispered discussions which may have reference to their work or may not.

They take prominent part in some of the college societies. In the
Y.M.C.A. their assistance is limited to preparing papers on subjects con-
nected with missions and reading them on the public nights; in the Philo-
mathic society they are more actively engaged. The object of this society
is to stimulate interest and inquiry in literature, science and philosophy.
Girls are elected on the executive committee and papers on literary sub-
jects are prepared and read by them throughout the session.

They are also

INITIATED INTO THE RITES AND CEREMONIES
OF THE PHILOSOPHICAL CLUB

and are very much in demand in the Glee club. Once in a while, too, a
girl is found on the editorial staff of the Dalhousie Gazette, and what the
jokes column would do, if stripped of allusions to them, is beyond our com-
prehension.

The athletic club, however, numbers no girls among its devotees and
it does not seem probable that it will — certainly not in this generation, at
least. The question of the higher education of girls involves a great many
interesting problems which are frequently discussed but which time alone
can solve satisfactorily. Woman has asserted her claim to an equal educa-
tional standing with man and that claim has been conceded to her. What

use then, will she make of her privileges? Will she take full advantage of them or will she merely play with them until, tired of the novelty, she drops them for some mere fad? Every year since girls first entered Dalhousie, has witnessed a steady increase in the number of them in attendance; and it is to be expected that, in the years to come, the number will be very much larger. But beyond a certain point we do not think it will go. It is not likely that the day will ever come when the number of girl students at Dalhousie, or at any other co-educational university, will be equal to the number of men. There will

ALWAYS BE A CERTAIN NUMBER OF CLEVER
AMBITIOUS GIRLS

who, feeling that their best life work can be accomplished only when backed up by a broad and thorough education, will take a university course, will work conscientiously and earnestly and will share all the honors and successes of their brothers. There will, however, always be a limit to the number of such girls.

Again, we have frequently heard this question asked: "Is it, in the end, worth while for a girl to take a university course with all its attendant expense, hard work, and risk of health?" How many girls, out of those who graduate from the universities, are ever heard of prominently again, many of them marrying or teaching school? Would not an ordinarily good education have benefited them quite as much? Is it then worth while, from this standpoint, for any girl who is not exceptionally brilliant, to take a university course?

The individual question of "worth while" or "not worth while" is one which every girl must scramble for herself. It is only in its general aspect that we must look at the subject. In the first place,

AS FAR AS DISTINGUISHING THEMSELVES
IN AFTER LIFE GOES,

take the number of girls who have graduated from Dalhousie — say thirty, most of whom are yet in their twenties and have their whole lives before them. Out of that thirty, eight or nine at the very least have not stood still but have gone forward successfully and are known to the public as brilliant, efficient workers. Out of any thirty men who graduate, how many in the same time do better or even as well? This, however, is looking at the question from the standpoint that the main object of a girl in taking a university course is to keep herself before the public as a distinguished worker. But is it? No! At least it should not be. Such an ambition is not the end and aim of a true education.

A girl does not — or, at least, should not — go to a university merely to shine as clever students take honors, "get through and then do something

very brilliant." Nay; she goes — or should go — to prepare herself for living, not alone in the finite but in the infinite.

SHE GOES TO HAVE HER MIND BROADENED

and her powers of observation cultivated. She goes to study her own race in all the bewildering perplexities of its being. In short, she goes to find out the best, easiest and most effective way of living the life that God and nature planned out for her to live.

If a girl gets this out of her college course, it is of little consequence whether her after "career" be brilliant, as the world defines brilliancy, or not. She has obtained that from her studies which will stand by her all her life, and future generations will rise up and call her blessed, who handed down to them the clear insight, the broad sympathy with their fellow creatures, the energy of purpose and the self-control that such a woman must transmit to those who come after her.

<div align="center">

LUCY M. MONTGOMERY.[27]

</div>

While in Halifax Lucy Maud's literary efforts earned her a notable reputation as a writer. Her academic achievements were equally as illustrious. The Halifax *Herald* commented that, "Miss Lucy Maud Montgomery, of Cavendish, although not taking the regular undergraduate course, has done excellent work, particularly in English. Miss Montgomery leads her classes in senior English for this term's work, and makes a first class in her second year's work in English."[28] The literary and academic success that Lucy Maud enjoyed at Dalhousie inspired her with renewed self-confidence. She would have loved to continue her studies for a Bachelor of Arts degree, but her financial situation precluded such a program. Thus, early in May, 1896, she returned to Cavendish and spent the next few weeks, like all young aspiring teachers, interviewing critical school trustees with a view to obtaining a teaching position. Lucy Maud was now prepared to dedicate herself to a teaching and literary career always hoping that she would eventually reach the elusive goal, "of true and honoured fame,"[29] that had been the keynote of her every aim and ambition since her early youth.

FOOTNOTES TO CHAPTER V

[1] L. M. Montgomery, "The Alpine Path," *Everywoman's World*, Vol. VIII, No. 11, (August, 1917), p. 32.

[2] L. M. Montgomery, "The Wreck of the Marcopolo," 1883, 20 August, 1892; this poem appears in L. M. Montgomery's scrapbook, 1890-1898; a notation in her own handwriting states that the poem was written in 1891.

[3] *The Daily Patriot*, 15 July, 1893.

[4] *The Daily Patriot*, 8 June, 1894.

[5] *The Daily Patriot*, 9 June, 1894.

[6] The Charlottetown *Examiner*, 11 June, 1894.

[7] *The Daily Patriot*, 11 June, 1894.

[8] *The Daily Patriot*, 9 June, 1894.

[9] Lucy Maud contributed five different articles. These can be found in her scrapbook (1890-1898). One of these articles, "High School Life in Saskatchewan," is published in Chapter III.

[10] L. M. Montgomery, "The Alpine Path," *Everywoman's World*, Vol. VIII, No. II, (August, 1917), pp. 32-33.

[11] L. M. Montgomery's scrapbook, 1890-1898.

[12] L. M. Montgomery, "The Alpine Path," *Everywoman's World*, Vol. VIII, No. II, (August, 1917), p. 33.

[13] *Ibid.*

[14] *The Daily Patriot*, 20 June, 1894.

[15] L. M. Montgomery to Penzie Macneill, 28 October, 1894.

[16] L. M. Montgomery, "The Alpine Path," *Everywoman's World*, Vol. VIII, No. IV, (October, 1917), p. 8.

[17] L. M. Montgomery, "The Alpine Path," *Everywoman's World*, Vol. VIII, No. II, (August, 1917), p. 33.

[18] *Ibid.*

[19] *Ibid.*, p. 16.

[20] L. M. Montgomery, "Our Charivari," published in Philadelphia, *Golden Days;* copy in L. M. Montgomery's scrapbook, 1890-1898.

[21]Archibald MacMechan to the editor of the Halifax *Evening Mail,* February, 1896.

[22]*Ibid.*

[23]Halifax *Evening Mail,* February, 1896.

[24]Belinda Bluegrass (L. M. Montgomery), "Which has the most patience under the ordinary cares and trials of life — man or woman?"; Halifax *Evening Mail,* February, 1896; copy in L. M. Montgomery's scrapbook, 1890-1898.

[25]L. M. Montgomery, "Fisher Lassies", *Youth's Companion;* copy in L. M. Montgomery's scrapbook, 1890-1898.

[26]Halifax *Herald,* April, 1896; copy in L. M. Montgomery's scrapbook, 1890-1898.

[27]L. M. Montgomery, "A Girl's Place at Dalhousie College," Halifax *Herald,* April, 1896; copy in L. M. Montgomery's scrapbook, 1890-1898.

[28]Halifax *Herald,* April, 1896, *ibid.*

[29]L. M. Montgomery, "The Alpine Path," *Everywoman's World,* Vol. VII, No. VI, (June, 1917), p. 5.

CHAPTER VI

INTERNATIONAL FAME WITH ANNE

Lucy Maud obtained a teaching position in Belmont, Lot 16, for the academic year 1896-1897. Belmont was and is a beautiful and thriving agricultural community fronting on the waters of picturesque Richmond Bay. Interestingly enough, the school in which Lucy Maud taught was situated on land donated to the district by a new resident, James Simpson, a nephew of her grandfather, Alexander Marquis Macneill.[1] Moreover, she kept the family connection alive by becoming engaged during the year to her second cousin, Edwin Simpson, a prosaic young man from Belmont, who was studying for the Baptist ministry. Although she broke the engagement a few years later, it provided some distraction for her during a school year that she did not particularly enjoy. She boarded a short distance from the school with Mr. and Mrs. Simon Fraser. Since Simon Fraser's brother, Daniel, kept the post office in the house, Lucy Maud's boarding house had a flavour reminiscent of the Macneill homestead in Cavendish.[2] Moreover, the beautiful Fraser home located a few yards from the shore of Richmond Bay was idyllic for Lucy Maud who was so attached to the sea. During her year at Belmont, she combined, with some sacrifice, a teaching and literary career. She elaborated feelingly in later years upon her experience:

During one of those winters of school teaching I boarded in a very cold farmhouse. In the evenings, after a day of strenuous school work I would be too tired to write. So I religiously rose an hour earlier in the mornings for that purpose. For five months I got up at six o'clock and dressed by lamplight. The fires would not yet be on, of course, and the house would be very cold. But I would put on a heavy coat, sit on my feet to keep them from freezing, and with fingers so cramped that I could scarcely hold the pen, I would write my "stunt" for the day. Sometimes it would be a poem in which I would carol blithely of blue skies and rippling brooks and flowery meads! Then I would thaw out my hands, eat breakfast, and go to school.

When people say to me, as they occasionally do, "oh I envy you your gift, how I wish I could write as you do," I am inclined to wonder with some inward amusement, how much they would have envied me those dark, cold winter mornings of my apprenticeship.[3]

In spite of this uncomfortable aspect of her environment, Lucy Maud enjoyed a good measure of literary success during her year in Belmont. It seemed that the cold, dark mornings tested her tenacity and sincerity of purpose. She wrote acceptable poems and short stories for many Sunday School publications and juvenile periodicals. Moreover, she managed to add several respectable new journals to her list. One of the poems written in Belmont that gave her especial delight was based upon a treasured Park Corner memory of her youth. She tells us of the background for the poem.

In Uncle John Campbell's house at Park Corner, there is a certain old screw sticking out

from the wall on the stair landing which always makes me realize clearly that I am really grown-up. When I used to visit at Park Corner in the dawn of memory that screw was just on a level with my nose! *Now*, it comes to my knees. I used to measure myself by it every time I went over.[4]

Poetic license changed the screw into "The Marked Door," and a poem by that name appeared in *The Ladies' Journal* in August, 1897:

THE MARKED DOOR

Long ago, when the children played
In the poplars' greenness of light and
* shade,*
Or danced at will through the dim old
* hall,*
Where the flickering shadows of vine-
* leaves fall,*
Never a birthday brought its joys,
To the lightsome hearts of the girls and
* boys,*
But they marked their height on the
* old hall door,*
To compare with the inches they'd gain-
* ed before.*

Every fleeting and happy year,
Has left the trace of its passing here;
There is the first-born's height at
* four —*
The earliest mark on the old hall door —
And again at six, and eight and ten;
Ah, me! How tall he has grown since
* then!*
The stern, grave soldier in army blue,
Might scarcely pass this low doorway
* through.*

Yet he stands to-night by his mother's
* chair,*
With his mirthful eyes and his sunny
* hair,*
A lad of ten summers forever more,
Charmed out of the past by the old hall
* door.*

The upward rows of the twins are here,
The last mark down in their sixteenth
* year,*
And, between them, their sisters, sweet
* and fair,*
With calm blue eyes and braided hair.

One lad has written his boyhood's name,
After years of toil, on the roll of fame,
But the grave of the other is far away,
And the girls are mothers and wives
* to-day,*
Yet they're here unchanged — they have
* grown no more,*
Since the last mark made on the old
* hall door.*
Long, long since have the children
* strayed,*
From the farmhouse old in the poplar
* shade.*

One by one they have slipped away —
The nest is empty of all to-day,
Hardly the mother her own may know,
Where are the children of long ago?
Here alone, at the old hall door,
In the hour of twilight they come once
* more,*
And the mother, at rest in the same
* old chair,*
Has all her darlings around her there.

Men and women no longer, they
Are here, but the children of yesterday,
With their old time frolics, and glee,
* and noise,*
Their April griefs and their childish
* joys,*
Their fresh, young hopes and their souls
* of truth,*
Their fair ambitions and dreams of
* youth.*

Oh! mother-heart! Though they all
* have grown,*
So tall and strange they are here your
* own.*
Always the same as in days of yore,
You may find them still at the old hall
* door.*

L. M. Montgomery[5]

Belmont, P. E. Island.

After spending the summer holidays with her grandparents in Caven-
dish, Lucy Maud accepted a teaching position in Lower Bedeque for the
year 1897-1898. This new teaching assignment thrust her into the United
Empire Loyalist heartland of Prince Edward Island. Descendants of early
Loyalist families such as the Hoopers, MacCallums and Wrights were num-
bered among the pupils that she taught in Lower Bedeque.[6] The growth
of Summerside and the decline of shipbuilding in the immediate area with
the departure of the famous Pope family greatly depopulated Lower
Bedeque. When Lucy Maud taught in the school there were only fourteen
pupils enrolled. But this low enrollment did not depress Lucy Maud.
Since her predilection was writing rather than teaching, the reduced teach-
ing load enabled her to devote more time and energy to her literary en-
deavours. The results were quite satisfactory. A substantial number of her
poems and short stories that she forwarded to periodicals were published.
The one that gave her the greatest pleasure both to write and to see in print
was a poem entitled — "A Country Boy" — which appeared in *Golden Days*
in December, 1897. It expressed Lucy Maud's deep personal attachment to
rural life:

A COUNTRY BOY

That's just what I am, sir — a country boy —
And mine is a life that is full of joy.
The city is jolly enough to see,
But the country, sir, is the place for me.

Dull, you call it? I think you'd find
Life on the farm would change your mind.
I've time for sport when my chores are done,
And the fun you've worked for is real fun.

It's jolly to skate on winter nights,
When the sky is agleam with Northern
* lights!*
Talk of your rinks — but the pond below
Grandfather's barn is the place to go.

The coasting over on Red Spruce Hill
Can't be beaten, say what you will;
And a snowshoe tramp when the moon is out
Is the best thing going, beyond a doubt.

In summer I fish and swim and ride,
And roam at will in woodlands wide;
Hunt for berries in long, clear days,
Or go a-nutting in beechen ways.

I'm friends with beetles and birds and bees,
With meadow blossoms and forest trees,
And I know the secrets of shy green nooks —
A knowledge you never can learn of books.

The cows all know me, the horses neigh
For pleasure whenever we pass that way;
And as for old Rover, whate'er I do,
Isn't half the fun if he's not there, too.

I'm as happy and glad as a boy can be,
And I know that this is the place for me,
The world may be wide and the city gay,
But the farm is just where I mean to stay.

> *L. M. Montgomery.*
> *Lower Bedeque, P.E. Island.*[7]

Unfortunately, Lucy Maud's literary outpourings at Lower Bedeque came to an abrupt halt. On March 5, 1898, her grandfather, Alexander Marquis Macneill, died suddenly in Cavendish from a massive heart attack at the age of seventy-eight.[8] Her aging grandmother was now left alone in the old Macneill homestead. It was simply inconceivable to Lucy Maud that her grandmother, who had provided her with a home since early child-hood, should be left alone in Cavendish. Although Lucy Maud did not relish the prospect of leaving Lower Bedeque and returning to the rigorous Macneill household, her sense of duty prevailed. She recognized that if she did not return to Cavendish, her grandmother would have to leave the old

home, and such a move would break her heart. Lucy Maud, therefore, resigned and the school was entrusted for the remaining 110 days of the term to Alpheus Leard, a son of Mr. and Mrs. Cornelius Leard with whom she had boarded while in Lower Bedeque.[9] Her leaving also terminated a few months of intense courtship with Alpheus' brother, Herman Leard, whom she loved deeply, but would not marry because of his lack of education and his station in life as a farmer. Lucy Maud need not have ruled out marriage in any case since Herman died of influenza the next year at the age of twenty-seven. Lucy Maud, at the age of twenty-four, was destined to dedicate all but a few months of the next thirteen years to the dutiful and often trying service of one who had been both mother and grandmother to her.

Upon her return to Cavendish, Lucy Maud had to make the necessary adjustments to her new way of life. The independence, and the comparatively free evenings she had enjoyed as a member of the teaching profession were now only memories. Her primary responsibility was to assist her grandmother in the management of the home and post office. It was necessary for her and her grandmother to exercise financial prudence. Her grandfather's will, which Lucy Maud described as "exceedingly foolish," in that it gave their farm to his son, John Franklin, placed them in "an anomalous position". John Franklin was obviously waiting for the moment when he could also assume possession of the old Macneill homestead. During these "Cavendish years" she frequently alluded to her onerous tasks in the sequence of letters that she faithfully exchanged with Ephraim Weber, her pen-pal of some forty years. Commenting on her domestic chores she wrote: "Recently, gardening, house-keeping, etc., has pushed literary work to the wall."[10] Some months later she complained: "I have been scrubbing and whitewashing and digging out old corners and I feel as if all the dust I've stirred up and swept out and washed off has got into my soul and settled there and will remain there forever making it hopelessly black and grimy and unwholesome."[11] The role of hostess also proved somewhat taxing at times. She wrote: "I'm tired — deadly tired — all the time — just as tired when I wake in the morning as when I go to bed at night — tired body, soul and spirit. I have constant head-aches and no appetite ... We had a houseful of guests all summer, the weather was fearfully hot and I was very much worried in one way or another almost constantly."[12] "I have been waiting for weeks," she wrote one year later, "in the vain hope of getting enough time to write you a decent letter 'at one fell swoop,' and not simply by fits and starts — five minutes now and ten minutes later on as most of my letters have been written this summer. We have had a houseful of company and I've been so busy! ... Our guests left last week, however, and now I

mean to settle down, if possible, to a good autumn's work."[13] It was obvious that the lure of Cavendish for visitors was an early phenomenon in Prince Edward Island's history.

As her grandmother advanced in years, Lucy Maud's role became even more arduous. She elaborated upon her difficult and demanding situation to her friend, Ephraim Weber: "You say you wonder why I don't travel. It is simply because I cannot leave home. Grandma is 82 and I cannot leave her, for even a week's cruise. We live all alone and there is no one I can get to stay with her. I am very much tied down but it cannot be helped. Some day, I hope to be able to see a bit of the world."[14] On another occasion she remarked: "As for photographs, well I have none on hand just now and I don't know when I will have any. I can't get to town for more than a day twice a year and there I'm always too tired and too worried to bother with photos."[15] In a moment of depression and fatigue she commented to Weber that she wished she "could get away for a trip and change, but that is impossible as I can't leave Grandma."[16] She could not even attend the premiere of the beautiful Island Hymn that she wrote in 1908. She commented sadly: "My Island Hymn was sung and presented as a stage picture at a concert in the Opera House in town the other night. The author and composer were called before the curtain and cheered. But only the composer could respond. The author couldn't go. She had to stay home and wish she could."[17] Thus Lucy Maud, with corresponding sacrifice, repaid her grandmother for the care she herself had received since her childhood. Lucy Maud asserts that these years were not easy "as her aging Grandmother made life hard for her in a score of petty ways." Lucy Maud managed to find some consolation with her camera. She became an excellent photographer, and developed her own pictures with all the efficiency and flair of a professional.

Although Lucy Maud's principal preoccupation was the care of her grandmother, she found time to make an appreciable contribution to her Church and community. From 1900 until 1911 she was organist and choir director of the Cavendish Presbyterian Church. She refers to this role with a touch of humor:

Well, it is nearly dark and time I was getting ready for Church, since I'm organist and must sit up on the choir platform and face the audience during the service. So I dare not slur my toilette but must appear point device. At our last choir practice, we practised up, "Behold the Bridegroom Cometh," for a collection anthem. Yesterday I had to summon an extra session of the choir to learn a new piece since the "supply" who preaches for us tonight really *is* a bridegroom, having been married only last week! It would have been a good joke to let the thing go on but I thought the poor man might feel insulted and ministers are so scarce that we dare not play any tricks with our chances of getting one.[18]

Lucy Maud also participated in the religious education of the youth even though she did not find this function particularly rewarding:

Yes, I teach a Sunday School class — but I don't like it much. I have a class of half grown girls but they seem stupid and commonplace. They never dream of asking a question, much as I have tried to induce them, and all their idea of "studying" a lesson seems to be to learn the printed questions in the quarterlies off by heart. I never can get them to give an answer in their own words and I don't believe they ever get one scrap of real good out of the lesson. I have to follow the old paths of thought & expression or I would get into hot water immediately. Cavendish is wholesomely (?) old-fashioned and orthodox.[19]

Despite her reservations about the tenets of her Presbyterian faith she never faltered in her outward adherence to its forms and practices.

In addition to her participation in Church activities, Lucy Maud played an active role in community affairs. She was a member of both the Cavendish Women's Institute and of the Cavendish Literary Society. Naturally enough, she took a deep interest in the Literary Society. It was formed in Cavendish in the year 1886, and its purpose was "the mutual improvement of its members by means of lectures, debates and the establishment of and maintenance of a circulating library."[20] Lucy Maud is first mentioned in the Society minutes of November 2, 1889, when, at the age of fifteen, she gave a recitation entitled, "The Child Martyr."[21] From this beginning until she left Cavendish permanently some twenty-two years later she was a very active participant in the program of the Society. She delivered numerous papers to the membership and was Secretary of the Society during the years 1905-1906.[22] She took especial satisfaction from serving as one of the editors of the yearly publication of the Society. In April, 1906, she remarked with some pride: "Yes — our Literary Society paper — the *Cavendish Literary Annual* — came off on schedule and was fairly good, though we — the editors — 'say it as oughtn't.' We had a number of contributions from various writers, one all the way from Scotland, so our table of contents was quite cosmopolitan."[23] Associated with and an important part of the program of the Society was a circulating library. Since Lucy Maud was an avid reader, she made excellent use of the library's facilities. "I have been," she wrote to Weber, "on a debauch of books for a fortnight. A long-delayed grist of books for our library arrived and I've simply read myself stupid and soggy over them I must sober up from book-saturation, get work done, and take up my pen again."[24]

Lucy Maud did not need to feel any compunction regarding her literary career. Although her household and post office duties limited the time available for writing, she carefully budgeted her minutes to give her some time each day for her literary activity. On one occasion she remarked:

"I only do three hours' literary work a day — two hours' writing and one typewriting. I write fast having 'thought out' plot and dialogue while I go about my household work."[25] Moreover, Lucy Maud constantly made preparations for her principal avocation: "When I come across an idea for a story or poem — or rather when an idea for such comes across me, which seems the better way to put it—" she explained to Weber, "I at once jot it down in my notebook. Weeks, months, often *years* after, when I want an idea to work up I go to the notebook and select the one that suits my mood or magazine."[26] This clever arrangement enabled Lucy Maud to ply her literary trade while engaged in many and varied activities.

Thus, from the time of her return to Cavendish in April, 1898, until she went to Halifax for a few months in 1901, Lucy Maud enjoyed a good measure of success in her literary efforts. "By 1901," she tells us with some satisfaction in "The Alpine Path," "I was beginning to make a 'livable' income for myself by my pen though that did not mean that everything I wrote was accepted on its first journey. Far from it. Nine out of ten manuscripts came back to me. But I sent them over and over again, and eventually they found resting places."[27] Lucy Maud had come up with a clever maneuver. The story or poem that did not interest one editor, she discovered, often proved to be just what another editor wanted. She employed this clever and quite legitimate strategy throughout her literary career, and with handsome results.

Lucy Maud expressed considerable satisfaction with the progress she made during this three-year period:

Munsey's came today with my poem, 'Comparisons' in it, illustrated. It really *looked* nice. I've been quite in luck of late, for several new and good magazines have opened their portals to this poor wandering shepherd of thorny literary ways. I feel that I am improving and developing in regard to my verses. I suppose it would be strange if I did not, considering how hard I study and work. Every now and then I write a poem which serves as a sort of landmark to emphasize my progress. I know, by looking back, that I would not have written it six months, or a year, or four years ago, any more than I could have made a garment the material of which was still unwoven.[28]

Her progress allowed her to hope for modest future recognition:

I wrote two poems this week. A year ago, I could not have written them, but now they come easily and naturally. This encourages me to hope that in the future I may achieve something worth while. I never expect to be famous. I merely want to have a recognized place among good workers in my chosen profession. That, I honestly believe, is happiness, and the harder to win the sweeter and more lasting when won.[29]

With such a high degree of application to her profession and with such integrity of purpose, it is easy to appreciate why Lucy Maud Montgomery achieved international acclaim.

From April of the year 1898, until her grandmother's death in March, 1911, she arranged only one long-term interlude away from home. In October, 1901, she went to Halifax, and there, the twenty-seven-year-old Lucy Maud obtained a position with the *Daily Echo*, the evening edition of the Halifax *Chronicle*.[30] "I'm a newspaper woman!"[31] she wrote excitedly in her journal of November 11, 1901. Her duties were many and varied. "Life in a newspaper office," she commented realistically, "isn't all 'beer and skittles' any more than anywhere else."[32] She corrected proofs, answered the telephone, edited a page of "society letters," some of which she had to compose herself, and wrote a weekly column, "Around the Tea-Table," which she signed Cynthia. The journalistic aspect of her position was quite helpful in that the inevitable newspaper deadlines helped to sharpen her powers of concentration and to develop instant facility of expression.

Of course, Lucy Maud did not neglect her literary career. Initially she found it extremely difficult to cope with the realities of her new environment. She elaborates upon the problem in her journal entry of November 18, 1901:

Have had a difficult time trying to arrange for enough spare minutes to do some writing. I could not write in the evenings, I was always too tired. Besides, I had to keep my buttons sewed on and my stockings darned. Then I reverted to my old practice, and tried getting up at six in the morning. But it did not work, as of yore. I could never get to bed as early as I could when I was a country 'schoolma'arm,' and I found it impossible to do without a certain amount of sleep.[33]

But Lucy Maud made a fairly simple discovery which allowed her to continue her creative work:

Hitherto, I had thought that undisturbed solitude was necessary that the pot of genius might burn and even the fire for pot-boiling. I must be alone, and the room must be quiet. I could never have even imagined that I could possibly write anything in a newspaper office, with rolls of proof shooting down every ten minutes, people coming and conversing, telephones ringing, and machines being thumped and dragged overhead. I would have laughed at the idea, yea I would have laughed it to scorn. But the impossible has happened. I am of one mind with the Irishman who said you could get used to anything, even to being hanged![34]

Lucy Maud's utilization of her spare moments in the office soon reaped handsome dividends. As the weeks passed she increased her literary output. "All my spare time here I write," she commented, "and not such bad stuff either, since the *Delineator*, the *Smart Set* and the *Ainslies'* have taken some of it. I have grown accustomed to stopping in the middle of a paragraph to interview a prowling caller, and to pausing in full career after an elusive rhyme, to read a lot of proof, and snarled-up copy."[35] The acceptance of her material by three leading American magazines of the day was a

Belmont School
(Courtesy Paula Coles)

Lower Bedeque School
(Courtesy Paula Coles)

Lucy Maud and her pupils at Belmont school, 1896-97
(Courtesy Dr. Stuart Macdonald)

L. M. Montgomery when Anne was written

Lucy Maud in her late 30's
(Courtesy Dr. Stuart Macdonald)

Window of Lucy Maud's room in Macneill homestead
(Courtesy Dr. Stuart Macdonald)

*Kitchen of Macneill Home when L. M. Montgomery wrote
Anne of Green Gables* (Courtesy Dr. Stuart Macdonald)

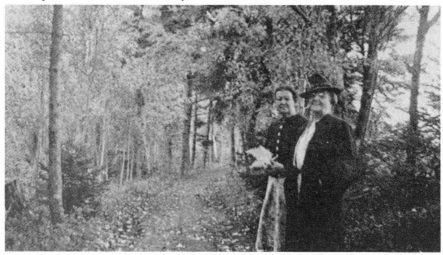

Mrs. Ernest Webb and Lucy Maud Macdonald in Lover's Lane, Cavendish

Halifax Daily Echo
(Courtesy Dr. Stuart Macdonald)

concrete indication of her growing literary stature.

In June, 1902, Lucy Maud returned to Cavendish where she remained almost continuously for the next nine years. She settled down to writing poems, short stories and serials, and to assisting her grandmother in managing the Macneill household. Her literary efforts were financially remunerative. In March, 1905, she informed Mr. Weber that she "had made nearly $600 last year — $591.85 to be exact."[36] "I shan't be content," she added, "until I reach the thousand mark though."[37] She soon began to give the one-thousand-a-year aim a good run. In the years 1905 and 1906, she gained acceptance in more prestigious national adult magazines that paid larger stipends. In June, 1905, for example, she tells us, that *Gunter's* Magazine, New York, sent her $25 for a short story. This, with $10 from the *National,* $20 from the *Designer,* $15 from *Modern Women* added to smaller amounts from various magazines gave her over $100 for the month of June.[38] In December, 1906, she announced gleefully that *Everybody's* paid her one hundred dollars for a 5,000 word story.[39] Lucy Maud was now recognized as a professional in the short story world. Perhaps the time was now at hand for her to attempt writing something much more ambitious — a book-length novel.

It was some two years after her return from Halifax when Lucy Maud began to entertain seriously the idea of writing a book. "It had always been," she later recalled, "my hope and ambition to write one. But I never seemed able to make a beginning."[40] And, in the end, the actual decision to write her first novel "just happened."[41] She explains the circumstances quite graphically:

I had always kept a notebook in which I jotted down, as they occurred to me, ideas for plots, incidents, characters and descriptions. In the spring of 1904 I was looking over this notebook in search of some idea for a short serial I wanted to write for a certain Sunday School paper. I found a faded entry written many years before. "Elderly couple apply to orphan asylum for a boy. By mistake a girl is sent them." I thought this would do. I began to block out the chapters, devise, and select incidents and "brood up" my heroine. Anne — she was not so named of malice aforethought, but flashed into my fancy already christened, even to the all-important "e" — began to expand in such a fashion that she soon seemed very real to me and took possession of me to an unusual extent.[42]

Lucy Maud also states that the adoption of a young girl, Ellen, by Pierce Macneill of Cavendish, helped to influence her in the selection of a story and plot for her book.

The captivating personality of *Anne* so intrigued her creator, Lucy Maud Montgomery, that she made a momentous decision:

She (Anne) appealed to me, and I thought it rather a shame to waste her on an ephemeral little serial. Then the thought came, "Write a book. You have the central idea.

All you need do is spread it out over enough chapters to amount to a book." The result was *Anne of Green Gables*. I wrote it in the evenings after my regular day's work was done, wrote most of it at the window of the little gable room that had been mine for many years. I began it, as I have said, in the spring of 1904. I finished it in the October of 1905.[43]

Thus, her first best seller, written in the evenings after her household duties were done, was completed by the talented Lucy Maud Montgomery in some eighteen months.

Like most authors, Lucy Maud now wondered whether her manuscript would merit publication. She kept her labor of love a well-guarded secret. "I didn't squeak a word to anyone about it," she later confided to a friend, "because I feared desperately I wouldn't find a publisher for it."[44] Her fears came perilously close to realization as publisher after publisher returned her manuscript with discouraging rejection slips. She elaborated upon her early misfortunes:

Well my book was finally written. The next thing was to find a publisher. I typewrote it myself, on my old second-hand typewriter that made the capitals plain and wouldn't print "W" at all, and I sent it to a new American firm that had recently come to the front with several "best sellers." I thought I might stand a better chance with a new firm than with an old established one that had already a preferred list of writers. But the new firm very promptly sent it back. Next I send it to one of the "old, established firms," and the old established firm sent it back. Then I sent it, in turn, to three "betwixt-and-between" firms and they all sent it back. Four of them returned it with a cold, printed note of rejection; one of them "damned with faint praise." They wrote that, "Our readers report that they find some merit in your story, but not enough to warrant its acceptance."[45]

This "damning with faint praise" so disheartened, humiliated and annoyed Lucy Maud that she relates that she "hid *Anne* away in an old hat-box in the clothes room, resolving some day when there was time to take her and reduce her to the original seven chapters of her first incarnation."[46] She would then, she was certain, have the story accepted as a serial in a juvenile magazine, and thus realize thirty-five or forty dollars for her efforts.[47] The manuscript lay in the old hat-box until she ran across it one wintry afternoon in 1907 while rummaging. After re-reading it, and still feeling it had possibilities, she decided to make another attempt to find a publisher. In mid-February, 1907, she sent her manuscript to L. C. Page Company of Boston, Massachusetts, a reputable publishing house that already published several successful books by well-known Canadian authors, notably, Charles G. D. Roberts and Bliss Carman.[48] This time, unlike previous occasions, her manuscript was not immediately returned. Lucy Maud's hopes began to rise as week after week, filled with suspense, passed. Finally, on the most memorable day of her life, April 18, 1907, she received

a letter from the L. C. Page Company accepting *Anne* and offering to publish it on a ten per cent royalty basis![49] Her life-long ambition had been realized.

That night an emotionally drained Lucy Maud Montgomery wrote with jubilation in her journal:

Well, I've written my book! The dream, dreamed years ago at the old brown desk in school has come true at last after years of toil and struggle. And the realization is sweet, almost as sweet as the dream. . . . The book may or may not succeed. I wrote it for love, not money, but very often such books are the most successful, just as everything in the world that is born of true love has life in it, as nothing constructed for mercenary ends can ever have."[50]

Lucy Maud was equally ecstatic when she shared her triumph with her pen-friend, Ephraim Weber:

Well, I must simply tell you my *great news* right off! To pretend indifference and to try to answer your letter first would be an affectation of which I shall not be guilty. I am blatantly pleased and proud and happy and I shan't make any pretence of not being so.[51]

It is not difficult to appreciate the immense satisfaction experienced by Lucy Maud Montgomery on having finally accomplished the challenging goal she had set for herself as a little girl while attending Cavendish school some twenty years before.

Although her book had at last been accepted, Lucy Maud had to wait many months before it was actually published. In the first place, she had to formalize the contract with the L. C. Page Company. She related some of the details of that formidable document in a letter written to Mr. Weber on May 2, 1907:

I signed the contract today; it is a fearsomely legal looking document all red seals and "saids" and "whereases". There is only one clause in it I don't altogether like. I have to bind myself to give them the refusal of all the books I may write for the next five years. The insertion of such a clause is rather complimentary, I suppose, but I'd rather not have to agree to it. However, I've done so and the rest is in the hands of the gods. I don't suppose the book will be out before the fall.[52]

Lucy Maud was being too optimistic. The artist responsible for the illustrations in *Anne of Green Gables* delayed the project for months, and it was not until June 20, 1908, that *Anne* made her unforgettable entry into the lives of millions. Lucy Maud recalls that momentous day:

"To-day has been, as *Anne* herself would say, 'an epoch in my life.' My book came to-day, 'spleet-new' from the publishers. I candidly confess that it was to me a proud and wonderful and thrilling moment. There, in my hand, lay the material realization of all the dreams and hopes and ambitions and struggles of my whole conscious existence — my first book. Not a great book, but mine, mine, mine, something, which I had created."[53]

After her long tedious years of apprenticeship, Lucy Maud richly deserved the happiness associated with the publication of her first novel.

Little did Lucy Maud anticipate the international acclaim that her first book would receive. She had always envisaged "a very moderate success, indeed, compared to that which it did attain."[54] "I never dreamed," she wrote in "The Alpine Path," "that it would appeal to young and old. I thought girls in their teens might like to read it, that was the only audience I hoped to reach. But men and women who are grandparents have written to tell me how they loved *Anne*, and boys at College have done the same."[55] She further commented on her astonishment in a letter to her first cousin, Professor Murray Macneill, of Dalhousie University:

It has been a great surprise to me that *Anne* should have taken so well with "grown-ups." When I wrote it, I thought it would be an amusing and harmless little tale for Sunday School libraries and "kiddies," but I did not suppose it would appeal to older readers. But it appears to have done so, and I have received a great many kind letters about it, from old acquaintances and strangers.[56]

"Don't stick up your ears now," she warned Ephraim Weber, "imagining that the great Canadian novel has been written at last. Nothing of the sort. It is merely a juvenilish story, ostensibly for girls."[57] For girls it may have been intended, but its appeal has been universal, to young and old alike, to men and women of every age, race and profession.

In the early summer of 1908, *Anne of Green Gables* reached the public market and was an immediate success. "You see," Lucy Maud reported to Mr. Weber in September, "*Anne* seems to have hit the public taste. She has gone through four editions in three months."[58] Three months later, she informed him that "*Anne* went into her sixth edition on December first,"[59] and that, "Sir Isaac Pitman & Sons, London, had brought out an English edition."[60] *Anne* was moving from continental to international recognition. In March of 1909, she announced that her sequel, *Anne of Avonlea*, was completed, but the publishers were delaying its release because "*Anne* was selling as well as ever and they do not wish to give her a rival as long as that continues."[61] The arrival of her first royalty for *Anne* was a barometer of its success: "In February, 1909, I got my first royalty cheque," she wrote, "for the amount due me up to the close of the year. It was for seventeen hundred and thirty dollars. Not bad for the first six months of a new book by an unknown author."[62] Since Lucy Maud received only nine cents per book on the wholesale price of ninety, over nineteen thousand copies had been sold. The success of *Anne of Green Gables* was truly phenomenal.

The sale of the book was helped immeasurably by the favorable publicity that it received. By September, 1908, there had been some sixty of-

ficial reviews of her novel. "Two," Lucy Maud told Weber, "were harsh, one contemptuous, two mixed praise and blame, and the remaining fifty-five were kind and flattering beyond my highest expectations."[63] Comments like those of the Pittsburg *Chronicle* that "the heroine of Anne of Green Gables is one of the cleverest creations in recent fiction,"[64] were repeated in review after review. "The reviews," Lucy Maud commented further in December, 1908, "keep coming in as usual. Success seems, as usual to have succeeded — that is they are almost all favourable now. Since I last wrote I have had only two unfavourable ones."[65] "*The Bookman*," she also noted, "has *Anne* listed as one of six 'best sellers' in ten different cities. This seems to me rather like something I've dreamed. I can't really believe it."[66] Lucy Maud was especially happy with the comments by the London *Spectator:* "It honoured me," she emphasized, "with a two column review and was exceedingly kind and flattering. I *did* feel flattered. The *Spectator* is supposed to be "the" review of England and praise or blame from it makes or mars I can't really believe that my little yarn, written with a single eye to Sunday School scholars, should really have been taken notice of by the *Spectator*."[67] The *Spectator* was a perfect mirror of the public since the whole world took notice of *Anne of Green Gables*.

Although the favorable tenor of these official reviews greatly pleased Lucy Maud, she derived even greater satisfaction from the personal letters of congratulations. As the weeks passed, hundreds of letters from all over the world poured into the home of the humble thirty-four-year-old author from Cavendish. "The letters are all nice," she remarked appreciatively to Mr. Weber, "and some of them are from people I am proud to think like my book."[68] She singled out Bliss Carman and Sir Louis Davies stating that "they had written very kind and flattering epistles."[69] Bliss Carman remarked that it was "a great test of the worth of the book that while the children are running all over the house looking for *Anne,* the head of the family has carried her off to read on his way to town. That is real success isn't it? Henceforth *Anne* will always remain one of the immortal children of fiction."[70] But the letter that touched her the deepest was from the seventy-three-year-old Mark Twain. He wrote that "in *Anne* she had created the dearest and most lovable child in fiction since the immortal Alice."[71] "Do you think," she asked Weber rhetorically, "I wasn't *proud* of Mark's encomium? Oh, perhaps not!"[72] After her long and arduous years of apprenticeship, Lucy Maud was eminently entitled to bask in the rays of such a noble tribute.

"With the publication of *Anne of Green Gables*," Lucy Maud wrote in "The Alpine Path," "my struggle was over."[73] She had certainly reached an important milestone in her career. As a child, Lucy Maud made the

following lines from "The Fringed Gentian" the keystone of her literary
objective:

> *"Then whisper, blossom, in thy sleep*
> *How I may upward climb*
> *The Alpine path, so hard, so steep,*
> *That leads to heights sublime;*
> *How I may reach that far-off goal*
> *Of true and honoured fame,*
> *And write upon its shining scroll*
> *A woman's humble name."*[74]

The universal acclaim which she received upon the publication of *Anne of
Green Gables* was evidence that Lucy Maud had climbed the Alpine Path
and written her name on the scroll of fame. But she was not prepared to
rest on her laurels. "I've reached a bit of upland now," she confided to
Weber, "and, looking back over the ascent, some things are made clear to
me that have long puzzled me. But there's lot of climbing to do yet. I
must take a long breath and start anew."[75] Millions of readers remain
grateful that the talented Lucy Maud Montgomery "continued climbing,"
and wrote some twenty-one additional novels during the remaining years of
her brilliant literary career.

FOOTNOTES TO CHAPTER VI

[1]H. H. Simpson, *op. cit.*, p. 229. James Simpson was a son of Hon. Jeremiah Simpson and Margaret Macneill. Margaret was a sister of Alexander Macneill. Mr. Simpson's grandson, Arnett Simpson and his wife provided the writer with valuable information on Belmont, past and present.

[2]*The History of Belmont,* Belmont Women's Institute, 1973. pp. 72-73.

[3]L. M. Montgomery, "The Alpine Path," *Everywoman's World,* Vol. VIII, No. 11, (August, 1917), p. 33.

[4]L. M. Montgomery, "The Alpine Path," *Everywoman's World,* Vol. VII, No. VII, (July, 1917), p. 35. The screw can still be viewed in the Campbell homestead in Park Corner.

[5]L. M. Montgomery, "The Marked Door," *The Ladies' Journal;* copy in L. M. Montgomery's scrapbook, 1890-1898.

[6]George A. Leard, *Historic Bedeque* (Bedeque, 1948), pp. 7-27.

[7]L. M. Montgomery, "A Country Boy," *Golden Days,* 1897; copy in L. M. Montgomery's scrapbook, 1890-1898.

[8]H. H. Simpson, *op. cit.*, p. 245.

[9]Department of Education Records, Lower Bedeque School, for the term ending June 30, 1898. Provincial Archives, Prince Edward Island.

[10]L. M. Montgomery to Ephraim Weber, 8 May, 1905, *op. cit.*, p. 31.

[11]L. M. Montgomery to Ephraim Weber, 2 May, 1907, *op. cit.*, p. 51.

[12]L. M. Montgomery to Ephraim Weber, 10 September, 1908, *op. cit.*, p. 75.

[13]L. M. Montgomery to Ephraim Weber, 2 September, 1909, *op. cit.*, p. 89.

[14]L. M. Montgomery to Ephraim Weber, 8 October, 1906, *op. cit.*, pp. 45-46.

[15]L. M. Montgomery to Ephraim Weber, 5 April, 1908, *op. cit.*, p. 66.

[16]L. M. Montgomery to Ephraim Weber, 10 September, 1908, *op. cit.*, p. 75.

[17]L. M. Montgomery to Ephraim Weber, 28 March, 1909, *op. cit.*, p. 87.

[18]L. M. Montgomery to Ephraim Weber, 10 November, 1907, *op. cit.*, p. 60.

[19]L. M. Montgomery to Ephraim Weber, 8 October, 1906, *op. cit.*, p. 46.

[20]Constitution of the Cavendish Literary Society, 19 February, 1886; H. H. Simpson, *op. cit.*, p. 182.

[21] *Ibid.*, p. 201.

[22] *Ibid.*

[23] L. M. Montgomery to Ephraim Weber, 8 April, 1906, *op. cit.*, p. 38.

[24] L. M. Montgomery to Ephraim Weber, 8 May, 1905, *op. cit.*, p. 31.

[25] L. M. Montgomery to Ephraim Weber, 5 April, 1908, *op. cit.*, p. 67.

[26] L. M. Montgomery to Ephraim Weber, 28 June, 1905, *op. cit.*, pp. 35-36.

[27] L. M. Montgomery, "The Alpine Path," *Everywoman's World*, Vol. VIII, No. III, (September, 1917), p. 8.

[28] *Ibid.*

[29] *Ibid.*

[30] *Ibid.*

[31] *Ibid.*

[32] *Ibid.*

[33] *Ibid.*

[34] *Ibid.*

[35] *Ibid.*

[36] L. Montgomery to Ephraim Weber, 7 March, 1905, *op. cit.*, p. 27.

[37] *Ibid.*

[38] L. M. Montgomery to Ephraim Weber, 28 June, 1905, *op. cit.*, p. 36.

[39] L. M. Montgomery to Ephraim Weber, 16 December, 1906, *op. cit.*, p. 49.

[40] L. M. Montgomery, "The Alpine Path," *Everywoman's World*, Vol. VIII, No. III, (September, 1917), p. 49.

[41] *Ibid.*

[42] *Ibid.*

[43] *Ibid.*

[44] L. M. Montgomery to Ephraim Weber, 2 May, 1907, p. 51.

[45]L. M. Montgomery, "The Alpine Path," *Everywoman's World,* Vol. VIII, No. IV, (October, 1917), p. 8.

[46]*Ibid.*

[47]*Ibid.*

[48]L. M. Montgomery to Ephraim Weber, 2 May, 1907, *op. cit.,* p. 51.

[49]*Ibid.*

[50]L. M. Montgomery, "The Alpine Path," *Everywoman's World,* Vol. VIII, No. IV, (October, 1917), p. 8.

[51]L. M. Montgomery to Ephraim Weber, 2 May, 1907, *op. cit.,* p. 51.

[52]*Ibid.,* p. 52.

[53]L. M. Montgomery, "The Alpine Path," *Everywoman's World,* Vol. VIII, No. IV, (October, 1917), p. 8.

[54]*Ibid.*

[55]*Ibid.*

[56]L. M. Montgomery to Murray Macneill, 6 July, 1909. This original letter is in the possession of Mrs. Ernest Macneill and Mrs. John Macneill of Cavendish. Ernest Macneill was a grandson of Alexander Marquis Macneill. John Macneill is the son of Ernest Macneill. Murray Macneill was the son of Reverend Leander Macneill, a brother of Lucy Maud's mother, Clara Woolner Macneill. The Macneills kindly allowed me to quote this letter.

[57]L. M. Montgomery to Ephraim Weber, 2 May, 1907, *op. cit.,* p. 51.

[58]L. M. Montgomery to Ephraim Weber, 10 September, 1908, *op. cit.,* p. 70.

[59]L. M. Montgomery to Ephraim Weber, 22 December, 1908, *op. cit.,* p. 80.

[60]*Ibid.*

[61]L. M. Montgomery to Ephraim Weber, 28 March, 1909, *op. cit.,* p. 85.

[62]*Ibid.*

[62]L. M. Montgomery to Ephraim Weber, 10 September, 1908, *op. cit.,* p. 71.

[64]*Ibid.*

[65]L. M. Montgomery to Ephraim Weber, 22 December, 1908, *op. cit.,* p. 80.

[66] *Ibid.*, p. 81.

[67] L. M. Montgomery to Ephraim Weber, 2 September, 1909, *op. cit.*, p. 93.

[68] L. M. Montgomery to Ephraim Weber, 22 December, 1908, *op. cit.*, p. 80.

[69] *Ibid.*

[70] Letter from Bliss Carman; copy in L. M. Montgomery's scrapbook, 1905-1917; scrapbook in possession of Ruth Campbell, Park Corner.

[71] L. M. Montgomery to Ephraim Weber, 22 December, 1908, *op. cit.*, p. 80.

[72] *Ibid.*

[73] L. M. Montgomery, "The Alpine Path," *Everywoman's World*, Vol. VIII, No. IV, (October, 1917), p. 8.

[74] L. M. Montgomery, "The Alpine Path," *Everywoman's World*, Vol. VII, No. VII, (June, 1917), p. 5.

[75] L. M. Montgomery to Ephraim Weber, 2 September, 1909, *op. cit.*, p. 92.

Epilogue

After the publication of *Anne of Green Gables* in 1908, Lucy Maud Montgomery wrote three additional novels before her departure from Cavendish in 1911. The first of these was entitled, *Anne of Avonlea*. The publishers of *Anne of Green Gables* were so enthusiastic about the story that they insisted that Lucy Maud prepare a sequel immediately. Although she would have preferred a respite, Lucy Maud complied with the request of her clamorous publishers. Thus the story of *Anne*, which Lucy Maud originally intended to terminate with the first book, went on eventually into a series of some eight titles. *Anne of Avonlea*, which was centered on *Anne's* teaching career in Avonlea school, received from Lucy Maud the same dedication that had been accorded *Anne of Green Gables*. Consequently, her second novel in two years, appeared in the bookstores in September, 1909. Lucy Maud took her second publication in stride. "The new book is out," she informed Weber, "as I got my copies yesterday. We soon get used to things. I was quite wild with excitement last year on the day my first book came. But I took this one coolly, very coolly and it caused merely a momentary ripple on the days' surface."[1] Lucy Maud entertained serious reservations about her second book. "I had to write it too *hurriedly*," she complained to Weber, "and the *freshness* of the *idea* was gone. It didn't *grow* as the first book did. I *simply* built it. *Anne*, grown-up couldn't be made as quaint and unexpected as the child, *Anne*."[2] She was even more frank in a letter to her cousin, Professor Murray Macneill: "My second *Anne* book will not be as successful as the first. I wrote it, not because I wanted to but because my publishers insisted, and I do not think such 'made to order' books ever have much life in them."[3] The phenomenal popularity of *Anne of Avonlea* certainly does not reflect the pessimistic views of Lucy Maud. While she, herself, was tired of *Anne*, thousands of readers hoped for additional sequels.

Anne of Avonlea, which Lucy Maud informs us contained less that was real than *Anne of Green Gables*, although it did incorporate some of her own teaching experiences, was followed in 1910 by *Kilmeny of the Orchard*. This story was written several years before the *Anne* books, and appeared as a serial in an American magazine, under another title.[4] Lucy Maud was, therefore, greatly amused when a few perspicacious reviewers commented that "*Kilmeny of the Orchard* revealed 'the insidious influence of popularity and success' in its style and plot."[5] She, herself, could have informed the reviewers that if the book did have serious shortcomings, they could be traced principally to the fact that the publishers omitted a whole chapter in the first edition! When Lucy Maud noticed the omission, she

telegraphed the publishers who had been unaware of their mistake. The new edition was corrected, the man responsible for the error was dismissed, and the author was granted damages after suing the company.[6] Her fourth book, *The Story Girl*, was written in 1910 and published in 1911. "It was the last book," Lucy Maud recalled nostalgically, "I wrote in my old home by the gable window where I spent so many happy hours of creation."[7] She always spoke feelingly of *The Story Girl*. "It is my own favourite among my books," she confessed in "The Alpine Path," the one that gave me the greatest pleasure to write, the one whose characters and landscapes seem to me most real."[8] Fittingly enough, she dedicated it to her cousin, and very very intimate friend, Fredericka E. Campbell, since many scenes, events and people of Park Corner, and of course, Cavendish, figured prominently in the thirty-two stories that constituted the subject matter of *The Story Girl*.

The year 1911 was an eventful one — a veritable watershed — in the life and career of Lucy Maud Montgomery. On March 5 of that year her grandmother, Lucy Woolner Macneill, developed pneumonia, and passed away five days later at the age of eighty-seven. Thirteen arduous years of faithful service by a devoted granddaughter was terminated. With her grandmother's death, the old Macneill homestead, Lucy Maud's home for thirty-four of her thirty-seven years, was abandoned. Her Uncle Franklin took possession of the property immediately, so Lucy Maud was happy to accept an invitation to move to her Uncle John and Aunt Annie Campbell's house at Park Corner, which had been a second home to her since childhood. After a short holiday in Boston, she returned to Park Corner, and lived with the Campbells until her marriage in July, 1911.[9]

' Lucy Maud's future husband was the Reverend Ewen Macdonald, a Presbyterian minister, born on the family farm in Bellevue, Prince Edward Island in 1870. After completing his undergraduate studies at Prince of Wales College and Dalhousie University, he studied theology at Pine Hill Seminary in Halifax. In September, 1903, he came to Cavendish as minister of the Presbyterian congregation.[10] During his incumbency he developed a close friendship with Lucy Maud whom he saw frequently in her capacity as Church organist and assistant postmistress. Although he and Lucy Maud were not engaged until 1906, he confessed he'd "had his eye on her from the beginning."[11] Lucy Maud responded to his proposal. She was in a position to do so since she had broken her engagement with Edwin Simpson, a person she had never loved. Moreover, she claimed that marriage with Edwin was always out of the question since the Macneills would never have allowed her to marry a Baptist. Lucy Maud stated in later life that she never regretted her decision since she really loved Ewen

and was always contented with her marriage and motherhood. Although Ewen was no Herman — she could never love anyone as much as she loved Herman — his age, education and social standing eminently qualified him to be her husband. If they had been allowed to follow the dictates of their hearts, they would have been married prior to his departure from Cavendish in 1906. But Lucy Maud had promised to remain with her grandmother as long as she lived, and she held steadfastly to her word. Thus there began for Ewen Macdonald five years of waiting for his bride. He spent the academic year 1906-1907, taking advanced courses in theology at the United Free Church College, Glasgow, Scotland. Upon his return to the Island, he accepted a call to Bloomfield charge which also included the congregation of O'Leary and Brae. He resigned in September, 1909, and moved to Leaskdale, Ontario in March, 1910, where he became minister of the congregation of Leaskdale and Zephyr.[12]

A few weeks after the death of Lucy Maud's grandmother in March, 1911, the shy and dour Mr. Macdonald asked the elders of the tiny Presbyterian church in Leaskdale for a three-month leave of absence. He wanted to return to Prince Edward Island to marry Miss Lucy Maud Montgomery and to spend a honeymoon in Scotland and England.[13] When one of the elders' wives ventured to produce her copy of *Anne of Green Gables*, the discreet and secretive minister remarked quietly that, "yes, I understand the young lady is a writer."[14] He also requested, if it wouldn't be too much trouble, that, "those who were decorating the Manse would see that the floors were painted green."[15] Satisfied with these arrangements, Ewen Macdonald departed for Prince Edward Island to marry the famous Island author for whom he had waited patiently through the years.

On July 5, 1911, at twelve o'clock noon, the Reverend John Stirling, pastor of Cavendish Presbyterian Church officiated at the quiet wedding of Lucy Maud Montgomery and the Reverend Ewen Macdonald in the living room of her Uncle John and Aunt Annie Campbell's home at Park Corner. While George Campbell's wife, Ella Johnstone Campbell, played the wedding march the bridal party entered the parlor while "The voice that breathed o'er Eden" was sung.[16] After the ceremony, the Campbell girls, Clara, Stella and Fredericka served the wedding banquet to the twenty-two invited guests. At four o'clock the happy couple left for Summerside, and three days later, the thirty-six-year-old Maud Montgomery Macdonald and her forty-year-old husband sailed from Montreal on the *Megantic* for a honeymoon in the British Isles.[17] When Lucy Maud was a student at Prince of Wales College she remarked flippantly to a friend that the man she married must be able to take her on a honeymoon to Europe. The

reality was probably no less pleasant even though her royalties were expended to sponsor the 1911 trip. For Lucy Maud, the trip, was, as she noted, "another dream of her life come true,"[18] for "I had always wished to visit the old land of my forefathers."[19]

The newly married couple spent the next ten weeks visiting the birthplace of their Scottish and English ancestors, exploring the areas made famous by noted poets and novelists such as Burns, Tennyson, Wordsworth and Scott, and viewing the many historic buildings that dotted the cities, towns, villages and countryside of the British Isles. As usual, Lucy Maud kept a journal, recorded vivid descriptions and impressions of the tour. While admitting that Scotland and England had magnificient scenery, she would not concede that it approached that of her native Island: "Beautiful, yes!" she wrote of Iona, "and yet neither there, nor anywhere else in England or Scotland, did I behold a scene more beautiful than can be seen any evening at home, standing on the "old church hill" and looking afar over New London Harbour."[20] After enjoying the splendor of Loch Katrine, she wrote: "Ah! beautiful as the old world is, the homeland is the best."[21] "Last night," she wrote nostalgically in Berwick, "we all went for a walk along the Spittal shore by moonlight. It was beautiful but so like Cavendish shore that it made me bitterly homesick."[22] It was possible to take the woman out of Prince Edward Island, but not Prince Edward Island out of the woman.

The highlight of her tour apparently was the purchase of a pair of china dogs in an antique shop in York, England. She had been looking for such a treasure-trove since her arrival in the British Isles. One of her treasured childhood memories was a pair of china dogs which sat (and still sit) on the sitting-room mantel of her Grandfather Montgomery's home in Park Corner. They were white with green spots all over them, and her father, Hugh John Montgomery, had told her that whenever they heard the clock strike twelve at midnight they bounded down on the hearth and barked. She found a pair with gold spots much larger than the Park Corner dogs. "They are," she wrote gleefully, "over a hundred years old and I hope they will preside over my Lares and Penates with due dignity and aplomb."[23] Another very enjoyable experience was her trip to Dunwich, England, where she visited the birthplace of her grandmother Macneill. She was delighted to find the old Woolner home, although now in other hands, in a good state of repair.[24] On September 21, saturated with sight-seeing, they sailed for home. After a short visit in New York, Lucy Maud and her husband departed for their new life in the small picturesque community of Leaskdale, Ontario, which comprised some twelve houses.

While the Macdonalds toured the British Isles, the Leaskdale church

ladies scrubbed, polished and painted the Manse. For their first three weeks in Leaskdale, Ewen and Lucy Maud boarded with the Misses Mary and Elizabeth Oxtoby, directly across from the Church, while the heavy crates of furniture, books and china kept arriving and being unpacked as the busy bride set up "her household gods" in the Manse.[25] One of the most precious arrivals from Prince Edward Island was her grandmother's cat, Daffy. "He's a peach!" she admitted, "Really, he's everything a cat should be except that he hasn't a spark of affection in his soul."[26] Finally, their household in order, and the dark-haired bride in her white satin wedding dress welcomed at a large formal church reception in early October, Maud Montgomery Macdonald settled down to fifteen years at Leaskdale as minister's wife, mother, and, of course, author.

Just as in earlier years Lucy Maud had combined a literary career with teaching and household obligations, at Leaskdale, and later at Norval and Toronto, she managed to integrate her literary pursuits with her responsibilities as minister's wife and mother to two children. The Macdonalds had three sons; Chester Cameron, who became a lawyer, was born July 7, 1912; Hugh Alexander, born August 13, 1914, lived only one day; and Stuart, who became a medical doctor and his mother's literary executor, was born October 7, 1915.[27] Her sons were a constant joy to her and she bestowed upon them unselfish love during the years that they were under her care, generously assisted them to obtain their higher educations in law and medicine, and to establish independent professional careers of their own. While there is considerable evidence to suggest that she did not particularly enjoy many of the tedious responsibilities associated with her role as wife of a minister in a small community, she religiously fulfilled her obligations. She regularly taught her Sunday School class, attended, gave outstanding leadership to, and occasionally lectured, the Women's Missionary Society, the Ladies' Aid, the Women's Auxiliary, and the Young People's Guild, accompanied her husband on visits to the sick, the aged, and the dying, and on his one-day-a-week parish visits in Leaskdale and Zephyr, and was present at the weddings, wedding receptions, wakes and funerals of all their parishioners. In the Manse, she performed her role with scrupulous attention to what she considered was expected of a minister's wife.[28] She was a perfect hostess and is remembered by the Leaskdale and Norval communities with reverence and love.[29] Not until her journals and private correspondence were made public was it realized how utterly taxing and meaningless many of these religious duties were to the basically untraditional and emphatically unorthodox Lucy Maud Macdonald.

Although she was now a minister's wife and mother, Lucy Maud was determined to continue her literary career. Her husband, who was always

quite proud of his wife's literary talents, recognized that writing should be given a high priority in her life. With the money that accrued from her publications she was in a position to employ competent and dedicated household assistants. This enabled her to set aside certain hours each day for her literary pursuits. "Normally," one of her Leaskdale housekeepers recalls, "Mrs. Macdonald wrote each morning from 9 to 12. She worked with her china dogs beside her, and often one of her pets as well."[30] "Mrs. Macdonald," she continued, "first jotted down her ideas, next she collected these together and planned her book. Later her story was arranged in chapters and sent to the publishers. She spent at least a year on each of the books she wrote in Leaskdale."[31] In the year following her arrival at Leaskdale, she published *Chronicles of Avonlea*, a set of Island stories reflecting her understanding and appreciation of the Island way of life. Although she gave birth to two children in the next three years, and kept pace with her zealous and dedicated husband, she wrote two books, *The Golden Road* and *Anne of the Island*.[32] *The Golden Road*, an elegy on childhood, completed the seasonal cycle of *The Story Girl*. Just as in *The Story Girl*, many of the characters and events in *The Golden Road* were drawn from real life. Lucy Maud relates that Jerry Peters was her grandfather Macneill's hired man for some seven years and the best servant the Macneills ever had. *Dan King's* "worst adventure," was herself and Dave Nelson coasting in Charles Macneill's field. The account of "how Carlisle got its name," was based on the story of how Hunter River was named. Peg Bowen and the Yankee storm are also real. Lucy Maud was not allowed, as she hoped, "to say farewell to *Anne* forever."[33] Her publishers asserted that her readers were demanding a third *Anne*, so she complied and wrote *Anne of the Island* which dealt with *Anne's* college days. She pointedly dedicated it "to all the girls all over the world who have 'wanted more' about *Anne*."[34]

Emotions stirred by the First World War led Lucy Maud Macdonald to a renewed activity in poetry. In 1916 she brought out a collection of poems under the title of *The Watchman and Other Poems*, dedicated to the Canadian soldiers who had died in the war.[35] Poetry has always been Lucy Maud's first love and passion since her early childhood, and this volume consisted principally of poems she had published in various magazines over the years. The title poem is a meditative monologue on the Resurrection, in a manner reminiscent of Robert Browning. Most of the other poems she selected for publication dealt with the indelible memories of her youth — the sea at Cavendish and the pastoral landscape of Prince Edward Island.[36] In 1917, *Anne's House of Dreams* appeared. The focus in this book moves from *Anne* to her family. Lucy Maud, although, "completely

stale on *Anne*"[37] wrote *Rainbow Valley* in 1919. When *Rilla of Ingleside* was written for publication in 1921, Lucy Maud declared emphatically: "In it I definitely and for all time conclude the *Anne* series, I swear it by the nine gods of Clusium."[38] But famous authors are often victims of their own success, and Lucy Maud's publishers pressured her to renege on her promise before her literary career ended.

In 1923 she began her Emily trilogy with the publication of *Emily of New Moon*. She dedicated it to one of her two platonic pen-friends, George Boyd Macmillan of Alloa, Scotland, "in recognition of a long and stimulating friendship."[39] The theme of a writer's ambition, which had been a sub-current in the early *Anne* books, became a major strand in the *Emily* series.[40] The climb of Emily Byrd Starr up "the Alpine path so hard, so steep," resembled, Lucy Maud stated, "in some respects," her own literary career. The *Emily* books are, on the whole, very much more autobiographical than the *Anne* series. *Emily of New Moon* was followed in 1925 by *Emily Climbs*.[41] She then interrupted the *Emily* series to write a novel for adults. It appeared in 1926, and was entitled, *The Blue Castle*.[42] In order to keep her friendship in balance, she dedicated it to her other lifelong pen-pal, Ephraim Weber. She expressed the hope that in *The Blue Castle* she had "climbed" past the stereotype of girls' books that had been the constant factor in her literary career.[43] The ambitious Lucy Maud was not departing from the resolution she had expressed after publishing *Anne of Green Gables*, that "there's lots of climbing to do yet."[44]

In 1926, Lucy Maud Macdonald had fifteen books to her credit, four written in Cavendish, and eleven in Leaskdale. But the career of author, minister's wife and mother of two energetic boys taxed her powers of endurance to the limit. In order to obtain necessary revitalization, she and the family frequently spent their annual holidays on Prince Edward Island. When once she set foot on the red soil of her beloved Island she experienced a welcome regeneration. She wrote of the rejuvenative qualities of the Island:

Peace! You never know what peace is until you walk on the shores or in the fields or along the winding red roads of Abegweit on a summer twilight when the dew is falling and the old, old stars are peeping out and the sea keeps its nightly tryst with the little land it loves. You find your soul then. You realize that youth is not a vanished thing but something that dwells forever in the heart. And you look around on the dimming landscape of haunted hill and long white-sand beach and murmuring ocean, on homestead lights and the old fields tilled by dead and gone generations who loved them . . . even if you are not Abegweit born, you will say . . . "Why . . . I have come home.''[45]

After frequent visits to her many "favourite haunts" in Cavendish and Park Corner and enjoyable social calls upon her many relatives and close friends, she would always return with renewed vigor to her regular activities.

Shortly after the return of the Macdonalds from a 1925 Prince Edward Island holiday, the Reverend Ewen Macdonald accepted a call to Norval, Ontario. It was with deep regret that the Macdonalds left Leaskdale. Lucy Maud had an especial predilection for the Manse. It was her first *real* home, the place where her three sons were born and where the majority of her books were written. But a change was necessary. Mr. Macdonald was in declining health and it was expected that the pastoral duties at Norval would be less onerous than those at Leaskdale. Thus, in February, 1926, the Leaskdale congregation reluctantly parted with the Macdonald family.[46] Lucy Maud's life at Norval followed a pattern similar to that of Leaskdale. But there was an added responsibility. Her husband suffered continually from a gradually worsening religious melancholia characterized by periods of deep depression and constant complaints about his health. Mr. Macdonald's periodic bouts with melancholia had begun early in his life. Although Lucy Maud was not aware of it, he had had nervous depressions at Prince of Wales College, at Dalhousie College, and during his year of graduate study at Glasgow Seminary. She learned later that the root cause was a sermon on hell that Ewen had heard when he was a student at Prince of Wales. He became convinced that he, himself, was predestined to hell; and periodically, this fear thrust him into depression and insomnia which often lasted for months. While she understandably maintains she would not have married him if she had known about his condition, she never faltered in her devotion to him. Lucy Maud attempted to hide her husband's melancholia from his congregation by maintaining a smiling countenance and by personally assuming responsibility for the fulfilment of many of his functions.[47] The years at Leaskdale and especially at Norval taxed Lucy Maud's powers of endurance to their extreme limits.

Meanwhile, her own career, as usual, was a world by itself. In 1927, she completed her *Emily* trilogy with *Emily's Quest*.[48] In 1930, another fantasy-child was added with the publication of *Magic for Marigold*.[49] *A Tangled Web*, which appeared in 1932, was the second novel written by Lucy Maud which was intended principally for adult readers. During these years at Norval, Lucy Maud added a *Pat* series to her *Anne* and *Emily* creations. *Pat of Silver Bush*, had as its setting, the old Campbell homestead nestled in a birch grove in Park Corner, Prince Edward Island, the home that Lucy Maud said in 1932 she loved "better than any place on earth."[50] The sequel, *Mistress Pat*, which was also a novel of Silver Bush, was published in 1935.[51] These stories, revolving around *Pat*, a convincing child deeply attached to her home and fearful of chance and change, appealed to "a new generation" growing up on *Anne* and *Emily*.

An interesting feature of the *Pat* series is the conspicious role played by

cats. Through Judy, the old Irish servant, in the *Pat* household, Lucy Maud keeps cats in the forefront. Her personal attachment to cats is almost unbelievable. From her early childhood, as her letters to Penzie Macneill reveal, she had a deep deep attachment to them. In Cavendish, Leaskdale, in Norval, and later in Toronto, cats had a privileged place in Lucy Maud's homes. One particular cat, Lucky, which Lucy Maud obtained in Prince Edward Island, was especially loved by her. "I loved other cats *as cats*," Lucy Maud commented, "I loved Lucky as a human being ... whatever Lucky was, he was *not* a cat ... it was not a cat soul that inhabited his body."[52] She even dedicated a novel, *Jane of Lantern Hill*, to Lucky. When Lucky died of cancer of the liver at an advanced age, he "lay in state" for most of the day on a chest in her bedroom in her Toronto home, was buried in the backyard and had his grave marked by a round red stone Lucy Maud had crated and sent up from Prince Edward Island.[53] It seemed fitting that cats which were so important to her personally should figure prominently in some of her novels.

Unfortunately, Mr. Macdonald's health declined progressively until he was obliged to resign from his ministerial charge in Norval in 1935. The Macdonald family moved to Toronto shortly after Mr. Macdonald's retirement from the active ministry. Toronto was chosen as their future home principally because their two sons were studying there. Chester was reading law at Osgoode Hall, while Stuart was studying medicine at the University of Toronto. Lucy Maud, of course, pursued her literary career in her new home at 210-a Riverside Drive in Toronto. Fittingly enough, her new home, which she called "Journey's End," was situated on the Humber River and within walking distance of Lake Ontario. In response to pleas from her publishers, two more *Anne* books were written. *Anne of Windy Poplars*, which she began "unwillingly" was published in 1936, and when the publishers begged for yet another, she produced *Anne of Ingleside*, "just a pot-boiler," in 1939.[54] Like so many successful authors, Lucy Maud, however reluctantly, had to accede to the tastes of her readers.

In addition to the two *Anne* books, Lucy Maud prepared two other publications while living in Toronto. In 1937, *Jane of Lantern Hill* made its appearance. One more girl was added to the list of Lucy Maud's beloved heroines. The story begins in Toronto, but *Jane*, her father, and eventually her mother, find Prince Edward Island to be the ideal home. Lucy Maud, who always felt that she, herself, had done "violence to her soul" when she left Prince Edward Island, did not want her heroine to endure a permanent separation from her "Island paradise." In the winter of 1942, she compiled a collection of magazine stories she had written many

years previously. Among these were some articles that had been in "limbo" since the successful resolution in 1930, of her lawsuit against the L. C. Page Company which had published them in 1920 without her authorization. In April, 1942, she placed this collection of stories, under the title of *Further Chronicles of Avonlea,* with the publisher.[56] It is unique in that the last chapter, "Tannis of the Flats," is set in Prince Albert. This is the only occasion in which Lucy Maud makes use of her father's adopted home where she had spent a memorable year in 1890-1891. This volume was the last of the twenty-two works of fiction which Lucy Maud Montgomery published during her long and successful literary career.

Her role as a famous personage grew more taxing as the years passed. She was in frequent and exhausting demand as a public speaker for innumerable Church groups, service clubs and professional societies. Her oratorical ability and impressive appearance made an excellent impression upon her many audiences as she spoke about or read from her poetry and prose. During her lifetime, she was the recipient of many honors. She was elected a Fellow of the Royal Society of Arts and Letters of England.[57] The Literary and Artistic Institute of France made her a member, and issued her a silver medal for her literary style.[58] And, in 1935, His Majesty, King George V of England, declared her an Officer of the Order of the British Empire.[59] Thus, the world officially recognized a woman, who, for over half a century, wrote stories that appealed to the young in heart of all ages.

But like so many successful people, Lucy Maud had to pay a high price for fame. In her own immediate circle on Prince Edward Island, success had brought her unexpected jealousies. "If you want to find out just how much *envy* and *petty spite* and *meanness* exists in people, even people who call themselves your friends," she commented to Weber shortly after she had published *Anne of Green Gables,* "just write a successful book or do something they can't do, and you'll find out!"[60] "I could not begin to tell you," she wrote later, "all the petty flings of malice and spite of which I have been the target of late, even among some of my own relations."[61] Although Lucy Maud did not experience the same kind of personal affronts during her years in Ontario, she had her share of professional problems. Throughout her life she was quite concerned with any adverse judgments upon her novels. She was an acutely sensitive person and she was deeply hurt by the "slings and arrows" of reviewers who did not like her literary productions. Fortunately these were few, because Lucy Maud never did manage to adopt a philosophic outlook on criticism.

Lucy Maud was also plagued with all the financial problems associated with a publishing career. Although it has been estimated that she made

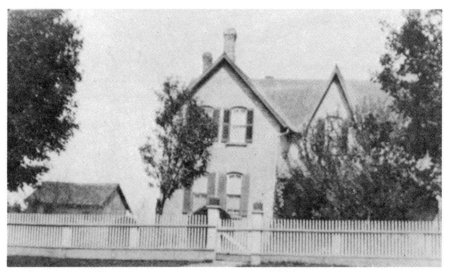

Leaskdale Manse
(Courtesy Mrs. Ronald Stiver)

Leaskdale Presbyterian Church
(Courtesy Mrs. Clara Trainor)

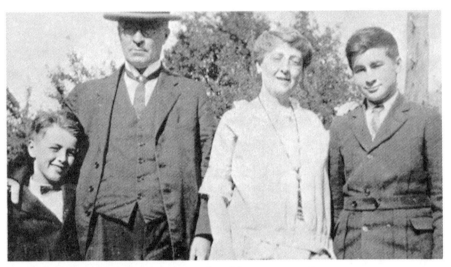

Stuart Macdonald, Rev. Ewen Macdonald, Lucy Maud Macdonald,
Chester Macdonald (1925)
(Courtesy Mrs. Murray Leard)

Norval Manse
(Courtesy Mrs. Louise Lowther)

Norval Presbyterian Church
(Courtesy St. Clair Trainor)

Lucy Maud Macdonald in the early 1930's
(Courtesy Anita Webb)

Lucy Maud Macdonald in the late 1930's
(Courtesy Anita Webb)

Rev. Ewen and Mrs. Lucy Maud Macdonald in the late 1930's
(Courtesy Anita Webb)

Rev. Ewen Macdonald
(Courtesy Dr. Stuart Macdonald)

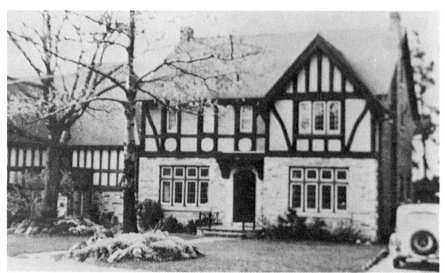

"Journey's End", 210 Riverside Drive
(Courtesy Ruth Campbell)

*Lucy Maud Macdonald's Funeral from "Green Gables", Cavendish,
April, 1942. (Rev. Ewen Macdonald on extreme left)* (Courtesy Anita Webb)

more than $200,000 from her writings, she realized with considerable chagrin, that if she had used more perspicacity in the matter of handling *Anne of Green Gables*, always a "best seller," she would have earned considerably more money. She had realized some $22,000 from *Anne of Green Gables* under her own copyright, when she imprudently sold her rights to it and its six sequels for $20,000.[62] With her husband's extremely low salary, and her two sons receiving expensive educations, she certainly could have used a more profitable financial arrangement. The L. C. Page Company, and its heir, managed to play the role of a financial albatross throughout her career. In 1920, the Company, without her authorization, published some of her short stories in a book, entitled, *Further Chronicles of Avonlea*. Lucy Maud indignantly protested against "piracy," and brought the case before the courts. The suit dragged on for nine years, wearying, often embarrassing and humiliating, and always expensive and irritating. Although she won the case, it was an expensive and hollow victory.[63]

In 1921, Page's of Boston authorized Hollywood to make a silent movie on her book, *Anne of Green Gables*. Since her contract gave her no royalties for "screen rights," she received no money and had no control over the treatment of the story made for film purposes.[64] She watched with dismay the distortion of her story, and cringed when she viewed the "Stars and Stripes" flying over *Anne's* school.[65] In 1934, *Anne of Green Gables* was again screened, but this time as a "talkie." The publishers sold its rights to the producer for $40,000. Once again, Lucy Maud was denied any share.[66] In 1942, shortly before her death, Ryerson Press, which had been Canadian agents for L. C. Page Company, planned a Canadian edition of her earlier works. Lucy Maud was in correspondence with them, but they ungraciously refused to make any change in the royalty arrangements. Her experience was the same with respect to two three-act plays based on *Anne of Green Gables*. It is easy to appreciate the resentment, bitterness and unhappiness that Lucy Maud experienced throughout her life because of what she considered unfair exploitation of her efforts by her publishers.

As the 1930's drew to a close, a change began to take place in the normally pleasant and resilient personality of Lucy Maud Macdonald. She often complained of exhaustion, and her friends remarked that, at times, she seemed quite nervous. Lucy Maud, in her younger days, often wrote of enduring months of sick headaches and nervous disorders. The nervous exhaustion attendant upon the publication of *Anne of Green Gables* in 1908, for example, prompted her to terminate a letter to Ephraim Weber — "Yours tiredly, headachely, listlessly, don't careishly — but *not* hopelessly — L. M. Montgomery."[67] "I have not been especially well this winter," she complained in March, 1909. "I've been very nervous and at times very morbid.

The doctor says my nervous system is run down and requires a course of raw eggs and cod liver oil. I am improving under such a regimen, and this last month I've been much better."[68] As the years passed, Lucy Maud, of course, did not enjoy the same recuperative powers. Her husband's total dependence upon her in his worsening melancholia was a tremendous strain. In July, 1937, she commented upon her husband's chronic condition to her cousin, Charlotte MacGougan. "Mr. Macdonald is very ill at present with a bad nervous breakdown and is confined to bed. He had a bad attack of bronchitis in the spring and lost so much sleep by coughing that his nerves gave way and the result was nervous prostration. He is slowly improving, but has a long way to go yet before he will be well."[69] In addition, the estrangement of her son, Chester, from his wife was also a great worry to her. At length, Lucy Maud herself collapsed under the pressure.

She suffered a serious nervous breakdown in 1938, which kept her in complete anguish for four months. "A dreadful restlessness," she commented, "obsessed me and I had to get up and walk the floor. . . . I shall never forget the terrible nights."[70] In the summer of 1940, her husband's pathetic mental condition, the depressing war news and fear that her only dependable son, Stuart, would be drafted, contributed to a serious mental collapse. "I do not think I will ever recover," she wrote helplessly to Weber. . . . "Let us thank God for a long and true friendship."[71] She never did recover permanently. By December of 1941, only the help of stimulants enabled her to cope with life. Finally, on Friday night, April 24, 1942, Lucy Maud Macdonald died suddenly in her Toronto home at the age of sixty-seven.

On April 28, her husband, Ewen, and her two sons, Chester and Stuart, brought her mortal remains to her beloved Cavendish, where they lay in state at "Green Gables," the house that she had made famous through her first novel, *Anne of Green Gables*. "Green Gables" was a saddened house indeed, as men and women, boys and girls, farmers, fishermen and businessmen came from miles around to pay their last respects to one who had been one of them.[72] On Wednesday, April 29, hundreds of relatives and friends, assembled for her funeral. A short service at "Green Gables" was conducted by the Reverend John Stirling, a close friend of the deceased, and the clergyman who had officiated at her marriage to the Reverend Ewen Macdonald in July, 1911. Her remains were then transferred to Cavendish United Church, the same church in which she had served as organist for many years. Mr. Stirling, who was in charge of the service, delivered the eulogy, while a message of sympathy, on behalf of the Moderator of the Presbyterian Church of Canada, was given by the Rev. Dr. Frank Baird. Her meditative poem on the Resurrection, *The Watchman*, was read, as well as relevant excerpts from *Chronicles of Avonlea*. The Lieutenant Governor of the

Province, His Honour B. W. LePage, and the Premier, Thane A. Campbell, were among the dignitaries present. The pallbearers, either contemporaries or close friends of the deceased, were: Messrs. Frederick Clark, Cavendish; George Henry Robertson, Mayfield; Alexander Macneill, Cavendish; William Toombs, North Rustico; Joseph Stewart, Bay View; and Jeremiah Simpson, Cavendish.[73] She was buried in Cavendish cemetery in a plot on the crest of the hill overlooking "Green Gables," a site, she, herself, had selected in 1923, because, as she noted, "it overlooked the spots I always loved, the pond, the shore, the sand dunes, the harbour." In December, 1943, her husband was interred beside her.

In 1948, the Historic Sites and Monuments Board of Canada honored her memory by declaring her a Canadian of national historic significance, and by erecting a monument to her in the National Park in Cavendish. Lucy Maud would have been quite pleased that Canada's memorial to her was situated in the National Park close to "Green Gables", since she had stated quite emphatically in 1939, that the National Park had preserved, to a very considerable degree, all her sacred and beloved haunts. The National Park itself is really a monument to her, since its central feature is *Anne's* beloved home, "Green Gables." Her greatest memorial, however, will always be the lasting quality and appeal of her writings, especially, *Anne of Green Gables*. Whether in book, in stage play, in movie, in television series, or in musical, whether in English, French, Japanese, or in Braille, *Anne* continues to captivate those who meet her.[74] During her life Lucy Maud Montgomery wrote some beautiful lines that seem to be a fitting epitaph:

The "Alpine Path" has been climbed, after many years of toil and endeavour. It was not an easy ascent, but even in the struggle at its hardest, there was a delight and a zest known only to those who aspire to the heights.

> "He n'er is crowned
> With immortality, who fears to follow
> Where airy voices lead."

> (Keats)

True, most true! We must follow our 'airy voices,' follow them through bitter suffering and discouragement and darkness, through doubt and disbelief, through valleys of humiliation and over delectable hills where sweet things would lure us from our quest, ever and always must we follow, if we would reach the "far-off divine event" and look out thence to the aerial spires of our City of Fulfilment.[75]

One can only add, with complete respect, Amen.

FOOTNOTES TO EPILOGUE

[1]L. M. Montgomery to Ephraim Weber, 2 September, 1909, *op. cit.*, p. 90.

[2]L. M. Montgomery to Ephraim Weber, 10 September, 1908, *op. cit.*, p. 74.

[3]L. M. Montgomery to Murray Macneill, 6 July, 1909.

[4]L. M. Montgomery, "The Alpine Path," *Everywoman's World*, Vol. VIII, No. IV, (October, 1917), p. 8.

[5]*Ibid.*

[6]Mustard, *op. cit.*, p. 7.

[7]L. M. Montgomery, "The Alpine Path," *Everywoman's World*, Vol. VIII, No. IV, (October, 1917), p. 8.

[8]*Ibid.*

[9]*Ibid.*

[10]H. H. Simpson, *op. cit.*, p. 207.

[11]Mollie Gillen, "Maud Montgomery: The Girl Who Wrote Green Gables," *Chatelaine*, Vol. 46, No. 7, (July, 1973), p. 54.

[12]*Ibid.*

[13]*Ibid.*

[14]Mustard, *op. cit.*, p. 2.

[15]*Ibid.*

[16]L. M. Montgomery's scrapbook, 1908-1915; in possession of Ruth Campbell, Park Corner, P.E.I.

[17]L. M. Montgomery, "The Alpine Path," *Everywoman's World*, Vol. VIII, No. IV, (October, 1917), p. 8.

[18]*Ibid.*

[19]*Ibid.*

[20]*Ibid.*

[21]*Ibid.*, p. 58.

[22]L. M. Montgomery, "The Alpine Path," *Everywoman's World*, Vol. VIII, No. V, (November, 1917), p. 38.

[23] *Ibid.*

[24] L. M. Montgomery to Mrs. Margaret McKenzie, 17 September, 1911. Letter in possession of Lloyd Warren, Toronto.

[25] Mustard, *op. cit.*, p. 3.

[26] *Ibid.*, p. 7.

[27] Simpson, *op. cit.*, p. 208.

[28] Gillen, *op. cit.*, pp. 54-55.

[29] Mustard, *op. cit.*, pp. 6-17.

[30] *Ibid.*, p. 15; statement by Elsie Davidson.

[31] *Ibid.*, pp. 15-16.

[32] Hilda M. Ridley, *The Story of L. M. Montgomery*, (Toronto, 1956), p. 108.

[33] Gillen, *op. cit.*, p. 54.

[34] L. M. Montgomery, *Anne of The Island*, (London, 1915), p. VI.

[35] L. M. Montgomery, *The Watchman and Other Poems*, (Toronto, 1916).

[36] Elizabeth Waterston, "L. M. Montgomery," *The Clear Spirit, Twenty Canadian Women and their Times*, (Toronto, 1967), p. 209.

[37] Gillen, *op. cit.*, p. 54.

[38] L. M. Montgomery to Ephraim Weber, 19 October, 1921.

[39] L. M. Montgomery, *Emily of New Moon*, (Toronto, 1926), p. V.

[40] Waterston, *op. cit.*, p. 211.

[41] *Ibid.*, p. 212.

[42] *Ibid.*

[43] *Ephraim Weber*, "L. M. Montgomery as a Letter-Writer," *Dalhousie Review*, Vol. 22, October, 1942, p. 303.

[44] L. M. Montgomery to Ephraim Weber, 2 September, 1909, *op. cit.*, p. 92.

[45] L. M. Montgomery, "Prince Edward Island," *The Spirit of Canada*, (Montreal, 1939), p. 19.

[46]Mustard, *op. cit.*, pp. 18-19.

[47]Gillen, *op. cit.*, p. 58.

[48]Waterston, *op. cit.*, p. 213.

[49]*Ibid.*, p. 214.

[50]L. M. Montgomery to Donald Campbell, 7 March, 1932.

[51]Waterston, *op. cit.*, p. 214.

[52]Quoted in Gillen, *op. cit.*, p. 58.

[53]Luella Macdonald to Ruth Campbell, 22 July, 1974; letter in possession of Ruth Campbell.

[54]Quoted in Gillen, *op. cit.*, p. 54.

[55]Waterston, *op. cit.*, p. 129.

[56]Ridley, *op. cit.*, p. 135.

[57]*Ibid.*, p. 129.

[58]*Ibid.*

[59]Simpson, *op. cit.*, p. 208.

[60]L. M. Montgomery to Ephraim Weber, 10 September, 1908, *op. cit.*, p. 75.

[61]L. M. Montgomery to Ephraim Weber, 22 December, 1908, *op. cit.*, p. 79.

[62]Gillen, *op. cit.*, p. 58.

[63]Waterston, *op. cit.*, p. 210.

[64]*Ibid.*, p. 211.

[65]Ridley, *op. cit.*, p. 127.

[66]Waterston, *op. cit.*, pp. 216-217.

[67]L. M. Montgomery to Ephraim Weber, 10 September, 1908, *op. cit.*, p. 76.

[68]L. M. Montgomery to Ephraim Weber, 28 March, 1909, *op. cit.*, p. 85.

[69]L. M. Montgomery to Charlotte MacGougan, 10 July, 1937. This letter was written on the occasion of the death of Charlotte MacGougan's mother, which occurred on July 9, 1937. Charlotte was a daughter of Mrs. Mary Emily Montgomery who was

Lucy Maud's aunt. This letter is in the possession of Charlotte MacGougan's son, Sydney MacGougan, of Malpeque.

[70]L. M. Montgomery to Ephraim Weber, 31 October, 1939.

[71]L. M. Montgomery to Ephraim Weber, 31 December, 1940.

[72]Charlottetown *Guardian*, 29 April, 1942.

[73]Charlottetown *Guardian*, 30 April, 1942; Interestingly enough, Alexander Macneill was a brother of her very close friend, Penzie Macneill, and George Henry Robertson was the husband of her other close friend, Amanda Jane Macneill.

[74]Gillen, *op. cit.*, p. 58.

[75]L. M. Montgomery, "The Alpine Path," *Everywoman's World*, Vol. VIII, No. V, (November, 1917), p. 40.

BIBLIOGRAPHY

The sources cited in this bibliography are limited to those consulted in the preparation of this book.

PRIMARY SOURCES

A. Unprinted Material

(1) Private Letters

L. M. Montgomery letters to Penzie Maria Macneill; this collection comprises 16 letters from Prince Albert written in 1890-1891, and a smaller number written on Prince Edward Island. These letters are in the Library of the University of Prince Edward Island, Charlottetown, P.E.I.

L. M. Montgomery letters to Professor Murray Macneill; these two letters were written in 1908 and 1909. They are in the possession of Mrs. Ernest Macneill and Mrs. John Macneill.

L. M. Montgomery letters to the Campbells of Park Corner; collection in possession of Ruth Campbell.

L. M. Montgomery letter to Mrs. Lorenzo Toombs, 15 February, 1916; this letter in possession of William Toombs.

L. M. Montgomery letter to Mrs. Charlotte MacGougan, 10 July, 1937; this letter is in possession of Sydney MacGougan.

L. M. Montgomery letters to Ephraim Weber, 1909-1941. P.A.C.

PRIMARY SOURCES

A. Unprinted Material

(2) Personal Portfolios

L. M. Montgomery scrapbook, 1890-1898; this scrapbook containing L. M. Montgomery's publications between these years is in her birthplace at New London, Prince Edward Island.

L. M. Montgomery scrapbook, 1898-1917; this scrapbook containing some of her publications and personal newspaper records is in the possession of Ruth Campbell, "Silver Bush," Park Corner, P.E.I.

PRIMARY SOURCES

B. Printed Material

(1) Public Documents

Canada. Parliament, *Sessional Papers*, 1900; Public Archives of Canada.

Canada. Department of The Interior, Record Group 15, B1, Box 1089, File 137340; Public Archives of Canada.

Prince Edward Island. Department of Education Records, 1883-1900; Provincial Archives, P.E.I.

PRIMARY SOURCES

B. Printed Material

(2) Newspapers

Charlottetown *Daily Patriot*, 1874-1942; Provincial Archives, P.E.I.

Charlottetown *Examiner*, 1880-1911; Provincial Archives, P.E.I.

Charlottetown *Guardian*, 1939-1942; Provincial Archives, P.E.I.

Ontario *Gleaner*, 1887; *Gleaner* office, Cannington, Ontario.

Prince Albert *Times*, 1883-1892; Saskatchewan Public Archives, Regina, Saskatchewan.

Prince Albert *Advocate*, 1900-1910; Saskatchewan Public Archives, Regina, Saskatchewan.

The Saskatchewan (Prince Albert); 1891-1892; Saskatchewan Public Archives, Regina, Saskatchewan.

SECONDARY SOURCES

(1) Books

Eggleston, Wilfred, ed. *The Green Gables Letters*, (Toronto, 1960).

Leard, George A. *Historic Bedeque*, (Charlottetown, 1973).

Montgomery, Lucy Maud. *The Road to Yesterday*, (Toronto, 1974).

Mustard, Margaret H. *L. M. Montgomery as Mrs. Ewan Macdonald of Leaskdale Manse,* 1911-1926, (Leaskdale, 1965).

Ridley, Hilda M. *The Story of L. M. Montgomery,* (Toronto, 1956).

Simpson, Harold H. *Cavendish, Its History, Its People,* (Truro, 1973).

Women's Institute, Belmont, *The History of Belmont,* (Charlottetown, 1973).

Women's Institute, Springfield, *Lucy Maud Montgomery, The Island's Lady of Stories,* (Charlottetown, 1964).

SECONDARY SOURCES

(2) Articles

Gillen, Mollie, "Maud Montgomery: The Girl Who Wrote Green Gables," *Chatelaine,* Vol. 16, No. 7, pp. 40-41, 52-58, (July, 1973).

Montgomery, Lucy Maud, "The Alpine Path", *Everywoman's World,* 6 Installments, (June-November, 1917).

Montgomery, Lucy Maud. "Prince Edward Island," *The Spirit of Canada,* pp. 16-19, (Toronto, 1939).

Sclanders, Ian. "Lucy of Green Gables," *MacLean's Magazine,* 64: pp. 12-13, 33-36, (December 15, 1951).

Waterston, Elizabeth. "Lucy Maud Montgomery, 1874-1942," *The Clear Spirit,* pp. 198-220, (Toronto, 1964).

Weber, Ephraim. "L. M. Montgomery as a Letter Writer," *Dalhousie Review,* 22: pp. 300-310, (October, 1942).

_____ "L. M. Montgomery's Anne" (Bibliography), *Dalhousie Review,* 24: pp. 64-73, (April, 1944).

L. M. MONTGOMERY'S PUBLISHED WORKS

Anne of Green Gables, 1908

Anne of Avonlea, 1909

Kilmeny of the Orchard, 1910

The Story Girl, 1911

Chronicles of Avonlea, 1912

The Golden Road, 1913

Anne of the Island, 1915

Anne's House of Dreams, 1917

Rainbow Valley, 1919

Rilla of Ingleside, 1921

Emily of New Moon, 1923

Emily Climbs, 1925

The Blue Castle, 1926

Emily's Quest, 1927

Magic for Marigold, 1930

A Tangled Web, 1931

Pat of Silver Bush, 1933

Mistress Pat, 1935

Anne of Windy Poplars, 1936

Jane of Lantern Hill, 1937

Anne of Ingleside, 1939

Further Chronicles of Avonlea, 1953 (First Canadian
edition); (Copyright, 1920).

The Watchman and Other Poems, 1916